The Subve

CONTRIBUTIONS TO ZOMBIE STUDIES

White Zombie: *Anatomy of a Horror Film*. Gary D. Rhodes. 2001

The Zombie Movie Encyclopedia. Peter Dendle. 2001

*American Zombie Gothic: The Rise and Fall (and Rise)
of the Walking Dead in Popular Culture*. Kyle William Bishop. 2010

*Back from the Dead: Remakes of the Romero
Zombie Films as Markers of Their Times*. Kevin J. Wetmore, Jr. 2011

*Generation Zombie: Essays on the Living Dead
in Modern Culture*. Edited by Stephanie Boluk and Wylie Lenz. 2011

*Race, Oppression and the Zombie: Essays on Cross-Cultural Appropriations
of the Caribbean Tradition*. Edited by Christopher M. Moreman
and Cory James Rushton. 2011

Zombies Are Us: Essays on the Humanity of the Walking Dead.
Edited by Christopher M. Moreman and Cory James Rushton. 2011

The Zombie Movie Encyclopedia, Volume 2: 2000–2010. Peter Dendle. 2012

Great Zombies in History. Edited by Joe Sergi. 2013 (graphic novel)

Unraveling Resident Evil: *Essays on the Complex Universe
of the Games and Films*. Edited by Nadine Farghaly. 2014

"We're All Infected": Essays on AMC's The Walking Dead
and the Fate of the Human. Edited by Dawn Keetley. 2014

Zombies and Sexuality: Essays on Desire and the Living Dead.
Edited by Shaka McGlotten and Steve Jones. 2014

…But If a Zombie Apocalypse Did *Occur: Essays on Medical,
Military, Governmental, Ethical, Economic and Other Implications*.
Edited by Amy L. Thompson and Antonio S. Thompson. 2015

*How Zombies Conquered Popular Culture: The Multifarious Walking
Dead in the 21st Century*. Kyle William Bishop. 2015

Zombifying a Nation: Race, Gender and the Haitian Loas on Screen.
Toni Pressley-Sanon. 2016

*Living with Zombies: Society in Apocalypse in Film, Literature
and Other Media*. Chase Pielak and Alexander H. Cohen. 2017

Romancing the Zombie: Essays on the Undead as Significant "Other."
Edited by Ashley Szanter and Jessica K. Richards. 2017

The Written Dead: Essays on the Literary Zombie.
Edited by Kyle William Bishop and Angela Tenga. 2017

The Collected Sonnets of William Shakespeare, Zombie.
William Shakespeare and Chase Pielak. 2018

*Dharma of the Dead: Zombies, Mortality and
Buddhist Philosophy*. Christopher M. Moreman. 2018

*The Subversive Zombie: Social Protest and Gender
in Undead Cinema and Television*. Elizabeth Aiossa. 2018

The Subversive Zombie

Social Protest and Gender in Undead Cinema and Television

ELIZABETH AIOSSA

CONTRIBUTIONS TO ZOMBIE STUDIES
Series Editor Kyle William Bishop

McFarland & Company, Inc., Publishers
Jefferson, North Carolina

LIBRARY OF CONGRESS CATALOGUING-IN-PUBLICATION DATA

Names: Aiossa, Elizabeth, author.
Title: The subversive zombie : social protest and gender in undead
 cinema and television / Elizabeth Aiossa.
Description: Jefferson, North Carolina : McFarland & Company,
 Inc., Publishers, 2018. | Series: Contributions to zombie studies |
 Includes bibliographical references and index.
Identifiers: LCCN 2018001679 | ISBN 9781476666730 (softcover :
 acid free paper) ∞
Subjects: LCSH: Zombies in motion pictures. | Zombies on
 television. | Sex role in motion pictures. | Sex role on television.
Classification: LCC PN1995.9.Z63 A36 2018 | DDC 791.43/675—
 dc23
LC record available at https://lccn.loc.gov/2018001679

BRITISH LIBRARY CATALOGUING DATA ARE AVAILABLE

ISBN 978-1-4766-6673-0 (print)
ISBN 978-1-4766-3188-2 (ebook)

Front cover: poster art for *Dawn of the Dead*, 1978 (United Film
Distribution Company/Photofest)

Printed in the United States of America

McFarland & Company, Inc., Publishers
 Box 611, Jefferson, North Carolina 28640
 www.mcfarlandpub.com

Acknowledgments

This book is an updated, developed, and refined revision of my doctoral dissertation. The research and writing processes have been as challenging as they have been transformative. I am forever indebted to the support and insights of my chair, Dr. Chris Voparil, and my committee members, Dr. Diane Allerdyce and Dr. Colleen O'Brien. Dr. Voparil, thank you for your unwavering and compassionate leadership, for pushing me when and how I needed it, and for knowing when I had to find the way on my own. You went well beyond the call of duty when you watched all those zombie films. Dr. Allerdyce, thank you for believing I had what it took to pursue a theoretical project, and for always reminding me to question my assumptions. Thank you, Dr. O'Brien, for encouraging me to tackle unconventional topics and texts using experimental methods and approaches, and for diving deep into these murky waters right alongside me. Collectively, my committee has shaped me into a better scholar, writer, teacher, and human being.

I want to extend my gratitude to my College of Lake County administrators, colleagues, and especially to my students, for inspiring and enabling the journey to a doctorate and into this book manuscript. I am a better professor and colleague for it.

I offer my thanks to McFarland for their support and honesty throughout the publishing process.

To my parents, Rick and Ginny: thank you for always believing in me even when I doubted myself. I could not and would not have achieved these dreams without your generous care.

And to my beloved husband, Colin: your uncanny ability to make me laugh during the toughest and darkest times is the greatest gift of all. I couldn't hope for a better partner in this life, or in the zombie apocalypse.

Table of Contents

Preface: Dawn
of a Zombie Scholar

The public ... or at least a certain portion of it ... seems
to have an interest in the walking dead.
　　　　—George Romero, Foreword to *Book of the Dead*

Years ago, at a pivotal point in my graduate studies, I
nearly turned away from the study of monsters, thinking
that nobody would ever take that research seriously.
　　　　—Deborah Christie, *Better off Dead*

Horror, with its brutal violence and science fiction influences, cer-
tainly makes for controversial cinema. The genre as a whole was origi-
nally and pervasively considered too repugnant to warrant critical
attention by serious critics and scholars until the breakthrough work of
Robin Wood in 1986. Wood captures the down-grading of horror, which
has:

> consistently been one of the most popular and, at the same time, most disreputable
> of Hollywood genres. The popularity itself has a peculiar characteristic that sets it
> apart from other genres: it is restricted to aficionados and complemented by total
> rejection, people tending to go see horror films either obsessively or not at all.
> They are dismissed with contempt by the majority of reviewer-critics, or simply
> ignored [69].

Beyond simply loving or loathing the genre, some consider an appreciation
of horror to be pathological. As Mark Jancovich further elucidates in his
introduction to *Horror, The Film Reader*, "[w]hile people may not actually
like certain genres, many consider the appeal of horror films a problem
in itself. A taste for westerns may be strange, but a taste for horror film is
often seen as somehow 'sick'" (22). Wood attributes this dismissal of horror
to bourgeois elitism since the genre, at its finest, radically protests the
dominant ideologies and consumerism upheld by the privileged classes.

1

This is precisely why the zombie horror genre is so radical and valuable and thus demands prompt, in-depth scholarly attention.

But the reputation of horror has changed, or is changing, according to Jancovich. He asserts how the horror genre is still "claimed to be interesting because of its supposedly marginal, and hence subversive, status as a disreputable form of popular culture" and yet this marginal status has mostly been erased by current academic interest in how "horror film raises questions of cultural analysis and cultural policy" (1). As Jancovich suggests, the chasm between horror and scholarship has significantly shrunk over the past few decades. According to leading zombie scholar Kyle William Bishop, "zombie scholars need no longer to hide in the shadows or struggle to come up with legitimizing euphemisms for their chosen scholastic passions" (*How Zombies Conquered Popular Culture* 1) now that the academy and publishing arenas acknowledge and promote the field of zombie studies.

Nonetheless—in my experience over the past few years—the stigma of zombie studies endures and theoretical work regarding this unique subgenre of horror remains nascent and underdeveloped, though it grows every day. "I knew I had the perfect book topic to propose," Bishop explained in his first book in the field, "although I recognized there would likely be some resistance from the more traditional quarters of academia" (*American Zombie Gothic* 6). For this reason, scholars seem compelled to acknowledge their own, often criticized or assumed deviant, personal attraction and academic dedication to zombie media. They share their first encounters with particular zombie films or the origin stories of their research, perhaps in attempt to simultaneously justify and apologize for their baffling commitment to these oft-obscene monster narratives.

I too have had my share of professional and inner conflict. When asked at family parties what I'm researching, I blurt, "radical representations in sci-fi films," and with a dismissive wave I add "Pbbt! Totally boring stuff. You wouldn't be interested," and then I stuff my mouth with a giant hunk of cauliflower so I clearly can't answer any follow-up questions.

But zombies aren't boring; they're *fascinating*, to me and this small but rapidly expanding army of academics and independent researchers who now devote much of their time and intellectual energies to engaging these disturbing and confounding texts. They *affect* us, somehow, and we need to know how and why. Speaking of horror cinema more generally, Carol J. Clover reflects upon the pleasures and perplexities she derives from the modern low and exploitation film. She explains:

[l]ike others before me, I discovered that there are in horror moments and works of great humor, formal brilliance, political intelligence, psychological depth, and above all a kind of kinky creativity that is simply not available in any other stripe of filmmaking [...] To a remarkable extent, horror has come to seem to me not only the form that most obviously trades in the repressed, but itself the repressed of mainstream filmmaking [20].

For some of us, it's the influential stature of some "low" and "exploitation" films that is remarkable, not only for their social criticism, but also their deep personal impact.

I can, however abashedly, admit that watching and studying zombies has literally impacted how I view myself, my body, and society in powerful ways, and I am not alone. As Hubner, Leaning and Manning acknowledge in *The Zombie Renaissance in Popular Culture*, the zombie monster is indicative of Julia Kristeva's theory of the abject in that it "occupies a liminal or transitional and ambiguous space, and is therefore troubling to us" ("Introduction"). Citing Badley and Bishop, Hubner et al. also recognize, in accordance with Mikhail Bakhtin's writing on carnival, how zombies "forc[e] us to confront the material body in all its messiness" which "not only inverts the social conventions of the body (and bodily fluids) but potentially disrupts and threatens the social order in other ways too" ("Introduction"). Personally, each of the complex qualities contributes to my devotion.

I am also compelled to study zombie narratives for their inclusion of binary-obliterating monsters, society-shattering apocalypses, vital characterizations, and the subversive politics of paramount zombie films. Natasha Patterson confesses, "the more I watch *Night* and *Dawn*, the more I find something quite exhilarating and, dare I say empowering in the abolishment of home and consumer culture" (112). After pondering the question "in what ways does the *Dead* trilogy open up 'democratic' or pleasurable spaces for female viewers?" Patterson admits "Romero's zombie films enable me to imagine revolution outside the context of my oppression" and explains "[t]hus, the pleasure I derive from viewing Romero's *Dead* films is like embracing my own abjection; it is the pleasure of seeing myself (ourselves) turned inside out" (114). Mark Bracher opens his introduction to *Lacan, Discourse, and Social Change* with the claim that "[a]ll critical and interpretive activities, like the cultural artifacts on which they operate, ultimately take their value from the difference they make in people's lives" (1).

Zombie narratives are almost universally understood as metaphors for societal ills and global fears, and I contend the best examples can work

as powerful social protest texts, yet their deep impact upon individual viewers and their conceptions of self may ultimately be the most lasting and profound. I am empowered by zombie media, and irrevocably changed. Since these claims may seem hyperbolic, I offer a brief foray into my own first contact and scholarship origin stories.

Like no other media could, zombie films (Romero's and others') call out to me and call me out. In other words, they inspire me to define my own criteria for living and to break out of my many zombie states. From Barbra in *Night of the Living Dead*, I recognized how my passivity and fears could render me catatonic and helpless. Like Fran in *Dawn of the Dead*, I knew I needed to claim access to the freedoms and skills necessary to navigate this life on my own terms. As Sarah must in *Day* (1985), I've grown to embrace and trust in both my femininities and my masculinities.

The independence, creativity, intelligence, and disreputability that once marked the genre are no longer requisite today. Unfortunately, the mainstreaming of the zombie narrative in the new millennium reveals a disconcerting return to conservative conceptions of gender and monstrosity. *World War Z* (2013) and AMC's *The Walking Dead* (2010–present) issue the zombie plague as a means for restoring white male heroics, the dependency and weakness of women, and the wholly monstrous zombie as a threat to the status quo. For these reasons, I'm fighting—like Debra in *Diary of the Dead* (2007)—to protect myself and others from this pervasive and irresponsible media.

Romero and his protégés have taught me so much. Long live the undead!

Introduction:
The Shifting Culture
of the Modern Zombie

I always thought of the zombies as being about revolution, one generation consuming the next.
—George A. Romero

All of the misinformation we receive that narrowly defines masculinity and femininity can be unlearned and replaced with new information and expansive choices about our gender identity and the possibility that our lives, unrestricted by these oppressive rules, can be delightful.
—Holtzman and Sharpe, *Media Messages*

Zombies are overrunning our popular culture.

You've seen them before, rotting reanimated corpses stalking the living across the remote countryside, within the suburban mega-mall, and in beer commercials played during the national football game. Current zombie media, performances, and products are much like the zombies themselves—before you realize it, *they're everywhere*: zombie films, TV shows, novels, graphic novels, video games, apps, walks, proms, flash mobs, bumper stickers, T-shirts, and so on. In recent years, news outlets and marketing teams began to tack the "zombie" label onto as many headlines, products, and television programs as possible, and the plan worked to drum up commercial attention, social media hype, and viewing audiences. One of the most popular basic cable shows is AMC's *The Walking Dead* (2010–present),[1] and two of 2013's biggest blockbusters were zombie films: *Warm Bodies* and *World War Z*. *World War Z 2*, the sequel, is slated for release in 2019.

Clearly, the zombie media infection is reaching pandemic proportions, and zombie-related scholarship is scrambling to catch up and

uncover why this resurgence is occurring in the 21st century. Each anthology suggests its own hypotheses for the current explosion of zombie popularity, or what Kyle Bishop and Peter Dendle refer to as the "Zombie Renaissance" (*American Zombie Gothic* 5). Bishop suggests the "renaissance" of zombie narratives is tied to post–9/11 sociopolitical fears of corrupt government, consumerism "gone wild," and global terrorism (see "Introduction"). Apocalyptic zombie narratives feed into survivalist fantasies and "offer a worst-case scenario for the collapse of all American social and governmental structures" (Bishop 23). Therefore, "zombie narratives have been reconditioned to satisfy a new aesthetic, but they have also returned to prominence because the social and cultural conditions of a post–9/11 world have come to match so closely those experienced by viewers during the civil unrest of the 1960s and '70s" (Bishop 25). In this way, Bishop explains, "the zombie film works as an important example of the contemporary Gothic, readdressing 'the central concerns of the classical Gothic,' such as 'the dynamics of family, the limits of rationality and passion, the definition of statehood and citizenship, the cultural effects of technology'" (26). Zombie outbreaks can stand in as allegories for current real-world fears including but not limited to "infectious disease, biological warfare, euthanasia, terrorism, and even rampant immigration" (Bishop 26). Ultimately, Bishop and Dendle conclude that since 9/11, "the popular culture produced by the United States has been colored by the fear of possible terrorist attack and the grim realization that people are not as safe and secure as they might once have thought" (Bishop 9).

I might agree with this assumption if the genre discussed were the alien invasion film, but I argue the modern zombie is more symbolic of internal and local threats—both sociocultural constructs within American culture and mysteries of the body and psyche—than of outside and foreign terrors. In the mid-eighties Robin Wood, a pioneer in zombie-related scholarship, first "identifie[d] the way in which the films critique 'normality'—the undermining of the heteronormative family and racial, gender, and sexual roles as well as the way in which zombies function as a critique of the lurch towards commodity fetishism and consumer capitalism" (Boluk and Lenz 11). Scholars Stephanie Boluk and Wylie Lenz go so far as to label the current population as "Generation Z" and to explain that the popularity of this unique monster is correlated to the fact that "the zombie functions as a machine programmed to collapse difference and break down binaries" (11–12). Wood, Boluk, and Lenz touch upon the most compelling reason for the genre's contemporary return and resonance.

Zombie Genre as Social Protest

Zombies have the power to transform society.

These radical monsters and the apocalypse they incite can—and, in my view, have and should continue to—rattle if not fully dismantle problematic Western heteronormative traditions, ideals, and dichotomies to their very core. The rise of the undead obliterates the fundamental conviction upon which all other binaries are built: human beings are either alive or dead. Zombies, not fully living nor dormant dead, call into question other assumed polar oppositions: normal and other, human and monster, good and evil. Differences are rendered mutable. Embodiments are revealed to be spectral, fluid. When these immaculate categories falter, the oppressive institutions and belief systems dependent upon them fail.

Zombies are threatening for more than just their existence as in between living and dead states. Zombies thrive in chaos, their horde grows as the surviving human population and its established order dwindle. As Steve Jones ascertains, "zombies at once unwittingly follow the established order, and yet threaten to overthrow and defamiliarize 'normal' relations to that system" ("Porn of the Dead…" 41). For these reasons, Jones explains, the zombie is "a figure that designates revolt, threatening the patriarchal order—the reproductive motif thus acts as a metaphor for increased power, infecting the populous, overturning the world order of the 'majority' with disease and chaos" (44). As the types of zombies adapt and evolve to reflect and challenge the current status quo, their power grows along with their social commentary and critique.

Beginning with George Romero's original *Dead* trilogy, the brightest zombie cinema protests the perceived sanctity and security of Western society and its status quo. Civilization collapses. Government erodes. Capitalism becomes obsolete, so the class system dissolves. Power returns to the people. Survivors of the initial zombie outbreak must band together, bond, then develop fresh paradigms for negotiating this new world disorder. Pragmatism replaces rugged individualism. Formerly marginalized citizens emerge as leaders, for they can teach the privileged how to endure an oppressive, common enemy.

Zombie narratives propose a critical pedagogy for challenging dominant culture as well as Hollywood propaganda that perpetuates white, patriarchal privilege. As Lawrence Grossberg explains in his "Foreword" to *Hollywood's Exploited*, "Critical Pedagogy wants to move people into places where they can 'see' that the world does not have to be the way it is, that it can be something different in the future, and that what we do

matters in shaping which future is actualized" (xiii). But as the editors of *Hollywood's Exploited* contend, "Hollywood is often actively engaged in supporting the dominant ideological positions of our epoch, including sexism, racism, xenophobia, American exceptionalism, and militarism" (3). Nonetheless, editors Frymer, Kashani, et al. believe that "cinema opens up space to step outside the dominant rationality and social order, and contemplate alternative modes of social organization [… and] challenge the status quo and current order of things" (3). Zombie films are especially equipped to accomplish this task.

Zombie movies meet the audience where and as they are—consumers of the popular—then invite them to consider new methods for conceiving and constructing a more just and balanced social order. This progressive cinema entertains viewers while it protests, and thus heeds Robert L. Hilliard's warning that "People don't want to be preached at in movies. They want to be entertained" (*Hollywood Speaks Out* 23). Since the genre is more popular and powerful than ever, today's emerging zombie media needs to uphold this social protest legacy.

While nearly all zombie scholars acknowledge the pervasiveness of zombie media in the new millennium is due in part to the political and social commentary associated with the genre, no single study devotes itself to what I consider to be the social protest aspect of these texts. Unfortunately, both current zombie media and its associated scholarship are at risk of losing this critical progressive thrust. Since the mainstreaming influence upon this genre is hyper-current, the recent degradation of the genre's representations of gender and monstrosity I see happening has yet to be sufficiently acknowledged and addressed.

Focus on Zombie Film and Television

This book primarily concentrates upon film since the modern American zombie originated in this medium and since it offers the best examples of protest via its complex character representations and social commentaries. This project will work as both an historical recovery of the social protest power of the genre as well as an in-depth investigation of the films and television programs that uphold this potential. While screen narratives are my principle focus, these analyses and insights regarding gender and the zombie monster are transferable to other contexts and mediums.

The radical representations and narratives in zombie films call into

question what it means to be human and monstrous, expose the overlap between these two states of being, and therefore reveal their foundation and value as social protest texts. As Bishop explains, "zombies look primarily like ordinary humans; this seemingly innocuous resemblance manifests visually what Freud calls the *Unheimlich*—an uncanny similarity between the familiar and the unfamiliar that makes such monsters even more disturbing and frightening" (*American Zombie Gothic* 95). This uncanny resemblance works to obliterate the line between us (the living) and them (the zombies) in several ways: all humans can turn into zombies, all zombies are formerly human, and humans often become monstrous—to one another as well as to "turned" family and friends—in their attempts to survive the zombie threat.

The overt connection between the living and undead reveals how the finest examples of modern zombie films grapple with complex issues of marginalization and otherness. They're us—yet we fear them for their otherness—and their differences are strange and terrifying. As Bishop explains:

> the protagonists of Romero's film [*Night of the Living Dead*] are systematically marginalized and "othered" by the overwhelming numbers of monsters [to which I add, by one another as well]. Put in such a precarious position, they quickly devolve into a more selfish, barbaric state. Survival, not society, becomes the top priority, and that paradigmatic shift has terrible consequences [*American Zombie Gothic* 95].

The very uncanny-ness of the zombies prompts both characters and audiences to examine their own values, morals, and ethics, as well as to recognize the precarity of their individual powers and their embodied identities. These survival narratives also prompt characters and viewers to rethink their assumptions regarding the individual versus the communal, the line demarcating self and everyone else, and how this solipsistic gap must be bridged in our efforts to secure survival and then advance positive social change.

Zombie films at their best, by the very condition of their complex representations, offer a powerful social critique of contemporary Western society radical enough to actually cause a paradigm shift in how we think, talk about, and live as marked bodies, and how we conceive of family, community, and capitalism. Zombie narratives also have the ability to teach viewers strategies for embracing difference and overcoming prejudice and its multiple oppressions. Fran in *Dawn of the Dead*, a divorced pregnant professional, is the only character insightful enough to recognize and combat—verbally and via her own actions—the allure of marketing

and blind consumption. She challenges fellow male survivors' feeble attempts to maintain their patriarchal power. Most remarkably perhaps, Fran realizes the outsider status and marginalization she shares with the zombies. For these reasons, Fran survives the zombie-infested megamall and pilots the helicopter carrying only herself, her unborn child, and Peter into another place and dawn. As Kim Paffenroth briefly recognizes, "Romero and other filmmakers use the 'fantastical' disease of zombies to criticize the very real diseases of racism, sexism, materialism, and individualism" and the "portrayal is so powerful and compelling in these films, that it is impossible to discount it as some thoughtless anti–American screed: it is a real, if extreme, diagnosis of what ails us all" (*Gospel of the Living Dead* 17–18). This "diagnosis of what ails us all" in preeminent zombie films may be the catalyst for overcoming these grave societal ills.

The Zombie Genre Under Attack

This once-subversive subgenre of horror is losing its critical potency now that it is being produced and consumed by and for the mainstream masses. In other words, the most recent and most popular zombie films and television shows are erasing the social protest foundations established by the genre in favor of restoring and promoting heteronormative characterizations and narratives more frequently associated with common action blockbusters.

Since few scholars focus on this negative trend, a key goal of this project is to illuminate the way in which gender norms and stereotypes in mainstream zombie blockbusters function to perpetuate and reinscribe traditional conceptions of masculinity, family, and monstrosity. For example, AMC's *The Walking Dead*—the first American episodic zombie tale (based on the Robert Kirkman et al.'s graphic novel series by the same name)—is the most popular adult demographic (18–49) basic cable drama series *of all time* (see Kain et al.). Regrettably, the show has struggled to develop truly complex gender and monster representations and thereby fails to engage with the social protest potential that can make this genre, at its best, quite inimitable and influential. I argue that *The Walking Dead*, masquerading as a subversive sci-fi zombie text, provides a mass-produced product riddled with reductive representations designed to restore the male as active and heroic and the female and other marginalized people as dependent and antagonistic.

Despite the society-shattering effect of a zombie invasion, *The Walk-*

ing Dead continues to propagate the stereotypes of masculine power and autonomy as well as female weakness and dependency. Every character in the show represents an archetype, a hyperbolized and flat characterization that represents a singular perspective/reactive personality in the wake of the zombie outbreak. Through several seasons, I have watched in horror as each female character—young and old, black and white—screams, cries, falls, and fails to exhibit any lasting physical fortitude, emotional depth, or psychological resilience. The rare occasion when an ancillary female character fends for herself is inevitably followed up shortly with the need for male heroism and rescue. The show's narrative punishes the few females who develop beyond their feminine stereotyping with tragedy, madness, and all too often gruesome death. As millions of viewers flock to the latest episode of this zombie saga, I hope I am not the only one hungering for a socially conscious and dynamic woman to appear.

The stereotypical characterizations and the conventional narratives of *The Walking Dead* perpetuate problematic binaries, essentialism, heteronormativity, misogyny, racism, and other prejudices. In this regard, *The Walking Dead* series works as a sort of morality play or allegory determined to reinstate and reinforce traditional Western values and neoconservative ideals regarding family, gender roles, race, and proper moral codes and standards. In other words, *The Walking Dead* works to reestablish the dominant ideologies and practices that Romero's *Dead* series and faithful successors worked so hard to subvert and overcome.

The social protest potential of today's most popular films and shows is greatly hindered by their tendency to reproduce and reinforce stereotypes, as evidenced by *The Walking Dead, Warm Bodies,* and the film version of *World War Z.* Female survivors in zombie apocalypse narratives are too often trapped in the role of dependency and by the repeated need for physical and emotional rescue. The prescriptive representations in current zombie media, almost wholly controlled by those who control the means of media creation (in this case, the predominantly white, American male writers and directors of modern zombie film and television) reveal preconceived and prejudicial notions regarding the roles, traits, and capabilities of women, as well as people of color and other marginalized groups.

My Contributions to Zombie Studies

My motivation to focus upon the modern zombie genre and its radical gendered representations stems from two key issues: few scholars have

devoted their work to zombies, and many of those who currently do merely touch upon issues of gender representation and the social protest potential of the genre at its best. Moreover, since the shift away from the radical and revolutionary stances of seminal zombie films is terribly recent, scholarship exposing the trend has yet to sufficiently catch up.

This book analyzes progressive and pivotal modern zombie films and television shows—from George A. Romero's original *Dead* trilogy to more recent iterations such as *28 Days Later...* (2002) the BBC's *In the Flesh* (2013–2015) and Netflix Original *Santa Clarita Diet* (2017–present)—and suggests how the radical characterizations and thematic content of these screen narratives elevate them to powerful social protest texts. In other words, the works should no longer be relegated to the dismissive designations—"gore porn," "camp" and "exploitation"—still too often assigned to them by film critics.

As the modern zombie genre evolves into the future, these unique monsters and their apocalypses should continue to challenge our conceptions of self, family, and the "Other." Zombie narratives provoke us to grapple with our fears regarding mortality, inhumanity, and the anomie of our hyper-technological society. In addition, these monster tales expose our sheer ineptitude to cope with global and domestic terrorism and to stave off mass infection and infestation on Earth.

We ignore the sociocultural representations of zombie narratives, their influences upon popular culture, and their indictments of modern society, at our own peril. The living dead scenario needs to be understood as a modern myth which invites viewers to contend with what it means to be human and to be Other; the zombie also inspires us to explore our fears of becoming Other and being overcome by the Other. As Mark Jancovich explains, body/horror and sci-fi/horror texts reveal how "the monstrous threat is not simply external but erupts from within the human body, and so challenges the distinction between self and other, inside and outside" (6). Zombie apocalypse texts also invite audiences to question the roles morality, ethics, and justice play in the community of survival.

When society and its institutions—its law and order—are rendered incompetent if not completely impotent, there remains the unique opportunity to recognize and critique the multiple oppressions and prejudices inherent within these systems. The modern zombie film has the potential to teach viewers how current stereotypes and subjugations are built upon faulty social constructs. Zombie apocalypse narratives can inspire the living to work together as they attempt to survive and rebuild a just soci-

ety. These powerful insights will prevail only if today's writers and directors once again create zombie media to protest societal ills and inspire positive social change. To put it simply, zombie films should continue to teach us about ourselves and enable us to realize who we want to become together.

Ultimately, this book aims to uncover and analyze the social protest power of seminal modern zombie screen narratives through time in an effort to reveal the enlightened influence of the genre at its finest. The project first takes up the immense and lasting relevance of George Romero's *Night of the Living Dead*, examining the radical representations of women and family, men and monsters, in the remainder of his original *Dead* trilogy and in other key works, including *28 Days Later...* and *Deadgirl*. The focus then shifts to exposing how the modern zombie genre is presently being co-opted and commodified—and therefore losing its protest thrust—as evidenced by works such as AMC's *The Walking Dead*, *World War Z*, and *Warm Bodies*. Finally, the discussion highlights how hope for the genre's protest potential prevails in the BBC's innovative and extraordinary mini-series *In the Flesh*.

While a handful of prominent critics and scholars have argued for the political relevance and feminist tendencies of Romero's *Dead* series (see Wood, Grant, Bishop, Harper, et al.), no single, sustained analysis of the modern zombie genre's radical representations and protest potential is available to date. Critical essays by Robin Wood, Kyle William Bishop, Kim Paffenroth, Stephen Harper, Natasha Patterson, and others recognize the significance of Romero's representations—of gender, family, and monsters—and illustrate how the brightest zombie texts radically expose or break stereotypes, binaries, and "ideals." However, no scholar carries this focus through a book-length investigation or into how most recent contributions to genre work to reinforce normativity and reinstate conservatism. This depth and breadth of discussion is necessary before we completely lose ourselves to mindless consumption of today's ubiquitous zombie media, the very genre that warned us about the grave consequences of viral capitalism.

Building upon the foundations of horror and zombie scholarship, this project develops a feminist film critique—one that supersedes previous analyses of gender and monstrosity predicated on stereotypes and binaries—capable of addressing the complex characterizations and illuminating the social protest value initiated by Romero's original *Dead* trilogy. Then, I apply this approach to key 21st-century contributions to the genre from other creators. My ultimate aim is to expose how new block-

buster zombie projects are using this once-subversive genre to restore the dominant ideologies that Romero's films worked so hard to expose and expulse. Though several current zombie scholars have published insightful analyses of Romero's unconventional films, few sustain these analyses beyond short essay depth and breadth. Fewer still bring their analytical lenses to other successful modern zombie films and filmmakers, and none yet acknowledge how some new mainstream zombie works reinstate generic gender and monster representations.

In these chapters, I explore how Romero's groundbreaking *Night of the Living Dead* generated an unprecedented and uniquely American monster myth capable of revealing and critiquing the dominant values and social prejudices of its day. Building on the scholarship of critics such as Robin Wood, Gregory A. Waller, and Barry Keith Grant, I advance the argument that Romero generated a socially conscious and critical subgenre of horror that works as social protest art. *Night of the Living Dead* is broadly recognized for building an allegory overtly criticizing Vietnam War violence and the civil injustices of the 1960s. Upon closer inspection, a more nuanced indictment of modern society and its institutions emerges. Through gendered performances of the living and the undead, *Night*'s narrative reveals the overtly oppressive and ultimately destructive impact of patriarchy and masculinity upon the community, the home, the family, and the female. This groundbreaking film disrupts traditional horror conventions and asserts remarkable and progressive influence over the genre for generations to come.

Chapter 2 examines how Romero's representations—of women, men of color, and family—adapt and advance throughout the original *Dead* trilogy. Carefully tracing the evolution of Romero's protagonists since *Night* to *Day of the Dead* (1985), this chapter reveals how these radical and dynamic characters critique typical Hollywood representations and challenge the conventions commonly upheld within the broader horror genre and the media at large. The female protagonists in the *Dead* series are too complex for traditional film theory and conspicuously ignored by key scholars including Linda Williams, Barbara Creed, Carol J. Clover, and Cynthia A. Freeland. Therefore, my analyses of these films and characters rely upon more recent, zombie-focused scholars including Kim Paffenroth, Kyle William Bishop, and Stephen Harper.

Chapter 3 addresses the critical flipping of the script regarding masculinity and monstrosity in modern zombie films. Beginning with *Night*, Romero and other zombie filmmakers have used the genre to critique the often violent and oppressive effects of hyper-masculinity, heteronorma-

tivity, and patriarchy upon society at every level. By challenging depictions of the idealized male hero and his institutions, these films open up the opportunity to reconceive the monster as representative of something more than wholly Other and necessarily antagonistic. Romero and others humanize the zombie and denounce lone wolf heroics—simultaneously condemning dominant norms on screen and in the real world—and thereby continue to develop and sustain the social protest agenda of the modern zombie film as an agent for dismantling conservative horror conventions and gender and monster stereotypes in popular culture. To date, the majority of zombie scholarship is still concerned primarily, sometimes only, with Romero films at the negligence of other works. While Romero is owed reverential credit for propagating and evolving the genre, one of my contributions is to broaden the scope of zombie scholarship to include other films and filmmakers such as Danny Boyle's *28 Days Later...* and Sarmiento and Haaga's *Deadgirl*.

Unfortunately, recent blockbuster zombie films and television programs reveal a disconcerting return of conservative conventions and generic stereotypes as demonstrated by works such as Zack Snyder's remake of *Dawn of the Dead*, AMC's *The Walking Dead*, *Warm Bodies*, and *World War Z*. Since this shift is incredibly recent, scholarship has not had the time or opportunity to catch up. Chapters 4–5 reveals how the once-subversive modern zombie, now more popular than ever, has been thoroughly co-opted and corrupted by the mainstream culture industry. White male leaders and heteronormative narratives are once again heroic. Zombies are faster, more vicious, and more horrific than ever. In the rare case of humanized monsters, as is the case in *Warm Bodies*, heterosexual romance and familial loyalty are offered as antidotes for the undead plague.

In Chapter 6, I explore the recent trends regarding the depiction of the female zombie protagonist and the questions it raises regarding the monster and the female characters. Barbara Creed's theories regarding "the monstrous-feminine" are embodied and updated in fascinating ways as we see in works such as *Raw* (2016) and *Santa Clarita Diet*. The final chapter calls attention to the remarkable and recent zombie-themed television program, the BBC's mini-series *In the Flesh*, as a prime example of zombie media as critical social protest for modern times. This show, I believe, is a necessary corrective to the misguided trends in recent zombie media including *The Walking Dead* and *World War Z*. *In the Flesh* is, to date, a two-season mini-series with a run of only nine episodes. Nonetheless, its brilliant bending of the genre (from horror into more of a sci-fi

drama) and the use of zombification as symbolic of social stigmatization demands prompt scholarly review. *In the Flesh* restores faith in the progressive powers of the zombie genre moving forward, and reveals how an emerging generation of zombie film and television has the potential to be more radical and enlightened than ever.

1

Romero and the Modern American Zombie

> Romero and friends wanted something more than gore and terror value; they wanted integrity as well.
> —Paul R. Gagne, *The Zombies That Ate Pittsburgh*

> The underbelly in all my movies is the longing for a better world, for a higher plane of existence, for people to get together. I'm still singing these songs.
> —George Romero, "Knight After Knight with George Romero"

George A. Romero's groundbreaking *Dead* films generated a newly-conceived monster myth, the modern sci-fi zombie, which works to expose cultural and sociopolitical concerns of its day. Although the modern zombie tale shares qualities with Gothic literature—the ominous landscapes, a sense of dread, and pursued protagonists, to name a few—as well as with other classic undead monsters—revenants, vampires, and Frankenstein's creature—Romero's zombie narratives nonetheless distinguish themselves in important ways. For example, these undead creatures have completely broken free from the master-slave dynamic of Haitian folklore; they have no oppressive leader(s) and no labor assignments. Unlike vampires, Romero's "flesh-eating ghouls" are not supernatural in origin and are therefore not indicative of evil incarnate. Unlike Frankenstein's creature, they are not the result of deliberate human meddling with science and nature or playing God. Additionally, the zombie hordes greatly outnumber and overwhelm the living while other mythic monsters tend to work alone or in very small groups.

Romero's ghouls are neither supernatural nor deliberately man-made but rather incidental, accidental byproducts of our industrial and capitalistic culture. For these reasons, zombie narratives invite critique of modern

society by exploring the grave consequences of upholding the status quo. This chapter details the ways in which Romero generated a socially conscious subgenre of horror and science fiction with *Night of the Living Dead*. On the macroscopic level, *Night* builds an allegory overtly criticizing the Vietnam War and the continued civil injustices of the era.

Upon closer inspection, more nuanced and noteworthy social commentary threads emerge through *Night*'s depictions of male antagonism. The gendered performances of the characters reveal the oppressive and ultimately destructive impact of patriarchy and socially scripted masculinity upon society writ large, as well as upon the community, the home, the family, and the female. These radical gender representations in Romero's *Dead* series, first developed through *Night*'s characters—their relationships with one another and their relation to the living dead—effectively challenge if not dismantle traditional horror conventions of the monster as an inhuman outsider or external threat, of the female as distressed damsel-victim, and of the white male as compulsory hero-savior.

Though most scholars recognize and acknowledge the sociopolitical relevance of Romero's films, few regard this to be his central contribution to the genre. Several current zombie scholars too easily dismiss close, analytical readings of *Night* in favor of rehashing the film's commonly known themes and interpretations or deferring to foundational theorists earlier work. Peter Dendle, in *The Zombie Movie Encyclopedia*, acknowledges that "[p]retty much everyone has commented that *Night of the Living Dead* documents middle-class America's eating of itself and the death of the nuclear family" (11). Dendle then traces quickly through various scholarly readings of the film: Hiroshima, Vietnam, environmental concerns, and the racial tensions of the decade.

While much has already been written about the parallels between the film and social anxieties of the late 1960s, there remains enough complexity and ingenuity within the *Night* to offer up a few fresh and significant discoveries. This chapter delivers an extensive critical review of this breakout film in an effort to demonstrate how Romero's work—its exceptional monster, its independent production and artistry, its radical representations of gender, its scathing social criticisms of institutions and authority, and its experimentation with genre conventions—has been feminist and progressive social protest cinema since the beginning. *Night of the Living Dead*'s lasting popular culture influence and iconography are largely uncontested, but discussion of its remarkable representations of gender and monstrosity as well as its social protest significance remains unfinished in zombie scholarship.

Reimagining the Zombie as an American Monster Myth

George A. Romero's groundbreaking *Night of the Living Dead* generated a fresh monster myth, a rebranded and modern American zombie, which has since proved to be both prophetic and profound. Mummies, vampires, ghosts, and revenants had been haunting Gothic landscapes for centuries. Raised from the dead by supernatural forces, these monstrosities typically hunted naïve travelers from the West and warned of the dangers of foreign and "exotic" cultures. The mythic figure of the zombie arose from the cultural collide between Europe and Africa. More specifically, stemming from the U.S. occupation of Haiti, as Kyle William Bishop explains, "[t]ales of reanimated corpses used by local plantation owners to increase production were of singular interest to visiting ethnographers [see the work of ethnobotanist Wade Davis], and the zombie quickly became a focal point for the investigation of the folklore of Haiti" (47). As Sarah Juliet Lauro further clarifies:

> [t]he zombie most clearly translates the experience of the African slave into a folkloric figure—biologically alive but "socially dead" [...] It is therefore not just a myth about slavery, but a "slave metaphor": usurped, colonized, and altered to represent the struggles of a distinctly different culture [*The Transatlantic Zombie* 17].

Bishop's *American Zombie Gothic: The Rise and Fall (and Rise) of the Walking Dead in Popular Culture* and Lauro's *The Transatlantic Zombie: Slavery, Rebellion, and Living Death* offer extensive historical and anthropological unearthings of this monster's storied origins and inspirations.

While the concept of the reanimated corpse and the name "zombie" (spellings vary) are shared between this Haitian folkloric figure and its American cousin—the modern zombie—this chapter is primarily concerned with how Romero's monsters are no longer enslaved victims but rather independent byproducts of industrialized Western society. As Dendle explains, "Romero liberated the zombie from the shackles of a master, and invested his zombies not with a function (a job or task such as zombies were standardly given by voodoo priests), but rather a drive (eating flesh)" (*The Zombie Movie Encyclopedia* 6). Romero didn't call his unique creatures "zombies" but rather "flesh-eating ghouls" or simply "ghouls," as we learn from the radio and television broadcasters in *Night of the Living Dead*, monsters allegedly inspired by the vampires in Richard Matheson's *I Am Legend* (Gagne 24). These ghouls wander through the countryside without any discernible leader or conscious agenda; instead, they pursue

the living, driven by an instinctive hankering for human (and sometimes animal/insect) flesh.

It is clear from first encounter these zombies retain some of their human aptitude despite common misconceptions to the contrary. Though often assumed to be completely soulless and mindless, *Night*'s ghouls demonstrate limited memory, knowledge, motor functions, and the ability to troubleshoot minor obstacles (thus justifying the trope that zombies can only be killed by destroying their brains). When Barbra (Judith O'Dea) flees the original ghoul and locks herself in the family vehicle, her pursuer bangs on the door, yanks on the handle, then picks up a rock and smashes out the window. Later, the gathering horde outside the farmhouse initially cowers away from Ben's (Duane Jones) corpse-bonfire, but within minutes they overcome this fear in order to launch their assault on the home. These qualities of Romero's zombie reveal a monster that is more recognizably human and domestic rather than utterly Other, alien, and evil. He not only "liberated the zombie from the shackles of a master" but also from its folkloric and supernatural origins.

Romero therefore generates a socially conscious and critical subgenre of horror and a uniquely American monster that bears little resemblance to the resurrected dead found in preceding texts and cultures; I dub this unprecedented monster the modern *sci-fi zombie*. The sci-fi zombie invites American audiences to contend with their flawed society and their precarious embodiments rather than encouraging them to fear an unknown or outside Other. The sci-fi zombie also threatens American ideals of liberty, sovereignty, and rugged individuality. Shawn McIntosh explains this critical paradigm shift when he elucidates that "Haitian peasants greatly fear being removed from 'the many' and becoming 'the one'" enslaved zombie under the control of a colonial master, exactly "opposite of what causes fear among modern audiences in industrialized society, who are afraid of losing their individuality" (3) and joining the modern American zombie horde.

The exact criteria for what qualifies this American monster is hotly debated and continuously evolving. In the interest of clarity, my basic definition for the original modern sci-fi zombie relies on the condition that this figure is a once-human creature rendered aggressive and cannibalistic through biological infection or social transmission. In other words, these monstrous post-human hordes are caused by humans, industrialization, and science-based contagion rather than by demonic possession or voodoo hypnosis. Moreover, unlike Dr. Frankenstein's creature, the modern zombie is not a deliberate aberration born from man's desire to play God in the name of science.

The sci-fi zombie instead rises up, unintentionally, from human meddling with science and nature. As Lauro articulates best, Romero's real breakthrough:

> is the association of the zombie with what was already a long-standing trope in science fiction: the harrowing notion that our own scientific achievements and technological advances could have unpredictable, and sometimes horrible, ramifications [*The Transatlantic Zombie* 93].

While the zombies may appear accidentally, as an unintended consequence of modern innovation and fiddling with nature, this fact does not absolve the living humans of their culpability.

Since these monsters are born from our bodies and our actions, we must shoulder the full accountability and burden of parenthood. Characters within the film's diegesis may interpret the zombie outbreak in terms of morality, as supernatural or godly punishment, but the viewer is afforded another perspective—an invitation to confront the fact that the zombie outbreak is wholly our doing and our problem—proof that God is dead (or never existed) and that humans are the only masters (and victims) of their collective fate. In *Night*, we bring back alien contaminants, radiation-based, from outer space. In *Dawn*, we are already the walking dead, blindly consuming, mindlessly shuffling through mega-malls. In *28 Days Later*, animal rights activists accidentally unleash the Rage virus which afflicts the living with relentless (formerly repressed) aggression.

Uniquely, the sci-fi zombie film grapples with the complex internal issues of human nature, identity, and ethics, as opposed to the external fears of the foreign, supernatural, and of all that is evil and immoral. Not only is this monster *us*, as Romero's characters continually and aptly exclaim, but it is entirely *our fault*. Furthermore, it is *our responsibility* to commune with one another, to socially transform together, in an attempt to resolve the immense domestic threat.

Zombie cinema breaks free from the conservative traditions of horror of the era, and the sci-fi zombie becomes the most viable and tangible monster of modern times. The zombie thereby transcends the role of monster as metaphor, a mere stand-in for repressed desires and societal fears, by offering audiences a very real and radical window into their biological bodies, their embodied experiences, and their socially scripted oppressions. Romero's ghouls are border-crossers. They blur the line between human and monster, between sci-fi and horror, between low-brow entertainment and sophisticated, socially conscious cinema.

The Relevance of Romero's Night of the Living Dead

It is beneficial to review how the reception and understanding of *Night of the Living Dead* has evolved in the years since its theatrical release; a brief acknowledgment of this well-known history will help to elucidate Romero's immense influence upon modern sci-fi horror cinema and criticism. Romero's landmark film has garnered decades of avid fans as well as of critical attention and scholarly analysis. It seems worthy to note that in January of 1969, after his initial viewing of *Night*, Roger Ebert was compelled to write up a review of the audience in the theater rather than of the film itself. He didn't rate the film (though a 2004 addendum attaches 3 1/2 stars to it) but with considerable emotion explained "I felt real terror in that neighborhood theater last Saturday afternoon. I saw kids who had no resources they could draw upon to protect themselves from the dread and fear they felt" (RogerEbert.com). Ebert (along with the unnamed staff reviewer for *Variety* magazine at the time) was provoked to consider whether or not the theater managers and the film industry commissioners had a social responsibility to withhold such morally repugnant media from the (primarily adolescent) movie-going public.

For the uninitiated early audiences, it was difficult to see beyond the cannibalism and gore of the film and into its independent ingenuity and progressive social commentary. It is well known by now that despite its paltry production budget, shocked audiences, and derisive reviews, *Night* continued to attract viewers in the late 60s and its "audience and critical response have gone far beyond the 'cult' following it attracted [...] establishing a reputation for Romero as a master of the horror film on a widespread, grass-roots level" (Gagne 1). Paul R. Gagne's *The Zombies That Ate Pittsburgh: The Films of George A. Romero* chronicles Romero's career (until the mid–80s) as an independent, regional filmmaker with a team of friends and colleagues passionate enough to turn down studio backing in order to preserve the original vision and viscera of their monster movies. Carol J. Clover argues how "innovation trickles upward as often as downward and that the fiscal conditions of low-budget filmmaking are such that creativity and individual vision can prosper there in ways that may not in mainstream environments" (*Men, Women and Chainsaws* 5). Since *Night*, Romero's influence has spread well beyond Pittsburgh and the latter half of the 20th century. The modern zombie has become a global icon, due in part to the fact that "Romero at least makes a conscious effort to give his work an underlying *intelligence* that few horror directors

even bother to attempt" (Gagne 5). Without such intelligence, it is difficult to imagine how Romero's ghouls would have survived the changing times. Without deeper purpose, they could have vanished with the drive-in movie theater, like the gigantic grasshoppers that trampled Chicago in the *Beginning of the End* (1957).

Since the first half of the 20th century, conventional science fiction and horror cinema traditionally espoused the necessity of order and authority in an unruly world. The "creature-features" of the 1950s frequently depicted a monstrous threat to the post-war idyllic American dream of the nuclear family or the safety of our industrial, capitalistic society. These films, time and time again, resolve the monstrous threat and restore this obligatory order before the final credits roll. In her famous essay "Imagination of Disaster" (1965), Susan Sontag argued "[t]here is absolutely no social criticism, of even the most implicit kind, in science fiction films" (48). Rather, Sontag contended, science fiction worked to allay our fears by offering audiences completely safe and innocuous distraction from real world concerns. Similarly, as George Ochoa asserts in *Deformed and Destructive Beings*, the "horror film allows audiences to enjoy these transgressions [of unrestrained sexuality and violence] vicariously, while providing the safety and satisfaction of having the ethical [moral] code restored at the end" and the opportunity to "walk away ethically" and morally unscathed (62). In other words, both genres originally afforded viewers a safe and satisfying outlet for conscious fears and repressed desires.

Prior to the New Wave movement, science fiction tended to perpetuate and endorse the conservative status quo. Joanna Russ referred to this tendency as "Intergalactic Suburbia" (qtd. in Melzer 5); regardless of how far we strayed from present realities, and from earth, these adventure stories still depicted a patriarchal, hegemonic, familial order. Anne Cranny-Francis explains in "Feminist Futures: A Generic Study" how this "(symptomatically named) 'hard' science fiction writing unproblematically enacts the dominant discursive formation. In these texts scientific discourse is essentially a patriarchal, bourgeois and white imperialist way of knowing and manipulating the world (220). Even today, writers including Jon Towlson see "[s]cience fiction/disaster movies since the Cuban Missile Crisis [as] replete with benevolent patriarchs who make it their responsibility to protect us" (11), and argue that so long as "sci-fi/disaster movies [...] opt to propagate the ideology that patriarchal authority is infallible and governments are necessary to protect us, we should consider them" wholly "inadequate" (12). Nonetheless, horror and science fiction stories can cre-

ate "blueprints of social theories" for only "within genres of the fantastic is it possible to imagine completely new social orders and ways of being that differ radically from human existence as we know it" (Melzer 2). As Anne Cranny-Francis further clarifies:

> [in the] "soft," or sociological, science fiction of Wells and his followers, however, scientific discourse may be inflected in the cause of social criticism. That is, science may operate as a means of displacement from the tyranny of the everyday, from common sense, and thus may de/reconstruct hegemonic ways of knowing and manipulating the world [...] [in this regard] sociological science fiction belongs to the postnuclear, postmodern, age [220–221].

Romero's original *Night* contributes to this shift from Golden Age to New Wave, from "hard" and conservative to "soft" and socially critical science fiction. The sci-fi zombie film, at its best, not only provokes social criticism as an intellectual exercise, as is demonstrated through a close analysis of *Night of the Living Dead*, but also has the potential to inspire social protest in action by its fans.

Not Your Mother's Monster Movie

Night of the Living Dead occasionally pays homage to other key directors and films of influence (Alfred Hitchcock and Howard Hawks most overtly), but Romero employs and disbands from common horror conventions as he so chooses, and thus secures the film's reputation as trailblazing rather than derivative. The story of how *Night of the Living Dead* was made is legendary; nonetheless, a brief recap is useful for grasping how circumstances shaped this ground-breaking contribution to horror cinema. After meager success in commercial production, Romero and his trusted colleagues at Image Ten (notably John Russo and the Streiner brothers; a group of ten in total) struggled to find financial and professional backing for their debut feature film. Over lunch one afternoon, according to Gagne's *The Zombies That Ate Pittsburgh*, Romero and friends agreed that a horror film was more viable and marketable than other genres made without great monetary means. Romero set out to adapt his own story, an allegorical tale inspired by Matheson's *I am Legend*, into a three-stage script that became the foundation for his original *Dead* trilogy. Drawing from the team's varied talents (Romero's writing/ directing/ cinematography/ editing, Russo's script development and revision, and Gary Streiner's sound engineering to name a few), "[t]hey were going to satisfy the horror-film audience," Gagne explains; if "the film was going to be about ghouls eating people, then they wouldn't sell it out; they were going

to *show* ghouls eating people" (23). They devised a plan to create a realistic and uncompromising film that obliterated the hokey, artificial qualities of similar genre movies made in previous decades.

The lack of "attachments" became an asset for *Night* since the limited budget shaped the film's artistry and independent production freed it from studio censorship, co-option, and commodification that would have debased the film's progressive vision. Critics and viewers have extoled *Night*'s distinguished aesthetic for decades, but the gritty realism of black-and-white 35mm film, still photography, and hand-held camera work are all byproducts of budgetary constraints according to Gagne. Nevertheless, this stark style gives *Night* the documentary or found-footage feel so popular in science fiction and horror media today. Rather than cutting away, or to close-ups of victim's contorted expressions, Romero zooms in on the carnage of cannibalism. The unmitigated viscera and violence was unparalleled in cinema of its time, though clearly inspired by, no more graphic than, and likely a commentary upon the graphic nightly news coverage of the Vietnam War. The unknown cast gave the characters and their performances a raw authenticity and veracity. The unlikely protagonists of the film, a white female followed by a Black male, enabled a rare critique of Hollywood's conventional representations of gender, race, and heroism. *Night*'s narrative further decries the power imbalances of normativity, the incompetence of authority, and the abuses of masculinity both onscreen and in reality.

Romero's *Night of the Living Dead* deserves critical interrogation beyond its shock value and graphic violence as well as the scholarly analyses it typically garners. The film's defiance of genre conventions, its representations of monster and gender, and its critique of traditional norms and institutions reveal the film's lasting social value and impact. On the macroscopic level, as mentioned earlier, *Night* overtly criticizes Vietnam War violence and the continued civil injustices of the 1960's. Upon closer inspection, more nuanced social commentary threads emerge through hyperbolic male antagonism. In other words, the gendered performances of the characters reveal the oppressive and ultimately destructive impact of socially scripted masculinity upon the country's leadership, the media, the community, the home, and the family. Women are under attack. The nuclear family unit is exposed as a despotic and obsolete institution. Media and law enforcement agencies are revealed as incompetent and ignorant, if not wholly impotent, in dire times. Additionally, deep parallels are drawn between the living males and these walking dead, revealing that both are monstrous and to blame for the collapse of modern American society.

First (but Not Final) Girl

Despite its renowned status in the horror cinema canon, even the most devoted critics and fans of *Night of the Living Dead* tend to fixate on the memorable flaws of the film's most prominent female. Barbra (Judith O'Dea) is a remarkable character, however, until inexorable male antagonism eventually breaks her spirit. Though young, pretty, and blonde, Barbra's buttoned attire and demure demeanor resist the stereotypical sexualization of women in horror and Hollywood cinema at large. Of equal import, she is resourceful and active until male strangers infringe upon her autonomy. She is—for these reasons, and even after her mental breakdown later in the narrative—a radical and feminist character despite common claims to the contrary.

After enduring her brother Johnny's (Russell Streiner; uncredited) callous teasing, evading the first modern zombie, and fleeing the cemetery, Barbra becomes the film's main protagonist for the remainder of Act One (though few scholars acknowledge this point). She loses her heels during her harrowing escape—shedding these symbols of her gender conformity and oppression—and runs barefoot through a large field. Soon, she locates and stumbles towards a modest white farmhouse, a beacon in an otherwise drab and rural landscape. She clutches the framed corner of the structure as if trying to hold onto this symbol of shelter and safety, the single-family home. Once inside, Barbra frantically fumbles the deadbolt until she successfully locks herself inside. She sighs and momentarily collapses onto the door before straightening herself to secure the interior.

Though unremarkable and modest, the darkened dining room halts her; she recognizes how this ordinary home has become sinister. The home is uncanny, *unheimlich*, literally creepy and not home-like: lifeless, vacant, cast in jagged shadows. She retreats back into the kitchen to grab a large butcher knife. Clutching the weapon tight to her chest, she tiptoes into the adjoined living room. A few items litter the floor: either the homeowners are untidy, left in a hurry, or there has been a struggle here.

In the face of the unsettling ominousness of this empty home, Barbra continues her courageous investigation. Next, she approaches the study. The view switches to a long shot, affording the audience a glimpse of the room before Barbra enters; an animal pelt hangs high on the interior wall. Once she crosses the threshold, the soundtrack shrieks in warning, and a series of taxidermy busts—wild boar, young and mature bucks—fire in rapid succession before returning in a reverse-shot back to a medium close-up of Barbra's half-lit face. Paffenroth points out, the ani-

mals "look disconcertingly both alive and dead" suggesting that the "hunters are now the hunted" (*Gospel* 35). Keep in mind, though, that Barbra is no hunter as evidenced by how she holds the knife tip down rather than pointing outwards. Paffenroth also contends the Hitchcockian direction in this scene aligns us with Barbra, causing us to be surprised along with her.

Though the viewing audience may startle at the sudden escalation in musical score and the erratic jump cuts, Barbra actually leans forward with determination when we jump back. It is the sudden knocking sound from outside that alerts her, not the garish trophies, and we soon see that this disruption marks the arrival of the original zombie to the farmhouse. Though fleeting, this short trophy room sequence harkens to Hitchcock's famous parlor scene from *Psycho* (1960)—during which Norman Bates (Anthony Perkins) reveals his unusual hobby and volatile personality to Marion Crane (Janet Leigh) under similar lighting—and effectively works as an allusion to the horrors of the family and in the home that Hitchcock's film pioneered. It also foreshadows how Barbra, who appears to be the main protagonist at this point, might eventually be slated with Marion's shocking fate.

Less than twelve minutes into *Night of the Living Dead*, we already sense how danger and violence permeate this world inside and out. The cemetery marks the honor and tradition of the burial of our beloved dead, and yet a dead man walks and attacks the living adult children. The white frame home is an icon of simple and safe rural living, and yet we sense dangers lurking in its shadows. The animal trophies inside mark humans as aggressors who believe they hold the power to conquer the natural world. Outside, however, the unnatural reanimated husk of a human intends to devour or at least convert the vulnerable living. Paffenroth argues that the zombie is essentially representative of the sickness of Western society; they "remind us that it is America that is eating itself alive," and "that the society being destroyed is rotten from within to begin with" (*Gospel of the Living Dead* 17). *Night* has only begun to reveal the ironies and illusions of its day.

Once she confirms the assault on the home—the cemetery ghoul beats the siding with the clothesline post he tore from the earth—Barbra frantically tries to dial an emergency operator on the rotary telephone. Her distress elevates when she realizes that this technology and the law enforcement institution she's been taught to depend upon are unavailable, marking two failures of the modern age. Immediately, like these lifelines, the outside goes dark. From the shadow of surrounding trees, more lum-

bering ghouls emerge, forcing Barbra to stumble back from the window, into a dining room chair, and towards the staircase. She climbs the stairs in a cautious retreat but is confronted by a graphically decayed corpse at the top landing; its bulging eyes and bared teeth elicit a scream of horror from Barbra. She races down the stairs and throws open the front door only to be blinded by headlights. An African American man, Ben (Duane Jones), with tire iron in hand, grabs Barbra and pushes her back into the house.

Since the opening scene, Barbra has endured several assaults: her brother's teasing, the cemetery ghoul, the graphic imagery in the home, and now the hands of this arriving stranger. Each person she has encountered throughout the day (living, dead, and undead) has been aggressive and antagonistic. Ironically, once inside, Ben locks the door, sighs, and says "It's alright," as if now that a man has arrived, Barbra will be safe and protected. "Don't worry about him," Ben says gesturing to the ghoul outside, "I can handle him." Ben's pronoun usage reveals that these walking dead are still coded as human, by gender, but also suggests that Ben is now the one claiming agency and power within the house. Barbra stands frozen at the door while Ben moves quickly around the first floor, shouting observations and questions at her. Exasperated immediately by her inaction and silence, Ben charges towards the telephone. "I suppose you've tried this already" he says, more to himself than to Barbra, as she moves into the room and cowers into another wall.

BREAKING BARBRA

Barbra has been rendered weak and dependent by these repeated masculine assaults, but also by her role as a (married; she dons a wedding ring) woman in the home. Since *Night* became a film scrutinized by scholar-critics, Barbra's character has been harshly condemned. She "would seem to support certain sexist assumptions about female passivity, irrationality, and emotional vulnerability," Gregory A. Waller explains (283). Barry Keith Grant cites this quote to kick off his essay on the necessity of *Night*'s 1990 remake and its revision of Barbra from a passive burden to an active survivor (200). Stephen Harper is one of only a handful of scholars to challenge "Grant's reading of Barbra in the original *Night of the Living Dead*" when he argues "that Romero manipulates not only images of active women, but also traditional or normative images of women as nurturing and caring, without jeopardising his feminist project" ("They're Us" 1). Perhaps, Harper suggests, "Romero's images of female

inaction are so pervasive and hackneyed [in *Night of the Living Dead*] (Judy Rose's dizzy vacillations, for example, are stereotypically feminine histrionics) that *Night* might read as a satirical comment on traditional representations of women in horror cinema" (They're Us" no pag.). Natasha Patterson sees Barbra "as symbolic of everything wrong with patriarchy and male-defined notions of femininity and womanhood" (110). Citing how Barbra dies later in the film despite her role as a "good" and passive female character, Patterson uncovers how, through Romero's original version of the character, Barbra "disrupts any fixed notions we have about women (in film), as one by one each archetypal female figure and what she represents is annihilated (i.e., 'wife/mother,' 'virgin,' 'good girl,' 'daddy's girl,' and 'lover')" (111). None of these scholars, however, acknowledge Barbra's strengths while she is liberated from the company of men.

Ben establishes himself as the "man of the house" and Barbra surrenders herself to a more the passive and domestic existence expected of film females (and all too often of women in real life), particularly in horror and science fiction. "We have to get outta here. We have to get to where there's other people," Ben says after his discovery of the dead body at the top of the stairs, thus foreshadowing the presence of other living in the house, but also the futility in relying on social tendencies. Barbra, continuing to express her tactile nature, now holds the knife's blade in her hand as she touches a stair and a mattress propped against the wall. Next, she strokes a door frame, hears a spattering noise, and follows it to spot a pool of blood on the floor. Blood splatters onto her hand and she runs into another room and wipes it off. Returning to Ben in the kitchen, Barbra rubs her face and her eyes, then surrenders her knife by setting it down with Ben's tire iron. "What's happening? What's *happening?*" Barbra asks with rising volume and desperation. As if in response to Barbra's question, smashing glass is heard from outside. Ben and Barbra rush to the window, but the audience is afforded an exterior view of the gathering ghouls beating out the car's headlights with large rocks. Ben grabs Barbra again, barrages her with more questions, and she screams out "I don't know! I *don't know!*" He pins her down in a nearby chair as her panic escalates.

When she is alone, Barbra is active and resourceful. Now, in the presence of Ben, she is once again imprisoned by the modern patriarchy. Save for a couple short-lived hysterical outbursts, Barbra remains nearly catatonic for the remainder of the film. Harper, too, recognizes how male antagonism catalyzes Barbra's catatonia; "Johnny's Karloffian posturing and mocking intonation of 'they're coming to get you, Barbra' playfully

foreshadows the aggression of all of the men at various points in the film" ("They're Us" no pag.). Additionally, I see Barbra as indicative of Betty Friedan's *Feminine Mystique*; that is, as the "Problem with No Name"; "The problem lay buried, unspoken, for many years in the minds of American women. It was a strange stirring, a sense of dissatisfaction, a yearning women suffered [physically, mentally, psychologically] in the middle of the twentieth century in the United States" (57). Put simply, the common housewife was trapped in her role in the home, marriage, family, and community. Once Ben and other male characters infiltrate the farmhouse, Barbra's socially imposed position in the home, as Simone de Beauvoir's "Second Sex" explains it, is restored.

GHOULY MEN

The parallel between the dangerous aggressions of the undead and the male living are soon solidified. Even when their numbers are small, it is clear these monsters aren't easy to conquer or control. Ben rushes outside with his tire iron as the last car headlamp burns out. He attacks the nearest ghoul, bashing him repeatedly in the head and to the ground, when another male ghoul converges upon him. A third male ghoul enters the unguarded farmhouse entrance behind Ben. Back inside, the camera view focuses on Barbra stricken in a chair. The monster creeps up behind Barbra unnoticed before Ben charges towards her (quite zombie-like) with outstretched arms. Ben throws Barbra out of the way and engages in battle, hand-to-hand then tire iron to head, until the creature is pacified. Ben struggles to remove his tire iron from the ghoul's skull and recoils only to see that the door is still open and another enemy (this one in pajamas and bathrobe) is on his way. Behind him a line of middle-aged, white male ghouls are queued.

It is worthy to stress that all threats to this point in the film have been white men (living and undead)—in relentless pursuit of one female and one Black male figure—a revealing comment, no doubt, upon the civil injustices of the 1960s. Despite the courageous efforts of women's liberation and the civil rights movement, life (particularly in the rural country landscape) continued to uphold white-male supremacy. Barbra stares into the face of the man with the hole in his forehead—though fleeting, the audience can sense a momentary connection between them—they share terrified and searching eyes. "Don't look at it," Ben shouts as he drags the corpse from the living room, as if he can still shelter Barbra despite the endless brutality she has witnessed since the cemetery. Ben

slogs the body onto the porch, lights a book of matches, and sets him on fire as the pack of ghouls looks on. This pyre introduces the lynching symbolism in *Night*, which develops fully later.

Next, Ben attempts to rally Barbra into becoming proactive in his plan to fortify the house. The notion of pragmatism and teamwork that becomes a hallmark of the living in zombie apocalypse narratives is thus invented. Back in the kitchen, Barbra continues to fiddle with her knife's blade while Ben springs into action. "Look GODDAMMIT!" A beat. "Look, I know you're afraid. I'm afraid, too," Ben pleads with Barbra more softly, "We'll be all right here till someone comes to rescue us. But we'll have to work together. You'll have to help me." Barbra slowly meanders into the living room, gropes the fireplace mantle, and absent-mindedly touches and turns on a music box. Harper notes how "Barbra is both infantilized (she toys with a musical box while Ben boards up the house) and identified with household items (such as the linen tablecloth and the embroidered arm of the sofa which she obsessively strokes). In other words, while the males act, the women—Barbra in particular—draw comfort from domestic goods" ("They're Us" no pag.).

Barbra's tactile tendencies should not be so easily reduced and dismissed. She uses sensory stimuli to cope with the onslaught of traumatic events. Since the cemetery, she has touched everything from trees to knives. She reaches out the fondle a leaf when brother Johnny starts his relentless teasing. This is clearly her go-to defense mechanism when under duress. "Here we start to see in *Night of the Living Dead* an engagement with the notion of traumatic witness and post-traumatic stress," Karen Randell notes, "a notion that is not recognized in explicit terms in the returning veteran films of this period and which is still absent from the American Psychiatric Association's Diagnostic Statistical Manual of Mental Illness" (71), and yet is fully manifest in Barbra's shell-shocked behavior and later catatonia. Dizzying shots of Ben in action, collecting wood and nails, are intercut with Barbra standing weakly in the next room.

Barbra depends on physical touch to quiet the turbulence of her external reality, but doing so makes her a vulnerable target. Over Barbra, crickets chirp and the bust of another buck is mounted over her head, thus marking her descent into a position of prey. She collects a few stray pieces of kindling from the fireplace and feebly assists Ben's fortification efforts, but it is clear that she will no longer be fully present in mind and body. Ben keeps moving and talking around her, and refers to the ghouls in genderless terms—"those things"—for the first time. He shares his origin/first-sighting story, marking the emergence of another trope of the

modern zombie narrative. Barbra begins to share her story, of Johnny and "the man" in the cemetery.

Ben is clearly annoyed and distracted as soon as Barbra starts speaking again, as if her story isn't as important as his. "Why don't you just keep calm," Ben interrupts, but Barbra continues working herself up into her final, hysterical frenzy. "HE GRABBED ME! AND HE RIPPED AT MY CLOTHES" she yells, hugging herself, and Ben repeats "I think you should just calm down" more forcefully, dismissing Barbra's confession of her traumatic, rape-like assault. "We have to wait for Johnny," Barbra insists, but her plea falls on deaf ears. It also provides more foreshadowing of what's (who's) to come. "Please! We have got to get him!" Barbra cries, "Please help me!" but now Ben is blatantly ignoring her as if she is no longer present.

It is often written that Barbra is an inactive burden for the majority of the film, but this state of mind is not triggered until approximately one-third of the way (around the thirty-minute mark) into the narrative. While Harper suggests that Romero infantilizes Barbra, Ben is also to blame for an additional micro-aggression: the silent treatment. Barbra grabs Ben in an attempt to get him to truly listen to her. "Listen…. Your brother is dead," he declares. Desperate, Barbra runs for the door, Ben grabs her, she slaps him, and he decks her right back. Barbra faints, and her catatonia officially begins. Seems Barbra deserves a bit more credit for all she endures before her psyche retreats. With Barbra passed out on the couch, the resourceful Ben returns once again to his fortifications.

Broadcasting
the Zombie Apocalypse

A while later (the time-lapse visually marked by a smooth dissolve), Ben locates, turns on, and tunes an old radio. This action marks the introduction of one more generic convention Romero integrates into the modern zombie genre: the omnipresence of radio and TV media. Radio and television broadcasts add to the verisimilitude of the film diegesis and reveal the role of media in the time period; the Vietnam War was the first to be visually broadcast into the home rather than over radio ways or on news reels at the local theater. The emergency radio coverage plays over Ben's continuous action sequence.

Media narration helps to establish the state of the world beyond the confines of the survivors and the growing number of undead we witness in and around the farmhouse. It becomes clear that this epidemic has

infected the East coast, from Pittsburgh (Romero's home base) to Florida, and across the Midwest. As Paffenroth explains:

> [h]orror movies often deal with two quite distinct threats—monsters that threaten the entire earth (as in *War of the Worlds* [1953 and 2005]), and those that threaten only an individual or small group (any psycho-killer movie, such as *Psycho* [1960] or *Halloween* [1978]). But *Night of the Living Dead* really presents both sides of the threat, where zombies are over-running a large part of the United Stated [and likely beyond], but we watch a tiny drama of seven people unfold as they fight a few dozen zombies [... which becomes] the formula for the subsequent zombie movies [*Gospel* 36].

At every turn, Romero is contributing a new generic convention that speaks on both the macrocosmic and microcosmic levels of social criticism.

In the zombie uprising, as in the real world, broadcasters rely on false leads, hasty expertise, and problematic language to relay breaking news. The radio voiceover explains how the news team will remain on air day and night as this "crisis" continues; "These are the facts as we know them: there's an epidemic of mass murder being committed by a virtual army of unidentified assassins [...] The murders are taking place in villages, cities, rural homes, and suburbs with no apparent pattern or reason [...] A sudden, general explosion of mass homicide." In an effort to explain the identities of these murderers, the news conveys eyewitness accounts: "Eyewitnesses say they are ordinary looking people. Some say they appear to be in a kind of trance. Others describe them as being..." Ben returns to a window to watch more white-male ghouls congregate around the vehicle parked outside.

Ben's own perspective through the farmhouse window provides more concrete evidence of the perpetrators outside, illuminating the futility of the radio news accounts. For the first time a female, in a flowing white nightgown, approaches from the distance. "So, at this point," the radio voice warns, "there is no really authentic way for us to say who or what to look for and guard yourself against." The domestic and familiar attire of this ghoul and others reveals the monstrousness of the ordinary. As Wood explains, horror films from the 1970s "without single exception, are characterized by the recognition not only that the monster is the product of normality, but that it is no longer possible to view normality itself as other than monstrous" (*Hollywood* 85). Newscasts are not only ubiquitous in zombie apocalypse narratives, starting with *Night*, but also unreliable and ultimately unhelpful if not outright dangerous.

When the normal human population becomes overtly threatening

and threatened, mainstream media and its agencies struggle to maintain authority. While Ben saturates a puffy armchair with lighter fluid, the radio voiceover continues: "response from law enforcement officials is complete bewilderment. [... No] organized investigation is yet underway [...] The scene can best be described as mayhem." Despite the lack of knowledge and insight on offer during this crisis, the media issues a directive for the captive listening audience:

> [the] message is for private citizens to stay in their homes, behind locked doors. Do not venture outside for any reason, until the nature of this crisis has been determined, and until we can advise what course of action to take. Keep listening to radio and TV for special instructions as this crisis develops further.

Despite warnings to stay at work, we're told, thousands of employees are crowding the streets in desperate attempt to reach their homes and families. Also choosing to ignore the radio's advice, Ben forges a torch from a table leg and curtain, ignites it, and ventures back outdoors. He incinerates the armchair and pushes it off the porch, towards to gathering ghouls. When flames engulf the furniture piece, the monsters scream and recoil, demonstrating that they still retain some sense of self-preservation and fear-logic. Inside, the broadcaster states that the President has called an emergency meeting, gathering top cabinet, FBI agency officials, and a team of scientists to put their heads together.

Romero strongly indicts the media, scientific experts, law enforcement agencies, and the government in his *Dead* series. These figures of authority fail to provide reliable information and to protect the public at large. Even more in-depth television reporting viewed later on in *Night* provides little practical value. "In Romero's classic, Washington officials are seen retreating from reporters who are seeking clarification, aid and information about the virus on the public's behalf. When advice is given by the authorities on how to survive the attacks, it is confusing, sporadic and changes by the hour," Jon Towlson explains:

> [a]t first people are told to stay put in their homes, and then later they are told to risk travelling to rescue centres for evacuation from the towns and cities. This speaks to a lack of civil defence planning on the part of the authorities that had echoes of the Cuban Missile Crisis and also anticipated future events like [hurricane] Katrina (which is uncannily echoed in Romero's later sequel *Land of the Dead* [2005]). The authorities have in effect turned their back on the population in *Night of the Living Dead* and it is left to vigilante groups to enforce order ["Rehabilitating Daddy" 12].

Despite media warnings and law enforcement agency advice, neither is able to offer actual assistance in the individual survival of the citizens.

Though the broadcaster speaks directly into this isolated farmhouse, and acts as a conduit for the country's authority figures, it is clear that Ben and Barbra are on their own. Barbra awakens. Ben lights a cigarette.

THE REAL HOUSE-MONSTERS OF PITTSBURGH

Once satisfied with the farmhouse fortifications, Ben's dominant and aggressive demeanor wanes. Confident in their safety and survival for the time being, Ben embodies both a caretaker and protector of Barbra and thus resumes his promotion to the role of *Night's* rightful protagonist-hero. He discovers a pile of women's shoes in a bedroom closet and picks out a practical pair of flats from the collection of mostly high-heels. He also spots and retrieves a rifle hidden in the closet's corner. Ben returns to the stirring Barbra on the couch as the radio announcer advises "Lock the doors and windows securely." "Hey, that's us," Ben says softly, nodding to Barbra as he slips the flats onto her limp feet, "we're doing alright." This tender moment reveals Ben's nurturing side and all but forgives his earlier insensitivity toward Barbra. They are in this together.

Another ironic trope of the zombie film is how survivors always band together and yet inevitably tear each other apart. Suddenly, Barbra screams as two men emerge from the basement, the older one wielding a makeshift weapon. Ben rushes the intruders and expresses his frustration that the men have been in hiding the whole time. "I could've used some help up here." Ben and the balding man, later introduced as Harry Cooper (Karl Hardman), begin to bicker. "That racket sounded like things were being ripped apart. How were we supposed to know what was going on?" Harry explains. Ben calls him out on his conflicting stories; first, Harry and Tom (Keith Wayne) claim it is hard to hear from the cellar, and now Harry is saying that it sounded like "those things" were in the house.

The squabble escalates as the two emerging leaders, Ben and Harry, jockey for patriarchal power. "It would be nice if you'd get your stories straight, man," says Ben, prompting Harry to stand, advance, and raise his voice. "I'm not gonna take that kind of a chance when we got a safe place [...] And you're telling us we gotta risk our lives just because somebody might need help, eh?" "Yeah, something like that," Ben replies, and Tom steps in to try to mitigate the dispute between these two hotheads. Tom soon reveals that his girlfriend and Harry's wife and daughter are still hiding in the basement, and that the child "has been hurt." Upon learning about the women and the sick child, Ben shifts his approach to

accommodate the safety of the group. "With all of us working," Ben insists, "we could fix this place up in no time."

The verbal confrontation continues as each man tries to defend his notion of safety and service, the audience remains aligned with Ben's perspective that duty (to all living in need) wins over loyalty (to self and family), and that fortifying the whole house is more prudent than trapping everyone in the basement without an escape plan. This allegiance is due in part to the fact that we have spent more time with Ben, to justify equal protection for all the farmhouse survivors, and lastly due to Harry's disrespectful tone, name-calling, and generally aggravating character. Nonetheless, these "would-be patriarchal heroes like Ben and Harry are too busy engaged in a pissing contest to lead the other survivors to safety," Towlson argues; "Each man's inability to defer to the other's plan of action (both of which are shown to be mistaken, incidentally) prevents the rest of the group from accepting the authority of either" (12). Harry defends his position that the basement is the safest place for everyone since it has only one entrance to defend. "The cellar is a deathtrap!" Ben yells. Tom raises his voice to assert that both men have good, and not mutually exclusive, points. They quickly work to strengthen the home's boarded windows and doors while the women and child remain underground. Contributions to reason from Helen Cooper (Marilyn Eastman) are later ignored in the ongoing fight for male authority in the home.

Dangerous fissures in the patriarchy's omnipotence, and its institution of marriage, are quickly revealed. Without any unifying guide or principles, the band of survivors fractures and eventually fails. Tom invites girlfriend Judy (Judith Ridley) to come up from the basement before Harry shuts himself and his family inside. "Well, we're safe now," Harry tells Helen as she comforts their ailing daughter Karen (Kyra Schon), "it's boarded up tight." He seems to take credit for Ben's fortifications, but Helen is more concerned with Tom and Judy. "If they want to stay up there, then let 'em," Harry shouts and then throws his crowbar to the ground. Helen turns her gaze away from her husband's violent outburst, so he lowers his voice for the moment. Helen admits "we heard the screams" when Harry informs her about the "man" and the "girl" upstairs. Her derisive tone elicits more aggressive outbursts from her husband.

Bonds between strangers and family alike prove to be inadequate, if not entirely divisive, when under the zombie threat. The survivors continue to argue with one another until televised media once again interjects its overriding authority. Huddled around the TV set, the group learns that the "murderers" plaguing the nation rise up from the dead to devour the

flesh of the living. The news anchor claims to offer the "definite course of action" for viewers, then introduces a list of "rescue stations" now established to provide citizens shelter, food, water, and the protections of the National Guard. In an effort to hypothesize the cause for the cannibal rampage, the anchor suggests the recent return of a radiation-contaminated "Venus probe" might be responsible for the zombie outbreak. Not surprisingly, a series of interviewed experts refuse to confirm or deny these allegations. Yet the suggestion is made that the nation's misguided quest for supremacy in the universe, attempts to conquer and colonize the galaxy, has threatened the sanctity of human civilization on earth.

On a smaller scale, yet symptomatic of the broader patriarchal culture, Ben and Harry are also blinded by their quest for dominion over the home and its inhabitants and provisions. They continue to bicker until the latest news media interrupts yet again. The telecast warns that anyone injured during the outbreak needs careful and immediate medical attention, so Ben's consideration turns to Karen Cooper. He commands Helen to return to her daughter's care and to send Judy back upstairs. "Baby. It's Mommy," Helen coos. "I hurt," Karen replies, speaking for the first and last time. Upstairs, Judy asks privately "are you sure we're doing the right thing, Tom?" "Well, the television said that's the right thing to do. We've got to get to a rescue station," he reassures her.

Despite Tom's best efforts to unify the group and its evolving mission, the men in charge ultimately fail in their efforts to protect the home from external threats. Their continued lack of cooperation and trust in one another emerges as an internal threat as well, along with their blind trust in the media's authority. Ben heads outdoors to hold the zombie horde at bay with a flaming torch while Tom and Judy drive the farmhouse truck to the fuel pump on the property. The situation quickly escalates when the zombies advance. The truck erupts in flames, consuming the young couple as Harry watches on in horror from the safety of the house. Ben rushes back to house to discover that Harry has locked him out. As Bishop notes, "the behavior of the besieged humans in *Night of the Living Dead* becomes even more monstrous and threatening than that of the zombies" (95). After Ben breaks back indoors, Harry reluctantly helps him to re-board the entrance. Once finished, Ben punches Harry in the face repeatedly and threatens to take him outside and feed him to "those things."

Romero issues *Night*'s strongest indictment of 1960s American culture when he solidifies the true terrorism of masculinity upon society and its communities, in the home and within the family unit. The telecast turns its attention to a large group of armed law enforcement and volunteers

roving the countryside on foot. Chief McClelland (George Kosana) coldly details how to kill the ghouls, and proudly claims his men have already slaughtered nineteen of them today. The sheriff's solution for the outbreak is to mimic the zombies, one horde of murderous men on foot versus the other.

Just then, the power goes out and the gathering zombies surge upon the farmhouse and its inhabitants. The survivors are now grossly outnumbered. Ben does his best to hold them back, but dozens of decaying arms and hands breach the fortifications and reach out toward the living. Harry grabs for Ben's rifle and commands Helen to retreat to the cellar. In the struggle, Helen is caught in the zombies' grasp and the gun accidently goes off, striking Harry in the chest. He stumbles downstairs alone as Barbra wrestles Helen free. Barbra is now back in action, and her efforts, albeit only momentarily, keep Helen safe. Helen rushes after her husband only to find daughter Karen feasting on her father's flesh. Shocked and sobbing, Helen stumbles back as Karen advances, wielding a garden trowel over her head. Upstairs, Barbra and Ben struggle to block the broken windows, but their efforts are in vain. The wooden boards crash inward revealing brother Johnny has returned to consume his sister once and for all.

Family, a small cog in the larger patriarchal wheel of American society, eventually destroys and devours itself. Daughter Karen murders her parents and brother Johnny finishes off his only sibling. The last man standing, Ben, is the one person without any known institutional affiliations. Karen charges for him with outstretched arms, but he manages to toss her aside. In an ironic twist, after resisting Harry's insistence that it is the safest place, Ben absconds to the cellar and locks himself in just as a now-massive zombie horde infiltrates the upstairs. Harry rises up, more monstrous than ever, so Ben immediately dispatches him with the rifle. Ben crouches, gun poised, as the stomping and moaning upstairs grows deafening. Dissolve to day; an external, sunlit shot of the farmhouse with birds chirping. There is still a shred of hope.

ZOMBIE THEATER OF THE OPPRESSED

After an assumed lifetime of racial prejudice and persecution, and a violently climactic evening with strangers and monsters, Ben—an African American man, without any known family, who tried his damnedest to do what was in the best interest of himself and his fellow survivors—will emerge heroic to witness a brighter future. But as Paffenroth so astutely forewarns:

[a]nyone who watches zombie movies must be prepared for a strong indictment of life in modern America [and England]. It is not just because of the dismemberments, decapitations, and disembowelments that these films are not "feel good" movies, but because of their stinging critique of our society. It is this pointed critique that lifts them above the ranks of other horror movies. But it is a critique that is not wholly unbelievable or misguided. Anyone who says that racism, sexism, materialism, consumerism, and a misguided kind of individualism do not afflict our current American society to a large extent is not being totally honest and accurate [*Gospel* 21–22].

A series of ominous shots of backlit trees unfolds. Hopeful chirping is disrupted when a news chopper swoops overhead, providing bird's-eye surveillance of Chief McClelland's brigade clearing the fields on foot, weapons cocked. The Chief orders a small posse, replete with a few K-9 officers, to stake out the old farmhouse in the distance. He follows close behind.

Night of the Living Dead nears its end once the living agencies reorganize and appear to gain the upper hand over the undead chaos, lulling viewers to assume that normal order has once again been restored in accordance with horror film conventions of the era. With only a few shambling ghouls in sight, vastly outnumbered by the ragtag band of police and makeshift militia, the spokesman with boots on the ground reports that "Everything appears to be under control." Back in the basement, Ben awakens from seated slumber, alerted by loud barking above.

While monsters are typically used to threaten the status quo in horror cinema, as Michael Ryan and Douglas Kellner note, they "can also be used critically and deconstructively if they draw attention to particularly monstrous aspects of normal societies" (*Camera Politica* 179). Romero issues the modern sci-fi zombie, however, as a mirror to expose human flaws and societal failure as evidenced by the overt parallels revealed between these warring factions. "By depicting normal people becoming monsters," Ryan and Kellner stress, "Romero subverts the line demarcating normality from monstrosity and suggests that much of what passes for normal life is in fact quite unseemly" (179–180). By breaking the binary between life and death, Romero obliterates the assumed distinctions between human and monster, normal and monstrous.

If *Night*'s cautionary messages regarding the monstrousness of "normal" modern American society—its violent institutions and its racial and gender-based oppressions—are not already abundantly clear, the closing sequence of the film finalizes Romero's radical and prescient politics. The police Chief, draped in a bandolier of bullets, directs a few vehicles packed with men toward a barn while he and a growing number

of armed civilians survey the burned out truck that incinerated Tom and Judy. The troops relish the opportunity to kill the few ghouls remaining on the premises. Upon hearing gunshots and sirens approaching outside, Ben cautiously stands and climbs the cellar stairs in search of his rescue party. Back in the living room, Ben studies the wreckage. He climbs over broken boards and furniture to peek through the curtains, rifle lowered but still in hand. "There's something in there," one man states as he nods toward the house, "I heard a noise." After spotting a silhouette through the window, the Chief points to it and instructs his underling to "Hit 'em in the head, right between the eyes." Ben and the Chief's subordinate simultaneously raise and aim their rifles, but the volunteer pulls the trigger first. Struck square in the forehead, the film's last-standing protagonist falls dead to the floor. "That's another one for the fire," Chief McClelland shouts callously.

The film reel is abruptly replaced by a series of grainy photographic images of white law enforcement agents, smoking cigars and brandishing guns and other garish weapons, intercut with close-ups of Ben's corpse. As the final credits roll, the men hook their fresh kill then drag his body outside and onto a pile of wood. They torch the pyre, and the fire of injustice rages on.

Zombie Genre as Social Protest

Traditional horror and science fiction texts are exceptionally well-suited to challenge normality—by threatening it with a monster-antagonist—before restoring the status quo as ideal, but Romero's *Night* refuses to adhere to this conventional design. Horror, by critic Robin Wood's basic definition, needs to follow one simple yet effective formula: "normality [or "conformity to the dominant social norms"], the Monster, and, crucially, the relationship between the two. The definition of normality in horror films is in general boringly constant: the heterosexual monogamous couple, the family, and the social institutions (police, church, armed forces) that support and defend them" (Wood *Hollywood* 71). *Night of the Living Dead* depicts each of these "boringly constant" symbols of normality in horror, but all are revealed to be flawed and powerless under unprecedented monster assault.

Rather than restoring order and safety in the end, the dénouement is disrupted when a vigilante murders *Night's* sole survivor. As Cranny-Francis writes:

writers may challenge the conventions, thereby problematizing the text and its readings. Generic conventions are themselves, of course, sites of/for ideological contestation; so that when writers engage with conventions, they also necessarily engage in an ideological textual practice. [...] Firstly, such a practice may denaturalize that convention, making visible its discursive operation. Secondly, it may confront readers with their own expectations, revealing these as discursively constructed and motivated. Thirdly, as a negotiation of signifying practices and meanings, it may produce wholly new meanings, new knowledge. Readers may thereby be positioned discursively in a new space, realigned in relation to their former discursive position—a realignment which readers must then renegotiate in their own terms. This almost inevitably entails a shift of subject position [219–220].

It is precisely the discursive positioning and "shift of subject position" that Romero masters in *Night*, and thus influences generic cinema as well as activates zombie film aficionados for generations to come.

While several scholars acknowledge the subversion of genre traditions as a political act, few discuss Romero's key contributions in this regard. Speaking more generally about the power of genre, Melzer argues that "[t]o recognize the magnitude of the genre in the cultural imagination of United States society is to treat it as a space where the exchange between the text and the reader/viewer engages with political as well as social concepts" (Melzer 3). For this reason, viewers are challenged to endure onscreen dangers in many genres, but sci-fi/horror is uniquely capable of not only evoking intellectual and psychological engagements with sociopolitical concepts but also provoking physical experiences of embodiment. *Night*'s early viewers shrieked and squirmed through scenes of ghouls devouring human entrails, but they likely needed to unpack and process the larger and lasting implications of this graphic onscreen violence long after their shock and nausea subsided.

By defying genre conventions of both traditional science fiction and horror cinema, Romero introduces the hybrid zombie genre as an agent for socially conscious protest of Hollywood cinema as well as the real world it pretends to represent. According to Wood:

Night of the Living Dead systematically undercuts generic conventions and the expectations they arouse: the woman who appears to be established as the heroine becomes virtually catatonic early in the film and remains so to the end; no love relationship develops between her and the hero. The young couple, whose survival as future nuclear family is generically guaranteed, is burned alive and eaten around the film's midpoint. The film's actual nuclear family is wiped out; the child (a figure hitherto sacrosanct) [...] not only dies but comes back as a zombie, devours her father, and hacks her mother to death. In a final devastating stroke, the hero of the film and sole survivor of the zombies [...] is callously shot down by the sheriff's posse, thrown on a bonfire, and burned [*Hollywood* 102].

Cynthia Freeland argues horror films are distinctly provocative "stimuli that tend to work effectively in certain ways or that reliably elicit certain kinds of emotions and thoughts; but they do not function on merely passive audiences. Rather, these films," along with socially conscious science fiction cinema, "require those of us in the audience to be active as we exercise our various mental abilities" (3). Key to this project is the recognition that sci-fi horror since *Night of the Living Dead* activates audiences to acknowledge and protest against the multiple oppressions of normality and heteronormativity.

Modern fans and critics—though lulled and dulled by decades of graphic gore and "torture porn"—still actively explore how the original *Night of the Living Dead* has influenced sci-fi/horror cinema ever since. More importantly, today's viewers recognize how this groundbreaking film's social criticisms are as progressive, applicable, and absolutely necessary today. As Wood explains, "[c]entral to the effect and fascination of horror films is their fulfillment of our nightmare wish to smash the norms that oppress us and which our moral conditioning teaches us to revere" (*Hollywood* 72). Romero summons viewers—then and now, throughout his *Dead* series—to not only fantasize about obliterating "the norms that oppress us," and to certainly not revere them, but rather to actively fight to eradicate these oppressive social constructs from our present-day world.

Only then, will a new *Dawn* break.

CHAPTER 2

The Evolution of Women in Romero's *Dead* Series

"What are you watching?" the girlfriends asked, [...] talking about the monster movies on TV, the women in the monster movies bolting through the woods or shriveling in the closet trying not to make a sound or vainly flagging down the pickup that might rescue them from the hillbilly slasher. The ones still standing at the credit roll made it through by dint of an obscure element in their character.
—Colson Whitehead, *Zone One*

On close inspection, all literature is probably a version of the apocalypse that seems to me rooted, no matter what its socio-historical conditions might be, on the fragile border (borderline cases) where identities (subject/object etc.) do not exist or only barely so—double, fuzzy, heterogeneous, animal, metamorphosed, altered, abject.
—Julia Kristeva, *Powers of Horror: An Essay on Abjection*

As Romero's *Dead* series progresses, its social commentary and human/monster representations adapt and evolve in fascinating and powerful ways. Perhaps the most notable of Romero's emerging tropes is the fact that his leading white female and Black male characters become the extraordinary survivors of the apocalypse; they inherit the earth, albeit a devastated place, once they break free from the stronghold of their megalomaniacal white male antagonists, the intoxication of the megamall, and the tyranny of the military-industrial complex.

The female heroines in the *Dead* series are too complex to fulfill feminine stereotyping and to fit the constraints of traditional gender and horror theories—put forth by key scholars including Laura Mulvey, Linda Williams, Barbara Creed, Carol J. Clover, and Cynthia A. Freeland—as these theories too often rely upon active/passive binaries or require female

characters become masculinized in order to triumph over their adversaries. Romero's female leads resist using their sexuality as a tool for negotiating the patriarchy. They forgo romantic engagement as a means for accessing positions of power. Romero also transgresses the cinematic icon of the white male hero in favor of promoting men of color to share the spotlight with their leading ladies.

These survivors, banding together, become a bonded unit that dramatically defies the dominant heteronormative portrait of the American family. The zombies also grow to defy common misconceptions about this popular monster. Therefore, with the help of Kim Paffenroth, Kyle William Bishop, Stephen Harper, and Natasha Patterson, who each recognize and begin to expose Romero's unique feminist tendencies, I further illustrate how Romero's radical representations in the modern zombie film work to elevate the genre from "camp" and "exploitation" into valuable social protest texts. While Patterson shares this liberatory value of Romero's zombie films on a personal level, I will provide a bit more depth and breadth to the social protest value his original trilogy proliferates.

Carefully tracing the progression of Romero's protagonistic women since *Night of the Living Dead*, through an analysis of *Dawn of the Dead* and *Day of the Dead*, I explore how Romero's original *Dead* trilogy radically dismantles gender norms and bourgeois family representations commonly upheld as ideal within the horror/science fiction genres as well as cinema-at-large. In doing so, these films work as powerful demonstrations against the enduring oppressive social norms practiced in real life and reenacted in the mass media.

Feminist Film Criticism Turns to Horror

Romero's leading ladies in *Night*, *Dawn*, and *Day* call critical attention to the role of women in cinema by hyperbolizing and obliterating the common stereotypes and limitations placed on gender representations in genre films and the media-at-large. Feminist film criticism focusing upon gender representation and spectatorship tends to overlook Romero's influence and has traditionally and problematically relied upon Freudian and Lacanian psychoanalysis, binary thinking, "women's genres" such as soap operas and romantic/maternal tear-jerkers, as well as upon viewer pleasure/experience. While the work of Mulvey, Williams, Creed and others developed a strong foundation for the discussion of gender and genre, more recent scholarship reveals the theoretical weaknesses and inappli-

cability towards genres coded as masculine, particularly modern horror cinema and science fiction. The criticism of Clover made great strides in exposing these through her examination of the "Final Girl" heroics found in some horror subgenres, but work still needs to be done in understanding even more complex representations and readings of Romero's sci-fi zombie subgenre.

During the Golden Age, Hollywood cinema perpetuated stereotypes of women using classical narrative style and structure presented as representative of reality. Aristotle's discussion of *mythos* and later Barthes, Brecht, and others' revelations of the construction of myth in narrative storytelling and character representation begin to reveal the trouble in representations born out of a patriarchal culture. Joanna Russ, writing about (primarily sci-fi) literature in 1972, remarked:

> you will find not women but images of women: modest maidens, wicked temptresses, pretty schoolmarms, beautiful bitches, faithful wives, and so on. They will exist only in relation to the protagonist (who is male). Moreover, look at them carefully and you will see that they do not really exist at all—at their best they are depictions of the social roles women are supposed to play and often do play, but they are public roles and not the private women [81].

In her landmark 1975 essay, "Visual Pleasure and Narrative Cinema," Mulvey recognized how cinematic structure and perspective were fashioned by and for a specifically sadistic "male gaze." Much of Muvley's discussion centers on the Lacanian psychological "pleasures of looking" and how cinema develops this "scopophilia in its narcissistic aspect" (9). With regard to gender difference both on and off screen, Mulvey contends how:

> [i]n a world ordered by sexual imbalance, pleasure in looking has been split between active/male and passive/female. The determining male gaze projects its phantasy onto the female form which is styled accordingly. In their traditional exhibitionist role women are simultaneously looked at and displayed, with their appearance coded for strong visual and erotic impact [10].

Ultimately, Mulvey's essay is a clarion call to create an "alternative [feminist] cinema" which can now be made since the advent of more affordable film equipment and accessible production houses. This alternative cinema "provides a space for a cinema to be born which is radical in both a political and an aesthetic sense and challenges [these] basic assumptions of the mainstream film" (8).

A prime example of this alternative cinema already existed with Romero's *Night*, created over six years before Mulvey's essay found publication. The gaze and the female characters in *Night* challenge classical styles and standards, and a few of Romero's later heroines work to oblit-

erate them. Like Mulvey, Linda Williams develops feminist film criticism through an examination of women beyond the erotic that also does not take into consideration Romero's radical representations, though *Night* and *Dawn* made tremendous commercial and critical impacts by the time of her publication. Nonetheless, she brought necessary attention to horror cinema. Writing about "body genres" in the 1980s, Williams pushed feminist film criticism towards an examination of modern horror and other "gross" films, noting how "'lapses' in realism, by 'excess' of spectacle and displays of primal, even infantile emotions, and by narratives that seem circular and repetitive" (3). She saw beyond women on screen as erotic objects for the dominant male gaze by understanding how females "on the screen have functioned traditionally as the primary *embodiments* of pleasure, fear, and pain" (4). More importantly perhaps, Williams noted how "in the classic horror film the terror of the female victim shares the spectacle along with the monster" (5).

Informed by Williams as well as Julia Kristeva's theories regarding abjection, Barbara Creed furthered this connection between female and monster by claiming that they do not merely share qualities and the gaze, but that they are one and the same; both exist as what she dubbed to be the "monstrous-feminine." In other words, Creed articulated how all that is monstrous is feminine and all that is feminine is monstrous. As Carol J. Clover explains, several aspects of cinema are gender-coded, including characters, symbols, and locations, and while "[h]orror is more complicated, […] the general point holds: the perceived nature of the function generates the characters that will represent it, mobile heroism wanting male representatives, and passive dank spaces wanting female ones" (13). Nonetheless, she sets out to complicate this prescription as well as the male gaze and spectator pleasures in her groundbreaking *Men, Women and Chainsaws: Gender in the Modern Horror Film.*

Though she too avoids acknowledgment of Romero's heroines, Clover fills in the gaps of her predecessors in feminist film theory when she unmasks the power of the gender-bending female, the character she dubs the "Final Girl," who often survives the narrative in slasher (and occult and rape-revenge) films to bear witness to a world in which normalcy and safety are restored. This still-standing heroine is easily spotted early in these films for she tends to defy the tendencies of the females around her. Her silly, simple, and seductive friends will get picked off one by one by the psycho-killer, along with other male counterparts, but she is responsible, smart, sporty, conservative, virginous, and therefore victorious like Laurie (Jamie Lee Curtis) in *Halloween* (1978). If her traits don't mark her

as the heroine, the androgyny of her name can often cue her role: think Ripley (Sigourney Weaver) in *Alien* (1979) and Stretch (Caroline Williams) in *The Texas Chainsaw Massacre 2* (1986). Furthermore, as Clover details in "Her Body, Himself," "[t]he killer is with few exceptions recognizably human and distinctly male; his fury is unmistakably sexual in both roots and expression; his victims are mostly women, often sexually free and always young and beautiful" (*Men, Women and Chainsaws* 42). While terrorized by this male monster, the Final Girl may cower, cry, scream, bleed, flee, and fall, but she picks herself back up again and again.

Clover's attention to the gender-bending aspects of the slasher-surviving female helps demonstrate how and why Romero's leading ladies warrant more scholarly attention and analysis, and how remarkable they are for not having to abandon their feminine-coded characteristics in order to endure multiple horrors and live to see a new day. In the climax of Clover's chosen slasher films, the Final Girl's resourcefulness and tenacity empower her. She weaponizes and attacks and walks away battered but fully alive. Just as intriguing is how male authority figures—detectives, psychiatrists, sheriffs, etc.—attempt to save her but fail quite easily and miserably in these screen narratives. The Final Girl must fend for herself and does so by further bending her gender identification. As Clover clarifies:

> [t]he gender of the Final Girl is [...] compromised from the outset by her masculine interests [sports for example], her inevitable sexual reluctance (penetration, it seems, constructs the female), her apartness from other girls, sometimes her name. At the level of the cinematic apparatus, her unfemininity is signaled clearly by her exercise of the "active investigating gaze" normally reserved for males and hideously punished in females when they assume it themselves [48].

Not only does the Final Girl look at and pursue the killer aggressively, Clover explains, but she also becomes male in a sense, made phallic or phallacized by wielding weapons and conquering her attacker. Clover discovers how the "Final Girl is, on reflection, a congenial double for the adolescent male" and therefore for the majority and targeted audience; "[s]he is feminine enough to act out in a gratifying way, a way unapproved for adult males, the terrors and masochistic pleasures of the underlying fantasy, but not so feminine as to disturb the structures of male competence and sexuality" (51).

The transformation from female-victim to masculine-hero is remarkable and complex in its depiction and function as well as in its effect upon audience. The Final Girl, however, is not necessarily the ideal feminist heroine. By her own admission, Clover warns that to "applaud the Final

Girl as a feminist development [...] is, in light of her figurative meaning, a particularly grotesque expression of wishful thinking" (53). Referencing Clover, Linda Williams explains how the Final Girl impacts viewer experience; "pleasure, for a masculine-identified viewer, oscillates between identifying with the initial passive powerlessness of the abject and terrorized girl-victim of horror and her later, active empowerment" (7). At their core, these films do not abandon but complicate sex and gender, marking a surprising development in "low" horror films (but according to Clover) not yet seen within the "high" art horror cinema of directors like Alfred Hitchcock and Brian De Palma.[1] Nonetheless, the feminine-identified viewer can also experience these same gender-bending pleasures of shock and terror and triumph, which may reveal how and why the popularity and audience demographic for campy horror films continues to increase to this day.

Romero's Binary-Breaking, Gender-Bending Heroines

As the popularity of zombie media develops beyond expectations and infiltrates the mainstream media and modern consciousness, now is the time to expand awareness of Romero's radical gender and family representations—how they reflect the sociopolitical concerns of each movie's day and why representations like these are still of great value today—in light of the fact that many of today's most popular zombie films and television tend to perpetuate traditional gender stereotyping. *Night of the Living Dead* provides a remarkable model for reconsidering traditional gender roles and values by highlighting the destructive impact of traditional masculinity—upon women, men of color, family, community, and American society—in the era of the women's liberation and civil rights movements. Clear from this first film in the *Dead* series, the patriarchal white male is just as (if not more) monstrous than the "flesh-eating ghoul." As the zombies demonstrate more complex drives and emotions throughout the original trilogy, they often garner more respect and sympathy than living male characters who attempt to maintain rigid gender norms and domination.

Rather than creating artificially flat and flawless heroines, Romero composes dynamic and nuanced female characters who display traits and agency that cannot be categorized as simply masculine or feminine-coded. Unlike the Final Girl, they display remarkable agency and tenacity

throughout the narrative, rather than conjuring at the climax of the film. They make mistakes and slip back into their social scripting at times, but manage to work their way back out of them. *Dawn of the Dead* depicts the profound ethical influence one woman, Francine (Gaylen Ross), can have professionally and personally in her fight against the continuing oppressions of male supremacy and the contagion of conspicuous consumption during late capitalism. Sarah (Lori Cardille) in *Day of the Dead* acts as an antidote for the lone wolf heroics of its contemporary 80's action film star like Rocky and Rambo (see Wood's "*Day of the Dead*: The Woman's Nightmare") by standing up against the institutionalized violence and sexism that is as prevalent in both the military and the sciences as it is in mainstream Hollywood cinema. It is also worthy to note that when Romero abandons these radical representations of women in later films of the *Dead* series, as he does most egregiously with *Land of the Dead* (2005) and *Survival of the Dead* (2007), their critical and commercial success suffer.

Before the analysis of Romero's leading ladies begins, I need to highlight a few fundamental issues I see regarding the majority of horror and zombie scholarship. First, and this is something I have witnessed periodically in scholarship regarding gender in horror, while male characters are noted for depicting the ignorance and violence of scripted masculinity, their individual characters are seldom described by hypercritical adjectives and wardrobe disparagements. Yet Grant refers to Barbra in the original *Night* and Barbara in the remake (initially, at least) as "'mousy,' as conventionally coded by her tightly buttoned high-neckline blouse, brooch and neckerchief, and the inevitable eyeglasses" ("Taking Back the *Night*" 203). Harper undermines Fran's role as the character who imparts Romero's "moral insights" in *Dawn* by describing her as being too preachy (see "Zombies, Malls"). He also refers to Fran as *Dawn*'s "spiky feminist heroine," again diminishing her strengths by insinuating that she is too easily offended and annoyed by her maltreatment. These gendered critiques of Romero's heroines undermine the characters' agency and therefore demand readings of Fran that recognize her as being fully aware and intelligent, and readings of Barbra and Sarah in their attire as armed against the hypersexualized female stereotype and objectification of women in horror. Scholars touting Romero's "generally positive treatment of women, even a striking empathy for them" (Grant 203), all of us, need to recognize our occasional forays into prejudicial analysis of his female characters.

Secondly, rather than having to deny or override their gender-stereotypic traits like Clover's Final Girl, I argue that Romero's female

leads display radical gender politics uniquely and best when they demonstrate how masculine-coded traits such as reason and fortitude are shown to work in harmony, fluidly, embodied, with feminine-coded abilities such as nurturing, compassion, emotion, and empathy—and not simply at the climax of a film either, but—throughout the entirety of the modern zombie film. In other words, horror and gender criticism should remain open to the feminist value of female leads that do not abandon or suppress their femininity and adopt traditionally masculine wardrobes and outlooks.

Finally, though almost all scholars agree that Romero's zombie films are uniquely valuable for their social commentary regarding racism, classism, and the multiple oppressions of media and war, many reduce the importance of the gender representations and the complexity of Romero's female characters, as well as his surviving males (as highlighted in Chapter 3). Grant contends that Barbara in Romero and Tom Savini's 1990 remake of *Night of the Living Dead* is Romero's most feminist character creation, but his reasoning relies on her revision into one of Clover's Final Girls who must shed their femininity in order to triumph.[2] Kim Paffenroth argues that Romero's "critique of sexism in zombie movies is not nearly as prominent [as racism], and seems more a mocking jibe directed at the audience's expectations, than it is an indictment of the characters and the audience" (*Gospel* 19). Though I agree in part that Romero's Barbra in the original *Night* offers both a "jibe directed at the audience's expectations" as well as an "indictment" of the characterizations and audiences of horror and cinema at large, I argue how Barbra is misunderstood by viewers and misrepresented by scholars who overlook her initial activity and agency to instead focus upon her ultimate collapse that results from repeated victimization.

Scholars leave room for further study into Romero's scathing critique of sexism even while examining the remarkable leading ladies in *Dawn* and *Day of the Dead*. Though Paffenroth recognizes how each "movie after the first features strong women characters who are nearly as effective at killing zombies as the male characters, and who are much more compassionate, caring, and cooperative with other humans than their male companions," he nonetheless argues that Romero's "depiction of women as caring nurturers tends in the direction of stereotypes, and when Romero tries to undermine it, he sometimes steps into another stereotype, such as the 'prostitute with a heart of gold'" as we see with Slack (Asia Argento) in *Land of the Dead* (19). Kyle Bishop explains the limited attention he gives to Fran and other issues of sexism confronted in *Dawn* when he claims that this topic has already been exhausted by Paffenroth's analyses

in *Gospel of the Living Dead* (see Chapter 4, *American Zombie Gothic*), but this too is a bit shortsighted.

As I have already stressed, Barbra in the original *Night of the Living Dead* might appear to be nothing more than a damsel in distress, just another hysterical woman on screen, but closer attention to her actions before her syncope prove that even this most-criticized Romero character has notable depth and importance. Though Fran and Sarah *are* remarkably nurturing and compassionate, they transcend stereotypical representation by demonstrating more complexity and nuance than other onscreen female characters in horror and beyond.

In the original *Dead* trilogy, Romero's living female characters represent so much more than stereotypes, passive victims, and erotic objects for the male gaze. They do not always subscribe to simple categorizations—lover/mother, good/bad, virgin/whore—and they are typically less monstrous than all other characters, living and undead. They transcend stereotypes by being not only nurturing and compassionate but also moral, ethical, insightful, resourceful, rational, active, battle-proficient, and socially prescient. Of equal import, Romero's female protagonists do not need to abandon their feminine qualities in order to triumph and survive.

In an effort to fill in the gaps of feminist film criticism and zombie scholarship in the face of Romero's complex characters, I first scrutinize the binary-breaking, stereotype-transcending female protagonists in the remainder of the original *Dead* trilogy through an examination of Fran in *Dawn of the Dead* and Sarah in *Day of the Dead*. In an effort to demonstrate that Romero is neither infallible nor exempt from occasional character representation pitfalls, I then detail a few shortcomings in his representations of women in *Land of the Dead*.

THE *DAWN* OF FRAN

Dawn breaks on a pretty blonde woman writhing and moaning on boudoir red carpeting. Before the audience can indulge in this eroticized image, the camera pans back as this woman startles from her fitful slumber to reveal that she is huddled in the corner of a TV station's sound booth. A male co-worker swoops in to shake her back to reality by asking "Are you alright?" She jumps to attention and resumes her behind-the-scenes duties as a TV news director. Meet Francine (Gaylen Ross), arguably the most remarkable and underappreciated of Romero's female leads. Critics like Barry Keith Grant, Stephen Harper, and Robin Wood devote some

attention to Fran, but she is usually cast in the shadow of the condemnation of Barbra (*Night*) and the lauding of Barbara (1990 *Night* remake) and Sarah (*Day*). In his essay on Romero and feminism in *The Dread of Difference*, Grant mentions her only in passing, noting that the men in *Dawn* (which he mistakenly refers to in this instance as *Day*) act as the undead in their "automatic relegation of Fran to a subordinate role" ("Taking Back the *Night*" 238), and continually argues that progressive sexual politics are seen only when female leads in horror adopt a (Howard) Hawksian professionalism marked by being unsentimental, level-headed, resourceful, and rational. Stephen Harper recognizes this reductive approach and effectively dismantles it in his essay, "'They're Us': Representations of Women in George Romero's 'Living Dead' Series" through an insightful analysis of Fran's professionalism and nurturing nature in *Dawn*, but even this essay invites expansion for its dependency on Grant's readings of Romero's heroines, its primary focus on Sarah (whom he refers to as "Sara") and its tendency to create a new binary—images of traditional v. "positive" and "active" women—in its effort to combat the old binary of passive versus active female characterizations.

Like the Final Girl, it is clear from the beginning that Francine is different from both the women and men around her. Dozens of crewmembers bicker, swear and throw papers in exasperation. She leads quietly, with calm conviction, while everyone else abandons diplomacy. She maintains composure and ethical reasoning skills even when insulted and challenged by the leading men on set. On the live stage, the white male guest (TV Commentator; Howard Smith) of the news program argues with a Black male host (Mr. Berman; David Early) about the recent outbreak of dead rising up and eating the living, a phenomenon spreading across Philadelphia and the rest of the big East Coast cities. Behind the set at every turn, male switchboard operators and other crew hurl commands at Fran with threatening and disrespectful tones. When challenged, Fran straightens tall and demands that all employee protests should be directed to her in her office. She rarely resorts to name-calling and disrespect.

It is clear, just a few minutes into the film, that Fran is the only person literally and figuratively capable of seeing the bigger picture and of viewing reality from multiple perspectives. Moments later, Fran sneaks above the chaos to view the live television set from the catwalk. Not only is she the main object of the audience's gaze to this point, but also the character with the agency of the gaze within the film's diegesis. In other words, at the onset of *Dawn* Fran already displays what Clover calls the "active investigating gaze" that the Final Girl only inherits in the climax of a typ-

ical slasher film. In doing so, she captivates the audience and becomes the film's first protagonist since we share her vantage point and respect her power. We applaud her decision to remove the "supers" (the scrolling names of area rescue stations superimposed over the live broadcast)— especially when another white male co-worker argues that viewers will tune out if they do—when Fran asks "Are you willing to murder by sending them out to stations that have closed down?" This exchange reveals the film's overarching social criticism; for too many people, capitalistic gains trump morality and ethics.

Most scholarship on *Dawn of the Dead* focuses solely or primarily on the film's scathing critique of late capitalism rather than upon its radical gender representations (not that these foci are mutually exclusive), which reveal the destructive role of rampant masculinity as well as the denigration of women and emotionality. When the argument between Fran and a male director about the "supers" occurs over a live speaker feed, Mr. Berman screams "Get that idiot off the air! Hey! Get that *fucking idiot* off the air!" referring to Fran despite the fact that the male co-worker also interrupted the airwaves. Fran is unflinching in her decision that public safety is more important than profit. Ignoring this exchange, Howard Smith continues his dictum on set: "If we dealt with this problem [the rise of the flesh-hungry dead] without *emotion*, without emotion, it wouldn't have come to this." He further iterates rationality as best practice, blaming morality and emotionality as the root cause for this zombie outbreak. In other words, at this moment he's essentially implicating people like Fran despite the fact that she embodies rationality, emotionality *and* moral fortitude and thus demonstrates that these qualities can and should work harmoniously. As if on cue, Fran's boyfriend, traffic helicopter pilot Stephen (David Emge), swoops in with a daring plan to rescue her from this desperate situation. Momentarily it seems as though traditional gender roles have been restored with Stephen's act of male heroism, but the scene abruptly cuts to another time and place where we meet police officers Roger (Scott H. Reiniger) and Peter (Ken Foree); both later join Fran and Stephen in the helicopter escape plan. Romero never allows his audiences to get too comfortable.

Our introduction to Fran reveals a divorced woman in a professional position of power who refuses to back down in the face of her co-workers' greed and disrespect. Nonetheless, between their take-off from the police dock to their eventual landing at the indoor shopping mall, Fran reverts to the role of a needy and dependent girlfriend in Stephen's company. Despite the great advances women made in the workplace in the 1970s,

contemporary society has trained Fran to accept subordination in her romantic relationship outside of the professional sphere.

Fran fully abandons her professional leadership power to conform to a more traditional heterosexual partnership. She shields her eyes from corpses by burying her face in Stephen's chest and follows his lead during stressful situations. When the group encounters walking dead at a small unmanned airport, Fran freezes as Stephen fights off a few attackers. Stephen proves his own incompetence when he demonstrates subpar shooting skills, so Roger steps in and expertly picks off zombies one by one. Roger is a crack shot, but clearly immature in his cocky revelry. A few minutes later, Stephen disobeys proper weapons protocol when he shoots in Peter's direction at a zombie shambling between them. Peter emerges as the only seasoned leader in the foursome with the ability to maintain composure and troubleshoot danger with calm expertise.

Once this group dynamic is established, Fran's role in the film narrative becomes ancillary. The men civilly agree on a plan to land on the roof of a mall populated by dozens of zombies. While Peter and Roger survey the property, Fran and Stephen chat overlooking the parking lot. "Why do they come here?" she wonders. "Some kind of instinct," Stephen answers, "Memory of what they used to do. This was an important place in their lives." Fran divests from her own critical thinking in favor of giving Stephen assumed expertise. Despite his confidence, it feels clear that Stephen's automatic us/them division is short-sighted. Once safely inside storage quarters on the top floor of the mall, Stephen rests while Peter and Roger strategize their "hit and run" supply acquisition through the mall. "This is exactly what we're trying to get away from," Fran protests, as if her voice returns as soon as Stephen falls asleep, but the officers' minds are made up. Zombies and the living share in their conspicuous consumption and entitlement, thus solidifying the film's criticism of late capitalism upon which the majority of *Dawn* scholarship focuses. More intriguing, however, is Fran's ability to see through it.

Once isolated in the cocoon of the mall, the men show little aptitude for self-awareness and adaptation but Fran continues to recognize and struggle with her nature and her social scripting. While Grant briefly mentions it is her professionalism that marks her as a worthy protagonist, Fran is a long ways from her workplace and she's only becoming more captivating and complex. As Harper notes in "Zombies, Malls, and the Consumerism Debate," "[o]f the film's characters, however, only Fran (Gaylen Ross) voices the film's moral insight" (PDF no pag.). I contend,

however, that her insight is not staunchly moral as much as it is socially prescient.

Fran certainly understands the difference between right and wrong, but she also sees through the cloak of social constructions and recognizes the dangers of consumerism. While on their "hit and run" mission, Roger and Peter turn the shopping complex back on to full power. Corny mall music and gunfire lure Stephen from his slumber. He grabs the gun Peter left with Fran and flees to meet up with the men on their manic shooting and looting spree. Due to the men's carelessness and blind consumption, Fran finds herself cornered and defenseless against a Hare Krishna zombie who has meandered up the stairs and into their living quarters. She strikes a flare and retreats up a step ladder before the men rush in to rescue her (from their own incompetence, to be clear). Fran stares silently as Stephen tries to comfort her—"We've really got it made here, Frannie. Fran?"— but she's not buying it.

After eavesdropping in on a disturbing conversation, Fran becomes acutely aware (if she wasn't already) of how the men perceive her as an inferior member of the group. She overhears them discussing whether Stephen wants Peter the abort her baby, as if the choice is theirs and her body is their property to do with as they see fit. "She alright?" Peter asks, "She looks blown ... really sick." "She's pregnant," Stephen explains—in complete disregard of the danger he has just put her through, which is the real reason she's so distraught—"three and a half, four months." As if her pregnancy is Fran's weakness and the men's burden and choice, Peter and Stephen discuss whether or not *he* wants to "deal with it." To clarify his offer, Peter continues, "Do you want to abort it? It's not too late, and I know how." In the clever shot, Fran has her back to them in the next room in a literal and symbolic demonstration of their opposing perspectives.

With Fran outnumbered, the men attempt to restore their ideal male-dominated social order. Fran recognizes their misogyny and resolves to call them out for it. The next morning Fran states wryly, "I would've made you all coffee and breakfast, but I don't have my pots and pans." Stephen rolls his eyes.

After the previous night's silent indignation, Fran has found her voice again, and she uses it to demand equality and call attention to the women's liberation efforts being undermined by men and the consumer propaganda of the day. Fran has a right to be a mother and an equal partner. "I'm sorry *you found out* [emphasis added] I'm pregnant," she says, implying that she is not, however, sorry for *being* pregnant, "because I do not

want to be treated any differently than you treat each other." Stephen tries to protest, but she continues, "And I'm not going to be den-mother for you guys." "Jesus, Fran," Stephen replies when she demands a say in all plans, but Peter shuts him up with a twap on the arm. "She's right." To Fran, Peter continues, "We're going out and you're not coming with us until you learn how to handle yourself." Fran agrees to weapons training, even though Stephen biological body precluded him from having to prove his own competency. Fran also insists upon learning how to pilot the helicopter and demands to never be left without a gun again. Roger remains quiet, arms crossed, throughout this whole dialogue exchange. When Stephen slams down his weapon and ammo, Fran retorts, "I just might be able to figure out how to use it," chiding Stephen's lack of skill. Recognizing her unnecessary harshness, Fran apologizes and tells him to be safe. Even in her hard-fought battle for respect and equality, she does not want to resort to childish insults. Once again, she proves herself to be the "bigger man."

Fran's crusade does not end with her self-interest and women's issues. She also tries multiple times to help her companions stave off zombie assault and the intoxication of conspicuous consumption. While the men indulge their consumer drives, shouting things like "It's Christmastime down there, buddy!" and "Let's go shopping!" Fran repeatedly warns them the mall is a dangerous mirage. As Harper notes, "[a]ccusing the men of being hypnotized by the mall, she tells Stephen: 'It's so bright and neatly wrapped you don't see that it's a prison too,' though he undermines Fran's perception when he says she "is expressing, albeit rather preachily [sic], Romero's own perspective"; nonetheless, "she highlights the tendency of human beings to become cultural dupes" ("Zombies, Malls" PDF no pag.). In this brief analysis, Harper seems to attribute her insight to Romero and yet criticize her for being the vessel to call it out.

Fran has proven since the opening sequence that she cares deeply for humanity, and that she is willing to do tough work in an attempt to protect her precious species despite its folly. Back in their quarters, Peter and Stephen strategize their next move while Fran tends to Roger's wounds in the next room. While some scholars like Harper read this scene as an extension of Fran's mothering and nurturing instinct (see "Zombies, Malls" and "They're Us"), I see it more as evidence for her diversified professionalism and her compassion for fellow human beings. Roger's room is later made up like a makeshift army hospital, and Fran is the stand-in medic. It seems unlikely that a male character fulfilling this same role would garner descriptors like maternal and nurturing for administering

morphine to a fallen brother. When Roger cries out in pain, Peter rushes in to comfort him with a bottle of Jack Daniels, making Peter more of a surrogate mother-figure in the scene.

Once locked inside the large department store, Fran's hatches the brilliant plan that the men should use the raffle car displayed on the concourse to drive around to lock and set alarms on all four mall entrances. Fran, the brains behind the operation, opts to hold down the fort as the men spring to action. Stephen bumbles handing off his key ring to Fran— further illustrating his ineptitude—but he narrowly escapes the converging zombies who turn to follow after him as he runs to catch up with the two officers. A zombie-nun's habit gets stuck in the door, but Fran smiles gently and releases her to join the shambling pack. They share a momentary gaze before the nun saunters off. Shortly thereafter, Fran sits in the lotus position on the floor and mindfully loads her revolver as a handful of zombies wander back towards her.

While Fran and Peter both show and share great nurturing compassion for Roger in spite of his personality flaws, only Fran has the capacity to demonstrate the same empathy for all creatures living, dying, and undead. Moans, like those of a newborn baby, emanate from one of the zombies wearing a Bach's Arco Pitcairn softball uniform. He (referred to by some scholars as "baseball zombie" and others as "softball zombie") slides into a seated position across from Fran, out from under the black cloak of another zombie as if born anew. Fran's eyes widen and her mouth gapes slightly as she and this "monster" gaze at one another. Neither Fran nor the zombie show any fear or aggression or desire to consume one another, yet they are not entirely passive either. Rather, they seem to engage with one another, in solidarity or familiarity. As Harper explains:

> [t]he monstrous image of woman in the horror film serves to reinforce the woman's abjection and otherness in the eyes of patriarchy. Thus, when Fran and "softball zombie" stare ruefully, rather than fearfully, at each other through the glass window of the store, their coequal exchange of gazes emphasises their solidarity. Indeed, while she may also be an active agent in the film, the pregnant Fran empathises with the infantile helplessness of the zombies in a way that the film's male characters would find impossible ["They're Us" PDF no pag.].

Harper's point is highlighted by the fact that just before this powerful though short exchange, Peter tells Stephen that they're "going on a hunt" right after all the entrances are locked and the mall is secured.

Even though existence is bleak and tenuous, Fran works in the present to help sustain a future for herself, her comrades, and her unborn child. Later on, we see Fran watering the plants in the mall in an attempt to sus-

tain life. This depth of foresight and compassion will be needed to not only survive but to thrive in the zombie post-apocalypse. By showing her companions and the audience how we need to break us/them binaries, and to recognize shared otherness and oppression based on our own embodiments, Romero through Fran is teaching the world how to progress into a bearable future even if it is post-apocalyptic.

The true test for the living comes not from the undead, but instead from the daily grind of living inside the mall once it has been cleared of all zombie threats. Nestled in the cocoon of free commerce, the group must now find ways to occupy and pass their time together. As Bishop recognizes in his essay "The Idle Proletariat," "[t]ime passes uneventfully, and the four survivors try to make their indefinite inhabitation of the mall as comfortable as possible by recreating as much of 'normal life' as they can—'playing' at normalcy" (243). In this attempt to restore "normal life," however, the group reinstates a social order prescribed by the late capitalism they (Fran, especially) already know to be defective and destructive. Fran tries on dresses and examines herself in the mirror. The men play with sports equipment, go grocery shopping, and collect expensive formal wear. The men play shooting games in the arcade, restoring violence to commercial child's play, while Fran skates the ice arena alone. Later, Fran and Stephen ascend the stairs carrying paper grocery bags as if returning home from the average day as a consumer couple. Bishop contends that:

> [t]o ensure their safety from any marauding bands of humans that might be out scavenging (a very real threat that manifests later during the film's climax), they outfit the upper offices of the mall like an apartment—bring up furniture, cooking supplies, and other accoutrements—and they board up the entrance to the stairwell to make it look like just another section of wall [243].

While this sequence might appear to depict the idyllic life of a leisure class, hordes of zombies still claw at the mall's entrances. "They're after us," Stephen remarks, "What the hell are they?" "They're us. That's all," Peter answers. As much as they try to preoccupy themselves with carefree indulgence, the grim reality of their broader circumstance is ubiquitous.

Though Fran will fight for survival when needed, she spends more of her time in contemplation and preservation. In other words, while she proves herself to be resourceful and capable, she refrains from killing zombies when they are not a direct threat to her group's safety. She exhibits the ability to discern between a zombie as direct threat and a zombie as an ally in otherness. This enables her to observe the undead and to recognize that although they may seem driven by "pure motorized instinct," the zombies remain distinct and individualized from one another. They

wear outfits and uniforms that mark their religious, professional, and personal affiliations in life. Even though she was earlier instructed by a male radio expert that "They must be destroyed on sight," Fran not only sees them for what they have become, to which she is sympathetic, but also for the humans they were before. They garner her forgiveness as do her living male companions. This is why she smiles and releases the nun, a symbol of sacrifice and compassion, from the grip of the door rather than automatically shooting her. Though I will later examine the complexities of Romero's and others' zombie representations, it bears mention here how Fran and the viewing audience witness now a new and radical glimpse into a monster that is not wholly evil and abhorrent. Romero's zombies in *Dawn* and later sequels are on occasion more individualized and sympathetic than the living male characters in the films, as are his women and men of color.

While some zombie scholars contend that Fran's empathy for the monster essentializes her as a nurturing female prototype, a model maternal figure, it is difficult to reduce her keen awareness, empathy, and recognition of shared otherness to a stereotypically natural drive. Grant argues how Romero's heroines must become active in order to fulfill feminist purposes. In "'They're Us,'" Harper attempts to forgo this assumption by explaining "[w]hile Romero depicts women as active agents, he also mobilizes the traditional notion of the nurturing woman for feminist purposes" as seen during "Fran's empathy with 'softball zombie'" which "demonstrates her commendable sensitivity" (PDF no pag.). Yet it seems reductive to create a new limited logic in an attempt to overcome another. Harper sees the flaw of Grant's active versus passive reasoning, so he argues how Romero's reproduction of other traditionally female-coded traits such as charity, sensitivity, and empathy must also be considered in analyses of his zombie film females as agents for feminism. Fran is not simply active and nurturing, either; therefore, the multiple and diverse facets of her character invite more careful attention and appreciation.

Fran is too flexible, fluid, fallible even, to focus on only a few major aspects of her character. Once she learns shooting competency, she mutters "mother-fucking sons of bitches" as she picks off zombies in the parking lot below. Here she demonstrates the ability to modify her standpoints based on a hierarchy of loyalties. In other words, when her closest companions need protection, she chooses to serve her immediate living community by overriding her broader empathy for the undead. Later though, Fran releases the trapped zombie-nun since her pursuit of Stephen is pathetic and non-threatening.

Fran's ability to process each situation in relation to her personal ethics reveals that she is never simply reverting to one of a few simple types of femininity. Fran is an active and nurturing pregnant female, yes, but these attributes are not the root cause of all her decisions and drives throughout the film. When Stephen witnesses Fran retching from morning sickness, she says: "Look, I just don't want you to see me like this, okay?" Fran pleads with her lover and the viewing audience to not reduce her to this pregnant state, and not to see her as weak because of it. Fran provides medical attention for Roger after he is bitten (due to his own carelessness and immaturity) in what looks to be a makeshift army hospital room. While scholars frequently attribute her care for Roger as merely evidence of her nurturing and maternal nature, I read this hospice care as an act of compassion as well as evidence of the diversification of Fran's expanding skills and service.

To this point in the film, Fran is the only member of the surviving group to demonstrate a drive for knowledge and practical skill acquisition necessary for longevity in the peril of apocalypse. She develops and at times suppresses her insight, but she never surrenders her sentience or her hope for a sustainable future as evidenced throughout the second act of the film. While Stephen, Roger, and Peter indulge in self-gratifying activities such as drinking, shopping, and playing violent video games, Fran exercises, reads parenting manuals, practices shooting, cuts the men's hair in the barber shop, and waters the plants in a garden center. In other words, while the men occupy their time with frivolous distractions, Fran devotes herself to learning and life-sustaining practices. It is only after Roger succumbs to his zombie infection, and Peter shoots him dead again, that Fran temporarily loses herself to hopelessness, and soon thereafter, to commodity fetishism.

Fran is remarkably self-aware and socially conscious but she is also flawed, a revelation that works to allay assumptions that her character offers only positive images of both traditional and active femininity. When Stephen proposes marriage over a romantic meal Peter stages for them, Fran declines: "We can't, Stephen. Not now. Wouldn't be real." Later however, she sits, surrounded and overwhelmed, in a circle of women's garments. That night Stephen and Fran, clearly post-coital, pose listless, like mannequins, alone in their own depressions. As morning breaks on the twenty-third day of their stay at the mall, a visibly pregnant Fran wanders aimlessly into the now fully-furnished living room wearing a drab muu-muu. Despite their best efforts to fabricate an "ideal" home, they have lost their luster for living in this artifice.

Fran seems to compromise her strength of character, if only tem-

porarily, when she surrenders herself to the prison of consumerism and modern domestic life she so adamantly warned the group about earlier in the film. Fran retreats to a performer's dressing room. Before the lights and mirrors of the make-up counter, she applies lipstick, fake eye-lashes, and lotion. We watch her mirror image, a classic doppelgänger device, as she spritzes expensive perfume and poses with a small revolver, humming to herself like Faye Dunaway in *Bonnie and Clyde* (1967). The mannequin head on the table beside her is also garishly painted, a glaring symbol of the grotesque emptiness of the feminine image marketed to women. "Attention all shoppers!" a pre-recorded voice abruptly announces from the mall's intercom system, ironically interrupting and ending Fran's momentary lapse into conspicuous consumption. That night, Fran prepares dinner, having found her pots and pans after all, while Peter and Stephen drink liquor and play poker. "What have we done to ourselves...," Fran laments after dinner. They are all just doing time now.

As a corrective for her brief foray into blind consumption, Fran begins a new day with helicopter flying lessons. She remains proactive and focused on acquiring and practicing valuable skills throughout the remainder of the film. Harper sees Fran's "mirror scene" as her "'fall from grace'" into the role of a "cultural dupe" as necessary to expose the oppressive influence of commodity fetishism and the narcissism of consumer ideology upheld by patriarchal culture in the late 1970s. As Harper summarizes, "*Dawn of the Dead*, then, presents a multi-faceted heroine. Fran is not only, as Grant claims, a professional, but also a nurturing and maternal figure; and even—albeit temporarily—a brainless cultural dupe of the fashion industry," thus affording viewers critical examinations of "the many possible images of femininity available to American women in the 1970s" ("They're Us" PDF no pag.). Though Harper's assessment significantly opens up the previous analyses of Fran by prominent zombie scholars, it encourages readings of Fran that do not rely upon packing the complexities of her character into a few neat and fixed categories.

Even though Fran's spirited resolve wanes, periodically and most pronounced when she cooks for the men and attempts to indulge in the advertised joy of women's beauty products deep into the group's sheltered habitation within the megamall, this is not a dead-end for her character. In these instances, Fran tests out performances of the ideal woman being sold through media and advertising but ultimately finds them to be unfulfilling. Therefore, I argue that Fran is not merely professional in the Hawksian sense (see Grant)—or a "cultural dummy" or "moral" character (as Harper maintains)— but a truly complex, dynamic, and perceptive repre-

sentation of womanhood. As I have attempted to illustrate, Fran's political campaigns throughout *Dawn* supersede women's issues to include conspicuous consumption, acceptance of and compassion for the Other, and the redefining of modern American family.

Fran is never trapped in her weaknesses; rather, she recognizes them quickly and works to regain her position as the forceful and radical protagonist she is and always has been. These qualities prime her for survival in *Dawn*. When the mall security is compromised by a marauding biker gang, Fran retreats to the top-floor storage room, a readies herself for an escape from this nightmarish place. When a zombified Stephen returns to their quarters with an army of undead, she climbs to the roof and checks and fires the helicopter controls. Putting her own safety at reasonable risk, she waits for Peter to join the flight into a new dawn.

SARAH GETS HER *DAY*

Few if any of horror's leading ladies, even Clover's Final Girls, ever achieve Romero's groundbreaking and revolutionary representation of womanhood as demonstrated by Fran in *Dawn of the Dead*. Even some of Romero's own female characters lose this social protest capacity later on in the *Dead* series. Arguably, Dr. Sarah Bowman (Lori Cardille) in *Day of the Dead* is the only heroine who exhibits a comparable level of the gender-bending, binary-breaking dynamism established by Fran in *Dawn*. Robin Wood calls *Day of the Dead* "The Woman's Nightmare," a film in which "the woman has become, quite unambiguously, the positive center around whom the entire film is structured" (292). While Wood credits Fran for learning to "assert herself and extricate herself from" the multiple oppressions of patriarchal society, he sees Sarah as the most remarkable of Romero's leading ladies since "[s]trikingly androgynous in character, she combines without strain the best of those qualities our culture has separated out as 'masculine' and 'feminine': strong, decisive, and resourceful, she is also tender and caring, and shows no desire to dominate" (292). Though I argue and illustrate how the same should be said for Fran, Sarah's role as *Day*'s primary anchor warrants critical attention along with her ability to demonstrate extraordinary gender-bending and balance.

Like *Dawn*, *Day* opens on a female lead rousing from a fitful sleep—in this case, Sarah, in a cinderblock cell—and thus establishes her as the film's central character. She too is dressed conservatively in professional attire, befitting her role as a scientist living underground at the Seminole Storage Facility alongside a ragtag military unit.

In the first action sequence, Sarah rides in the back of a helicopter also occupied by three men; but in contrast to Fran, Sarah is the clear leader of this group as evidenced by the fact that she calls the shots. Unlike her predecessors, Sarah does not recoil when confronted with the gruesome carnage on the ground. Her accompanying party seems resistant to join Sarah in her search for survivors, but she carries on with her mission before retreating back to the safety of the helicopter. Once back at base, a make-shift camp set deep within a missile silo, the bearded man in her group collapses in prayer in the back of the helicopter. This is Miguel (Antoné DiLeo), who we later learn is Sarah's dramatic and unstable lover. Sarah attempts to coax him from his position, asserting tenderly, "You're collapsing from stress," an observation that prompts Miguel to lash out. "We're all collapsing—this whole fucking unit is collapsing—everybody except you," Miguel growls. "I know you're strong, alright? So what? Stronger than me. Stronger than everyone. SO WHAT? So fucking what." Sarah's nurturing and protective act triggers Miguel in his distressed state, as if he sees her stability and compassion as a threat to his masculinity and ego.

As the film's only female surrounded by male scientists and troops, Sarah elicits backlash from several men jockeying for a dominant position of power. When she and Miguel volunteer to help wrangle zombies for scientific testing, their military escorts Steel (G. Howard Klar) and Rickles (Ralph Marrero) harass her with verbal insults and sexual aggression. Steel repeatedly calls Sarah "lady" in a pejorative sense and threatens to expose his "meat" but claims he does not want to "excite the lady." "You're incapable of exciting me, Steel," Sarah says, "except as an anthropological curiosity." Steel doesn't understand what she means by this, so Rickles explains, "She means you're a caveman, asshole." Sarah recognizes that these men are undereducated and immature, so while she stands up for herself when necessary, she does not allow anger to disrupt her professional objectives. Miguel is too shell-shocked to engage in his own defense.

Sarah proves herself time and time again to be thick-skinned and level-headed when working through series of misogynistic assaults. When Steel tells Sarah he does not want her help in capturing specimens for Dr. "Frankenstein" Logan's (Richard Liberty) experiments, that she is not strong enough, she retorts, "What do you mean I'm not strong enough? I've done it dozens of times." She follows up her verbal claim with tangible and successful action to prove him wrong. When Miguel loses his grip on a leashed zombie, Sarah jumps in to regain control. When Steel attacks Miguel for putting Rickles in harm's way, Sarah raises her rifle at him until

he releases Miguel. During this sequence, Sarah rescues Miguel twice, from a zombie and from Steel. Back in his private quarters, Sarah fills a syringe with a serum to calm his nerves. "I'm not gonna let you dope me up!" Miguel protests. "You need a sedative," Sarah declares, "You're behaving dangerously." Once again, Sarah's strengths, both physical and mental, are perceived threats to these military men and their masculinities. "You made me look like an asshole out there," Miguel sobs, "You made me feel like a piece of shit." Here, Miguel blames Sarah for his own incompetence and the loss of face witnessed by Steel and Rickles. When she approaches him, cautiously but with determination, Miguel smacks her across the face with all his might. He then sobs again, strokes her cheek, and collapses in her embrace. Despite this rapid cycle of domestic abuse, Sarah's care and compassion for Miguel does not wane.

Unlike Fran, Sarah's resilience and resolve never waiver under the pressures of romantic partnership, sexual discrimination, and threats of violence. Sarah refuses to combat violence with violence, particularly with loved ones but even when faced with the film's greatest antagonisms; this refusal is perhaps the greatest strength of Romero's heroines. During their dramatic embrace, Sarah plunges the sedative-filled syringe into Miguel's shoulder. He recoils in horror then lunges back at her, stopping only when she freezes. She stays strong and thoughtful without abandoning her nurturing nature or sacrificing her best intentions and decisions. "Bitch," Miguel whimpers, then caresses her shoulder and collapses onto his cot. As Paffenroth explains, the "violence that is acted out or threatened against Sarah is much more overt that in the previous two films. While Ben hit Barbra to end her hysterics, Miguel only has his wounded male ego to blame for hitting Sarah" (*Gospel* 80). The theme of the monstrosity of male masculinity emerges with Miguel but is fully solidified when we see how Captain Rhodes (Joe Dilato) treats his men and Sarah as the film progresses.

Though Sarah is not technically in charge in either the group of scientists or the military unit coexisting in this underground bunker, she exhibits great leadership as she attempts to act as a liaison between both factions during a major dispute. During a tense meeting in the mess hall, called by Rhodes, it becomes clear how masculine lust for power impedes the respect and harmony needed to sustain communities of survivors. Rhodes tells scientist Fisher (John Amplas) that the agreement the deceased Major Cooper made between the military and the research team "is dead" and that he is "in command now," therefore Fisher and his "playmates are running out of friends down here." Sarah enters the hall shouting "We're in a desperate situation here. We *need* each other. Can't we all just

get along?" "The way I see it, lady, I'm not so sure we need you at all." Again, like Steel and Miguel, the military men continue to use "lady" and "bitch" to address Sarah in an attempt to undermine her voice by relegating her to the assumed abjection of her gender. She continues to argue for cooperation as it will best serve and protect everyone.

Sarah matches Rhodes' vocal tone, attitude, and strong body language without resorting to threats of violence. In other words, she adapts her voice and demeanor to each person and situation without fear or apology and more importantly, without losing her humanity. She takes this opportunity to argue for Miguel's compassionate care, but Rhodes threatens to quarantine him anyway. "We're talking about a man's life here, you son-of-a-bitch," Sarah replies. Rhodes adds that it is time to "give some of the rest of us a shot at the action," suggestively raising his fingers to his open mouth. Once again, the male leader threatens sexual violence when he fears that Sarah's contributions challenge his ego and status. Later in the film, Rhodes drops his threats of sexual violence in favor of threatening to kill Sarah when she refuses his orders to sit down. In an effort to demonstrate his ultimate control over everyone, he demands that Steel kill Sarah while Rhodes points a gun at him. Even though Steel has been relentless in his disrespect for her, Sarah sits quickly to spare Steel's life.

Sarah embodies both scientific reason and humane emotion, rationality with compassion, demonstrating how these qualities can and should work harmoniously within an individual and throughout a collaborative community. Sarah's mental acuity and physical agency help carry her between the military and the scientists, but it is clear that she does not actually or ideologically fit into either camp. Not only does her gender set her apart, but also her social values and empathy. In Dr. Logan's lab, Sarah surveys the gruesome scene: blood spattered sheets and lab coats, and undead bodies chained to the wall, hooked up to machines, and discarded on the floor. Dr. Logan argues excitedly about how the zombies can be conditioned, controlled, and domesticated. Dr. Logan earns the sinister connotation of his Frankenstein nickname for he values scientific knowledge acquisition more than the sanctity of human life. His scientific aims, to clarify, are to gain more power and dominance rather than to help save and restore humanity. As Wood details:

> "Science" in *Day* is "Dr. Frankenstein," and it is revealed as yet another symbolic extension [as is the military] of masculinist ideology. If what distinguishes the human beings from the zombies is their potential for reason and emotion, then the science of Dr. Logan represents the overvaluation of a certain kind of rationality at the expense of other distinctly human qualities ["The Woman's Nightmare" 292].

Sarah is deeply disturbed to discover that the most dissected body, a brain and body autopsied but "alive," belongs to the late Major Cooper (Barry Gress is credited for playing his corpse) who established the working relationship between scientists and military at the facility. To Sarah, Major Cooper was of more value as a living compatriot than as a scientific specimen.

Sarah soon discovers that she is not entirely alone in her dissent from the hyper-masculinized majority. In the hallway she reaches out to John (West Indian) (Terry Alexander) and Billy McDermott (Irish-American) (Jarlath Conroy), the helicopter pilot and radio operator from the opening sequence of the film. "Maybe if we tried working together we could ease some of the tensions," she shouts, giving the men pause. "We're all pulling in different directions." John and Billy turn to face her. "Well that's the trouble with the world, Sarah darling," John responds in his island accent, "people have different ideas concerning what they want out of life."

A mutual respect is born now that it is clear John and Sarah share a broader world view than their colleagues. Later, after another tense exchange with Miguel, Sarah and Billy share pulls from a brandy flask. He invites her to his and John's private quarters on the outskirts of the underground compound named "The Ritz." Their front "yard" is decorated with a tropical island theme: lawn chairs, an umbrella and a beach tapestry. Inside, the space is filled with quaint and homey furnishings from plush recliners to embroidered pillows, insinuating that John and Billy may share more than a platonic partnership. The have created their own oasis away from the cold and barren military bunker and its associated drive for traditional masculinity and dominance. "You're a mystery to me," Sarah says to John, "not like those other goons in there. You have a sense of..." but she cannot find the right words to complete the thought.

Once again, as Fran and Peter demonstrate in *Dawn*, differences in gender, race, and sexuality that set these characters apart from the dominant social norm work to bring them together, and thus signify their potential for survival. "We could start over," John says to Sarah, "start fresh. Get some babies and teach them, Sarah, teach 'em never to come over here and dig these records [of commerce and culture before the collapse] out." John envisions the devastated state of the world as an opportunity to give rise to a wholly new civilization led by the insights and principles of the formerly oppressed.

Day opens with Sarah's nightmare in which she is strangled by dozens of zombie hands. In the film's end, Billy, John, and Sarah make a run for the helicopter in an attempt to flee the overrun bunker in search of an

island paradise. As Sarah climbs into the chopper, a zombie attacks. The scene dissolves to Sarah awakening on a beach. She sits up, stretches, and sees John and Billy happily fishing and feeding seagulls down the shore. This ambiguous ending leads many scholars and critics to assume the worst, that the film's unlikely protagonists escaped what John believed to be hell on earth only through inevitable and untimely death. This beach is their version of heaven in the afterlife. Whether or not Sarah and her pals literally or figuratively escape to this paradise, the metaphorical conceit is complete. It takes an apocalypse to break society open for a full rebirth. It takes a nightmare to inspire Sarah's dream of a future beyond the hellish conditions of the modern patriarchy.

No Woman's Land

Romero's *Land of the Dead* is his first contribution to the zombie resurgence in the 21st century. After a twenty year hiatus, during which he worked in television (*Tales from the Darkside*), collaborated with other horror masters (namely the famed Italian thriller director Dario Argento), wrote screenplays for and directed other low-budget films, and remade and updated earlier *Dead* films, Romero returns to the subgenre he initiated with a new *Dead* installment, a larger budget, and Hollywood studio backing. Beholden to these professional attachments (and to maintaining their R-rating requirement)—and under the pressure to compete with the critical and commercial successes of Boyle's *28 Days Later...*, Anderson's *Resident Evil* (2002–present) franchise, Snyder's *Dawn of the Dead* (2004) remake, and Wright and Pegg's zombie parody *Shaun of the Dead* (2004)—Romero manages nonetheless to further humanize the zombies and to evolve the social protest agenda of the genre at its best. *Land* focuses on broad and scathing criticisms of Bush-era war-mongering and classism, and on an evolving and organizing zombie union, but loses its social protest thrust at the level of character representation and depth.

By favoring macroscopic political and social satire, the film subsequently sacrifices the radical feminist representations of its predecessors in the series. This shift is clear from the first sequence of the film. In the first three *Dead* films, Romero begins with and maintains focus upon a main (living) female protagonist who exhibits agency and an investigative gaze. *Land* instead opens observing the zombies, in various states of decay and with various levels of ability: a few stagger aimlessly across a graveyard, a small band fiddles with their brass band instruments in a gazebo,

and zombie-protagonist Big Daddy (Eugene Clark) emerges from his Gas and Repair shop when the arrival bell rings. From there, we meet and follow Riley (Simon Baker), and soon thereafter his foil Cholo (John Leguizamo), as well as Riley's simple-minded sidekick Charlie (Robert Joy). The human and zombie protagonists in this film are all male.

Land advances lone wolf heroics (human and zombie) and relegates female characters to ancillary and stereotypical roles in the process. We see and hear an occasional female during the first act of the film, often dressed in military fatigues, shooting down zombies, or radioing in from tanks stationed in remote locations, but none participate fully in the film's developing action and dominant narrative. It isn't until nearly the thirty-minute mark that Riley liberates a scantily clad woman, Slack (Asia Argento), from being forced to sport-fight zombies in a pit surrounded by a rowdy crowd of gamblers. As if to repay him for her rescue or to even the score, Slack then pushes Riley out of harm's way and takes a bullet to the arm in the process. "I'm okay ... thank you," she says, and Riley replies, "thank *you*," but their roles and influences are far from balanced. Officers arrest Riley, Slack, and Charlie for inciting a riot. In jail, Riley shares his plans to retire from the scavenging unit to seek refuge in the remote countryside of Northern Canada. Slack pleads her case for joining him, insisting that she is an asset since she can shoot guns and completed army training before she was forced into prostitution. "I can be pretty fucking useful," she says. Charlie explains that Riley prefers to be alone. "I don't want to hear your fucking story," Riley tells Slack, "Everyone's got a story and I am sick of hearing them."

In *Land of the Dead*, Romero seems to rest his laurels on populating the narrative with a handful of gender-nonconforming (in name, style, and weapons-aptitude) Final Girl types. Slack is rescued by this lone wolf hero and then has to beg to be included in his survival plans. She eventually earns her spot on his team after repeatedly demonstrating that she is in fact a crack shot capable of taking down zombie and human enemies. Slack becomes one of three heavily-armed females onboard Riley's super-fortified tank named "Dead Reckoning." She joins Pretty Boy (Joanne Boland) and Monica "call me Motown" (Krista Briggs) and a few other male characters who have demonstrated their loyalty to Riley's reluctant leadership. Together, this gender and ethnically diverse crew flees the escalating class tensions of Uniontown in search of uncharted territory. The audience is left to wonder whether this unconventional family will be able to rebuild a social system founded on equality and justice for all.

Reconstructing the American Family

As in *Night of the Living Dead*, traditional male heroism, heteronormative relationships, the patriarchal family unit, and symbols of modern domestic life become horrifying in *Dawn of the Dead*. Like the leading ladies in Romero's *Dead* series, men of color are often insulted and undermined by their white male antagonists, whether enduring racial epithets or physical threats from their co-workers and superiors. Those who defy or evolve beyond heterosexist norms eventually identify, bond and escape with the female character who shares the same outsider status.

Each of the *Dead* trilogy's heroines develops deepening yet non-romantic relationships with her leading men of color co-stars, thus signifying how otherness is a shared strength that fosters empathy, compassion, and paves the way for an evolved though uncertain future. Once his own immediate safety is secured in *Night*, Ben turns his attention to caring for the shock-stricken Barbra. He finds a pair of women's flats, bends on one knee, and slips them onto Barbra's limp feet. Later, Ben does his best to serve and protect the expanded group of survivors in the farmhouse even though he shares no racial or familial ties to them. Peter in *Dawn* defies his masculine-coding when he provides compassionate care for his ailing friend Roger. Under Fran's influence, Peter begins to recognize the corruptive and oppressive reality of late capitalism and sexism. He distinguishes himself from Stephen and Roger and learns to relate to this new reality in a way that opens him up to true partnership with Fran. When the foursome sets out, armed to absurdity, to clean and lock down the mall, Peter pushes the ailing Roger in a wheel barrow as if he's a child in a stroller, thus solidifying his role as Roger's surrogate mother-figure. Peter later joins Fran and her unborn child in fleeing the zombie-infested megamall upon Stephen's helicopter. In *Day* John and Billy avoid the brutish violence of the military's underground barracks by living literally and figuratively far away from it; rather than sleeping in bare bunk cells with their colleagues, they share a cozy homestead replete with quaint crocheted signs and plush furnishings, and they welcome Sarah's visits and share her defiance of Rhodes' corrupt leadership.

Though Romero's *Dead* trilogy wholly condemns the traditional American family as a violent organization, he revises and reconstructs the bonded human unit rather than eradicating it entirely. As Tony Williams attests in *Hearths of Darkness*, "[a]s an institutional prop of bourgeois capitalism, producing colonized subjects and reproducing ideological values, the family is extremely dangerous. A case may be made for

abolishing it entirely. But this argument is too rigidly dogmatic" (14). Instead, Romero suggests an alternative concept of family built upon shared values and identifications rather than governed by biological ties and patriarchal design. A pattern emerges; those few humans in Romero's *Dead* series, all white women and men of color (the one exception being the Irish-American character Billy McDermott, companion to the West Indian John in *Day*), who see the errors of their professions and the oppressions of the status quo, just might have a chance to unite and survive beyond the mayhem of the zombie apocalypse.

Alternative Family Values
28 Days Later...

Danny Boyle's *28 Days Later...* is one of the few contemporary zombie films to further this reform of the modern family in the 21st century, though the gender and race roles are reversed; the part of protagonist is shared between Jim (Cillian Murphy), a sensitive young white male, and Selena (Naomie Harris), a strong and initially unsentimental Black woman. Jim's survival throughout the film is wholly dependent upon Selena's strength and cunning. Over time, Selena adapts and modifies her survival strategies to meet the demands of shifting action and deepening relationships. When they join widower Frank (Brendan Gleeson) and his teen daughter Hannah (Megan Burns), Frank acts as a surrogate father to all of them until he is tragically infected with the zombielike Rage virus. Hannah shares her father's masculine-coded skills and interests as well as his compassionate and trusting personality, so she too defies gender stereotyping without becoming a Final Girl derivative.

Though *28 Days Later...* is similarly critical of governance structures, it invites viewers to reconsider the value of the family unit. When society is stripped of its citizenry and structure, the few remaining survivors must learn to reconstruct a newly conceived clan. When a naked emaciated male (Jim) awakens in an abandoned hospital, he immediately unhooks himself from several machines and disregards his personal well-being in an attempt to find other people. He peeks through horizontal blinds and calls out "Hello? Hello?" For several minutes, this is all he does. He leaves his room in search of someone, anyone. He tries all of the pay phones in an attempt to connect. Only afterwards does he search for sustenance, soon chugging a warm can of Pepsi he finds on the hall floor. This order of actions reveals how Jim's instinct to socialize and bond initially over-

rides his urge for food and survival after awakening from a coma. What, after all, is the value of survival without community?

Family in *28 Days Later...* is the strongest, contractive bond beyond one's own immediate survival. Each individual belongs to multiple communities or families. These affiliations help to construct one's moral identity, for better or for worse. The first infected to directly threaten Jim is a priest (Toby Sedgwick). Jim backs away and says "Father" with concern, but the priest continues his aggressive lurch, forcing Jim to hit him in self-defense. This reluctant action demonstrates that Jim's faith in his own value and survival is most important right now. "Oh, I shouldn't a done that" Jim says out of guilt and former loyalty to his religious upbringing and his respect for priests as "fathers" and "family" leaders. Moral obligation and religious law are not pure and essential, and the individual as well as the family unit need to remain flexible enough to adapt to the changing environment. Jim runs away from the church, literally and figuratively, thus attracting groups of infected to chase after him.

Jim is momentarily punished for abandoning his loyalty to the church, but soon finds compatible brethren in the fight against this rage-fueled world. As Jim runs from hordes of hungry infected, two figures cloaked in protective clothing throw Molotov cocktails to distract the infected and shout "over here!" twice, revealing the limited living now have an inherent obligation to protect one another. They lead Jim to their hideout in a convenience store in the London Underground. The pursuing infected makes slaughtered pig sounds, both likening them to beasts but also triggering guilt that they are an animal victim of human action and error. The rescuers reveal themselves to be a Black woman named Selena (Naomie Harris) and a white man named Mark (Noah Huntley). All three characters are close in age, twenty-something.

In an attempt to establish familiarity, the rescuers question Jim about his identity, introduce themselves, and then reveal the chain of events that led to their present predicament. Jim is the first living soul they've seen in six days. Jim asks "what about your family?" to which Mark replies, "dead. Like Selena's," prompting Selena to say "yours will be dead, too" with conviction. After another long pause, Jim says "look, I have to find them...." Selena says, "you'll go and comeback, huh?" When Jim says "yeah," she forcefully asserts that "no one ever comes back." Mark says "Lesson One: you never go anywhere alone unless there's no choice." Up until this point, Jim hasn't had the option of travelling with companions. Now, faced with the opportunity to establish a bond with other survivors, Jim is initially hesitant. His devotion to his own preservation is the only

reliable relationship he has been afforded. Mark quickly realizes that they are not getting through to him and says, "we'll go find your dead parents together, okay?" The shot cuts to an eerie, but promising, yellow sunrise symbolic of the hope of community. A high tracking shot follows the three survivors as they walk away along the train tracks, in triangular formation, symbolic of the strength of trinity and of a newly contracted bond that has the potential to transcend traditional religious congregation and biological family.

Initially, the bond with Jim's birth family overrides this nascent community affiliation. The inside of his boyhood home is quiet and awash in a soft yellow glow. As Jim slowly ascends the stairs, he reels and covers his nose. It is obvious someone has died in the house, and this fact solidifies the audience's empathy with and loyalty to Jim as the protagonist. Jim bursts into the master bedroom to find his dead parents cuddling in bed. His mother holds a photo depicting Jim as a child. Pills and alcohol, evidence of their deliberate suicide, litter the nightstand. Jim covers the deceased with sheets and takes the photo. A few minutes later, Jim turns the photo over and discovers a note that reads, in feminine handwriting, "Jim,/ With endless love, we left you sleeping./ Now we're sleeping with you./ Don't wake up. X." Jim's mother and father wanted to ensure that their devotion to their only child carried into the afterlife.

Mark and Selena decide it is safest to stay in Jim's family home for the night; symbolically, they are initiating an alternative family for this recent adult orphan. But Jim, still clinging to his deceased parents, lights a candle to reminisce in the kitchen and thus attracts infected to break in. Mark is bit, and Selena swiftly kills him while Jim watches in horror. Jim and Selena set off again. They wander the city until they see a high-rise apartment decorated with blinking Christmas lights, which are representative of a guiding light for family gatherings. Once again, the infected are in hot pursuit. An armored man keeps the rabid at bay as he ushers Jim and Selena into his high-rise apartment. The man, Frank (Brendan Gleeson), lives there with his teenage daughter, Hannah (Megan Burns). Frank exclaims "This is cause for a celebration!" several times. They share their food and shelter with Jim and Selena.

If this new group identity is established—through development of shared beliefs, consensus, and trust—biological and cultural differences between peoples are revealed to be wholly arbitrary. Overnight, Selena tries to convince Jim to escape since she fears that an older man and a young girl will slow them down. Jim insists "they're good people" as the camera gaze hones in on their family photo. Jim acknowledges that he'd

be dead by now without Selena's help, and in doing so, she seems to understand the subtext here is that they, together, can and should do the same for Frank and Hannah. In the morning, Frank says, "Hannah and I do need you more than you need us. We can never make it on our own," to which Hannah argues "we need each other" just the same. The foursome packs the car and hits the road together.

Selena is still apprehensive about expanding her trusting bond to include Frank and Hannah. Several consecutive shots show Selena standing or sitting apart from the group; her reliance is returning to herself. This may be due, in part, to the fact that she doesn't yet share any standpoint with the other characters. She is the only Black woman. Jim and Frank are both white men, and Hannah shares blood ties with Frank. Individuals are marked for group memberships due to socially constructed expectations of race and gender, limiting the choices one has in defining and identifying oneself. The ladies bond for the first time during their shopping spree in the abandoned supermarket. Their shared position as women, regardless of race, is revealed. In this way, the power and importance of identity affiliation trumps mere horror and survival as the apocalypse continues.

Once immediate survival is accomplished, identity plays an important role in the rebuilding of community and offers hope for future solidarity. After this scene, Jim, Selena, and Hannah are seen together in an extreme close-up in the back of the car. Hours later, the characters stop for gas. Jim wanders inside to find several dead victims of the infected, including a baby corpse which makes Jim wince and whisper "Oh Jesus." A young infected boy attacks him, and Jim hesitates before killing him. The gaze cuts to a shot of young Hannah waiting in the car. Imagery of children throughout the film builds the theme of family and the parents' role of protecting and caring for them. Next, Jim, Hannah, and Selena picnic in a triangular formation. They're laughing when Frank calls their attention to a pack of wild horses. "Look," he says, "like a family!" Minutes later, during a private walk, Selena admits "I was wrong." "About what?" Jim asks. Selena says, "all the death, all the shit. It doesn't mean anything to them because she's [Hannah] got a dad and he [Frank] has his daughter. So, I was wrong when I said 'staying alive is as good as it gets.'" Jim says, "you see, that's what I was thinking." Selena steals a kiss then quickly apologizes. "It's all right," he says, "you can keep it."

These two scenes work together to foreshadow that Jim, Selena, and Hannah will form a new, alternative family during this post-apocalypse.

That night, in Jim's nightmare, he again shouts "Hello!" repeatedly and without receiving response. Frank wakes Jim to tell him he's just having a bad dream. In his stupor Jim says "thanks, Dad" and falls back asleep. Jim is in limbo between being a child/son and becoming a man/father. In the morning, back in the car, the sun shines and an angelic chorus sings. Hannah and Selena are seen through the rearview mirror smiling and playing cards.

The small group shares peace and strengthens their bond in the car, but the fires lining the distant horizon are a warning that this new family unit is about to be seriously threatened. They arrive to the radio's alleged safe-zone to find an abandoned military encampment. Ignoring Selena's protests, Frank stubbornly refuses to flee the promised place, separating himself from the group for a few minutes. A black crow's cawing attracts his attention; when he looks up to investigate, a lone drop of infected blood falls into his eye. He immediately tells Hannah he loves her. Concerned, she approaches her distraught father. Frank violently pushes her away in an attempt to keep her safe, demonstrating the conflict between love and loyalty. He tries to fight off the infection, but it is no use. Jim hesitates in his obligation to kill Frank in order to protect Selena and Hannah. Shots from a nearby sniper take Frank out.

A military convoy drives the three remaining protagonists to their compound; their alternative family unit is tested when this larger institutionalized brotherhood attempts to absorb it. The castle compound is run by Major Henry West (Christopher Eccleston). A few scenes later, Selena and Jim whisper while Hannah naps. "How's she doing?" Jim asks. "She's lost her dad, that's how she is," Selena replies. Selena starts to cry, showing vulnerability for the first time. Jim tries to console her by saying that Hannah is strong and she'll be able to cope. "I don't want her to have to fucking cope," Selena cries, "I want her to be okay." Selena is mothering naturally now that Hannah is orphaned. Jim kisses her, and for the first time, they are physically intimate.

Selena and Jim automatically assume responsibility for Hannah after Frank dies, and together they form a blended family without any biological connection. When the men at the military "safehouse" reveal their intention to rape and impregnate Selena and Hannah—to raise morale amongst the troops and to secure a future for the human race—the pervasive sickness of sexism, rape culture, and male entitlement in the modern age is thoughtfully critiqued. In the film's climax, Jim learns to adopt reptilian instincts in order to defeat the other male antagonists. While the film's feel-good, happy ending is often harshly criticized and not without fault,

28 Days Later... challenges patriarchy and hyper-masculinity, reconceives the family unit, and thus reflects the sociopolitical concerns of the post–911 world as it carries forth Romero's progressive agenda to contemporary audiences.

The Uprising of Women, Men of Color and the Undead

With each film in the original *Dead* trilogy, the female leads progress the deeper they survive into the zombie apocalypse. That is, Barbra in *Night* is our first witness to the walking dead, and she exhibits the least fortitude in the face of this unearthly uprising. The longer Fran survives in a world overrun with zombies, the smarter and stronger and more dynamic she becomes. By the time we meet Sarah, it is clear that zombies have been devastating the planet for quite some time, as whole cities are abandoned and blighted and underground military bunkers house scientific research teams sent to study the plague. While Natasha Patterson argues that it is the zombies' "presence in the films that enable his female characters to be so demonstrably aggressive and unapologetic" ("Cannibalizing Gender and Genre" 111), I see the zombies as catalysts for exposing these women to the multiple violences and oppressions that have always been ruling and ruining their lives. The zombies help to expose the dangers of unchecked masculinity and patriarchy by breaking through their stronghold on modern capitalistic society.

The undead population grows in number and power exponentially with each film, so the few remaining living characters are demonstrative of an unnatural selection process through which only the fittest—the most dynamic and binary-breaking and socially progressive—people survive. Since *Night of the Living Dead*, the main survivors of Romero's original *Dead* trilogy include the white female lead and the Black male protagonist. In *Dawn*, Fran, her unborn child, and Peter escape the mall in the helicopter and fly off together into a new day. Only those who have compassion and the ability to adapt alongside one another, and the overwhelming Other, can endure. A new, blended family is born— one not reliant upon race, ethnicity, biological ties, or a heteronormative father-figure—giving hope to a new generation and future in which equality and empathy triumph over power, patriarchy, and hegemony. In this way, the zombie and living male antagonisms prevalent in these

films effectively dismantle the traditional, heteronormative family dynamic. The white male "hero" is exposed and expulsed. In other words, men too steeped in Western traditions, too blinded by consumerism and institutionalized violence, are figuratively and literally eaten alive.

They are the real monsters.

Of Monsters and Men

Flipping the Script on Masculinity and Monstrosity

The gruesome new monsters in writer/director George A. Romero's terrifying vision gave audiences such a shock that many were literally afraid to leave their seats after the closing credits ran and the lights went up. People freaked out. They covered their eyes, clung to the arms of complete strangers, and screamed at the top of their lungs for the nightmare to end. Then, when it finally did, they turned around, bought another ticket, and went back in for more…. The modern zombie was born.
—Matt Mogk, *Everything You Ever Wanted to Know About Zombies*

"They are us. They are extensions of us. They are the same animal, simply functioning less perfectly than us…. They can be tricked into being good little girls and boys.
—Dr. Logan, *Day of the Dead*

Flesh-eating ghouls. The living dead. Undead. Rotters. Stragglers. Walkers. Skels. Zack. Zs. Whatever they're called, zombies are everywhere and they're here to stay. This undead creature has risen, spread, infected global audiences, and overrun classic monsters to become the most prevalent and popular monster in the 21st century. The zombie has evolved well beyond Matt Mogk's "litmus test"—from a "relentlessly aggressive," biologically infected human corpse" (6–7) that travels in hordes—into a sympathetic character imbued with individuality, a capacity for learning, and a growing humanity.

The modern zombie first broke free from the Haitian lore master-slave narrative to become its own entity in Romero's *Night of the Living Dead*. We first witness this new incarnation, Romero's principal "flesh-

eating ghoul," in the cemetery where Barbra and Johnny make their annual visit to their long-dead father's grave. In the distance, a tall and lanky coded-male figure lumbers about, stiff and uncoordinated but otherwise entirely human-like. Once close enough, he lurches at Barbra with outstretched arms. She manages to escape his bony embrace, but her antagonistic brother Johnny isn't so lucky. By becoming the first victim of the first modern zombie, an important parallel is drawn between the whiny and cruel young Johnny and his undead attacker. They are both dangerous. Aggressive. Infected with rage, with violence and an insatiable drive to consume. The zombie and the living male character become nearly indistinguishable.

But unlike the heteropatriarchal males we meet in Romero's original *Dead* trilogy, the zombie develops dramatically from the lumbering ghoul of Romero's *Night*; the distinctly dressed zombies in *Dawn* become sympathetic creatures saturated with individuality, and Bub in *Day* emerges as an intelligent and heroic character. That is, as his *Dead* series develops, Romero introduces us to more individualistic and empathetic zombies who challenge our perceptions of ourselves and the Other in remarkable ways.

Other filmmakers continue to modernize and manipulate this iconic monster. Since Danny Boyle's *28 Days Later...*, zombies have become fast, rabid, indiscriminate killers, a trend perpetuated by notable works such as Zack Snyder's *Dawn of the Dead* remake and the ongoing *Resident Evil* and *Left 4 Dead* franchises. In Grace Lee's mockumentary *American Zombie* (2007), zombies are high-functioning citizens of Los Angeles who rise up to fight for their inalienable rights. *Deadgirl* begins with only one zombie, a beautiful but undead naked female found shackled to a table in an abandoned mental institution. She later becomes a victim turned heroine when she avenges her maltreatment by a gang of teen boys. The BBC's complex reimagining of the zombie for *In the Flesh* mini-series, as a personalized and persecuted minority of the human population, is original and provocative enough to warrant its own examination.

To reveal the groundbreaking work Romero did to create and thereafter revise and humanize the modern zombie monster, I must first expose the common misconceptions of the sci-fi zombie, touch upon the individualistic zombies in *Dawn*, and then delve deeply into the unprecedented characters of Bub in *Day* and Big Daddy in *Land*. This way, the groundwork will be paved to open an examination of a few influential British and American zombie works since Romero's *Dead* series as they continue to progress radical and dynamic undead protagonists.

Not only do zombie films offer progressive and gender-binary defiant females and boundary-breaking monsters, but they also hyperbolize the monstrous nature of traditional conceptions and performances of manhood. As early as Romero's *Night*, masculinity and heroism are revealed to be incompetent, violent, and oppressive. This progressive social criticism thread is carried through the next two installments of the *Dead* series and continues in the best zombie cinema and television today.

Unlike the leading male roles in other popular genres, the perennial principal men in sci-fi zombie films are difficult to identify with or aspire to once we witness their inability to adapt to the apocalypse and to commune with other survivors. Brother Johnny in *Night* is immediately unlikeable. He complains about visiting his father's gravesite, and he teases and taunts his sister for demonstrating respect and devotion to the dead. Since their father has been deceased for over a decade, the breakdown of Barbra's family is already clear. Soon thereafter, when Johnny tries to intervene in his sister's attack, he is immediately overwhelmed by the graveyard ghoul and Barbra is abandoned to fend for herself. As I have already argued, she proves to be quite resourceful when on her own, but reverts back to the passive and dependent position upon Ben's abrupt and aggressive arrival to the farmhouse.

This flipping of the conventional male-hero figure begs close examination; as the zombies evolve, the living patriarchal males devolve into these films' actual antagonists. In *Night*, the lone African American Ben is revealed to be the tragic hero while Barbra's brother Johnny is one of the main villains, both when he is alive and after he becomes undead. Literally and symbolically, the interior of the home becomes a prison ruled by the male head, so when another dominant male emerges from his hiding place in the cellar, great conflict arises over which man is in control. Harry Cooper, the white husband/father figure becomes the main antagonist of the drama that occurs within the farmhouse. This fight for dominance and dominion between Ben and Harry Cooper proves destructive. The undead family members soon seek revenge upon the living. Barbra is attacked by her original antagonist, Johnny, and Mr. and Mrs. Cooper are devoured by their zombie-daughter Karen. Ben, the only character with no known family affiliation to speak of, is the only member of the household to survive the night. Ultimately, the all-white male law enforcement officers, in their attempt to clear the territory of the zombie threat, epitomize the apex of horror when they shoot Ben dead at the end of the film.

Repeatedly, Romero's original *Dead* trilogy unmasks the malevolence of the white supremacist hetcropatriarchy. Other films following in his

footsteps, particularly Marcel Sarmiento and Trent Haaga's *Deadgirl*, illustrate the devastating impact masculinity and its assumed entitlements have upon modern society. Therefore, these works uphold and develop the social protest potential of the modern zombie film as an agent for dismantling conventional and stereotypical representations of men and monsters in popular culture. My aim is to build upon the foundational scholarship of Robin Wood, Tony Williams, Kyle Bishop, Kim Paffenroth, and Stephen Harper regarding the power and value of zombie cinema, and to adapt their work to newer, often overlooked iterations of the modern zombie. The majority of gender and zombie genre theory focuses on representations of women in horror and most zombie scholarship concerns itself primarily, sometimes only, with Romero films at the negligence of other works. While Romero is clearly owed reverential credit for propagating and evolving the gender and zombie representations, one of my contributions is to broaden the scope of zombie scholarship to include other foci and films/filmmakers at work within the field.

This chapter first unearths the abilities and limitations of Romero's original ghouls, next examines the roles individuality and gender play in the construction of the zombie as monster, and then exposes the radical readings the undead provoke as the zombie evolves over time and in other filmmaker's hands. A discussion of how the dismantling of the conventional male hero and his patriarchal organizations manifests the revolutionary impulses of the humanized zombie figure: undermining white hegemony, heteronormativity, patriarchy, and late capitalism. When the genre moves away from the radical representations of monsters and men, the zombie grows in popularity but loses its social protest thrust.

Autopsying the Modern American Monster

It is necessary to briefly illustrate and debunk some of the common myths about the modern sci-fi zombie by providing an in-depth understanding of the capabilities and limitations of Romero's original "flesh-eating ghouls." In *Night*, the walking dead are made up of common country folk, local to the area near the farmhouse where the few living make their last stand. These zombies are of the slow, shambling ilk: recently turned by a contagion (allegedly carried to Earth by a space probe), with stiff appendages, clad in pajamas, business and birthday suits. They instinctively pursue the living driven by a hunger for human flesh.

In small numbers, they seem quite easy to escape and ignore. Modern

audiences tend to find these ghouls to be rather silly and comical; after all, they can be avoided and eluded with a brisk walking pace. They also seem to be intimidated by fire and unable to do much more than pound windows and doors with their open palms. Kyle Bishop argues that these zombies "are dumb and unintelligent creatures" wholly "lacking any intellectual capacity beyond basic instincts and motor response" (*American Zombie Gothic* 159). As Stephanie Boluk and Wylie Lenz explain in *Generation Zombie*, the zombie "is simultaneously a figure of pure automation, of programmed memory that infinitely loops. This undead creature is at once horribly animal, horribly machinic, and neither of these" ("Generation Z…" 7).

While experts within *Night* and those who review the film tend to assume that these creatures have no organization, no higher brain function, close observation reveals otherwise. The original cemetery ghoul tries to open the car door and smash in the window with a brick in his attempt to capture Barbra. It is clear he retains some basic understanding of automobiles and tools from his former life. Additionally, zombies congregate in groups. When their numbers grow, they quickly become an intimidating, overwhelming horde. The zombies overcome their fear of fire to eventually and systematically break through the farmhouse fortifications. They do not tire, rest, or quit. Inside the house, the ailing daughter of the Coopers, Karen, succumbs to her mysterious illness. Upon turning, she rises up, grabs a gardening trowel, and slaughters and feasts upon her mother. She not only recalls how to wield a tool as a weapon, but also seems to retaliate against her parents who clearly have a dysfunctional if not wholly abusive relationship. These original modern zombies deserve more credit and credibility. They are not merely the comical, brainless monsters they're often made out to be.

Romero progressively develops the individuality and intellectual capacity of his zombies with each installment in the *Dead* film series. In *Dawn*, the size and uniqueness of the undead population increase dramatically. As if participants in a Halloween parade, each zombie is marked by an exclusive costume that harkens to its interests, activities, or professions in life: a red softball jersey, a black habit, and an orange Hare Krishna robe (to specify a few). Though Bishop reasons that the zombies in Romero's first two films "are primarily 'othered' creatures possessing virtually no subjective, human qualities and encouraging almost no psychological suture with the audience" (159), I contend that these outfits enable the film's characters and audiences to relate to, or at least find familiar, the human beings within these monsters.

The passivity of the mall zombies further makes them less threatening and more pathetic. In other words, the zombies in *Dawn* become quite sympathetic creatures. These individualized zombies do not appear to be relentlessly aggressive as Mogk conjectures; they often mill about the mall aimlessly as if window-shopping, and they lounge outside the department store even though a potential meal sits mere inches away. As I covered earlier, Fran even learns to empathize with the softball zombie who sits across the glass partition from her as she thoughtfully loads her pistol. She later frees the zombie nun whose habit gets stuck in the door jamb, and the nun meanders away. Therefore, the viewer is invited to "suture" and identify with Fran and Peter, who both in their otherness learn to identify with the zombies.

Dawn's zombies are mainly aggressive towards the living humans who demonstrate violence towards them, and yet most characters within the film fail to recognize this tendency. One medical expert asserts that the zombies demonstrate some mental capacity, but assumes it to be wholly basal. When asked about zombie intelligence, Dr. Millard Rausch (Richard France) replies, "Intelligence? Seemingly little or no reasoning ability, but basic skills remain [and] more ... remembered behaviors of normal life. There are reports of these creatures using tools. But even these actions are the most primitive; the use of tools as bludgeons and so forth." Though he admits they have some mental function, Dr. Rausch argues "these creatures are nothing but pure, motorized instinct." And yet when the Hare Krishna zombie pursues Fran, he does so rather patiently and peaceably. She keeps him at bay with harmless flares as she retreats up a ladder, and he pitifully appears to want to convert her to his ways as he must have in life, approaching strangers with his holy message. When the men come to the rescue, Peter convinces Stephen to lower his weapon. They both emerge from the confrontation alive, though Fran is shaken and the Hare Krishna is knocked unconscious and removed from their private quarters. By the end of the film, it is evident that only the living humans who can see that these zombies are more than just moving targets are spared. That is, those who revel in their slaughter are effectively dismantled and devoured.

Zombie scholars too often gloss over how Romero's zombies individually act and react in favor of focusing on what they collectively represent in terms of cinematic theme and social commentary. Discussing *Dawn*'s undead, Bishop states, "[i]n a disgusting parody of human capitalism, the ghouls eat and eat and eat, yet they always want more" (*American Zombie Gothic* 140), yet it is clear they are actually somewhat selective in their aggression and appetites. As Shawn MacIntosh argues:

the fact that the zombies now had a physical and biological drive, and that some aspect of their mentality still existed (thus the need to destroy the brain core to really kill them), nicely conflated the underlying themes that zombies had long represented; the cherished idea of life after death and the connection between our physical bodies and what we consider our souls or spirits, which in secular Western terms translates into "thought" or "mentality" ["The Evolution of the Zombie" 9–10].

But the zombies obliterate cherished assumptions about the afterlife and radically undermine the connectivity between body, mind, and soul. As Paffenroth suggests:

[z]ombies are frightening because they are depicted as killing and eating their victims, but so do most threats in the horror genre (sharks, serial killers, viruses). Zombies are monstrous versions of human beings, but so are lots of monsters (vampires, werewolves, mutants). Zombies threaten the complete overthrow of civilization as we know it, and possibly the end of all human life, but so do asteroids, meteors and plagues. The zombie threat is made worse by the fact that their victims then turn into the creature that attacked them. This too is similar to other monsters (werewolves and vampires) and also similar to the sub-genre of infection/plague films. In the case of zombies, however, this may carry a greater sense of dread and revulsion: vampires and werewolves can be seen as desirable, potent, intelligent, virile creatures whom one might like—in some ways at least—to become; a mindless ghoul condemned to wander aimlessly across an empty, ruined earth seems much less attractive [*Generation Zombie* "Zombies as Internal Fear or Threat" 18].

While zombies do share many characteristics with other horrors and monsters, Paffenroth draws these conclusions using only the original and simplest iteration of Romero's "ghoul" while overlooking how much this figure has already evolved. Zombies are terrifying for reasons beyond their ability to turn us into them.

Zombies represent more about how we are in life rather than in death and the afterlife. They teach us that we are, in life, already zombies. They reveal what hides beneath our humanity and drives our physical impulses and mental desires. They provoke us to think more deeply about our problematic social constructions and their multiple oppressions. Regarding the "thinking" of the horror films of the 1970s, including Romero's *Dead*, Robin Wood stresses how these political texts "can lead logically only in one direction, toward a radical and revolutionary position in relation to the dominant ideological norms and the institutions that embody them, and such a position is incompatible with any definable position within mainstream cinema (or even on its exploitation fringes); it is also incompatible with any degree of comfort or security within the dominant culture" (Wood 91). Zombie films can even inspire us to celebrate our dif-

ferences. If that is not "radical and revolutionary" for horror as well as media in general, I don't know what is.

THINKING ZOMBIES

Zombies have the ability to expose how our higher reasoning abilities fool us into feeling justified in our prejudice, oppression, and violence towards those who are only slightly different than the dominant norm, be it women, men of color, or the living dead. Romero's *Day of the Dead*, the film Robin Wood refers to as "The Woman's Nightmare," hyperbolizes the antagonisms the female and the zombie face in their dealings within male-dominated spaces and professions; that is, in an underground bunker and a scientific lab filled with scientists and military personnel. The ragtag band of soldiers imprisons dozens of zombies kept "alive" for scientific study. Every so often, a handful of zombies is caught and transferred to Dr. Logan's lab, where the lead scientist dissects, mutilates, and hooks these reanimated bodies up to various machines. Though the primary objective for the scientific team's study was to find out what causes this plague, Dr. Logan becomes obsessed with figuring out how to train and enslave the living dead. His star pupil is Bub (Howard Sherman), an extraordinary specimen who exhibits the ability to recall and relearn knowledge from his former life.

Bub represents the extraordinary leap Romero takes by transforming his utterly familiar and uncanny modern zombie into a true monster-protagonist. When we meet Bub, he is dressed in fatigues and shackled to the wall of an exam room by his neck. In other words, he is visually marked as a both soldier and as a prisoner-slave. Dr. Logan (Richard Liberty) names him "Bub" because "that's what the club fellas used to call my father," who was a successful surgeon. The fact that Logan names this remarkable zombie after his father resonates on a few levels: Logan identifies with Bub's intelligence, finds him utterly familial, and expresses his oedipal drive to conquer the beast. To test Bub's abilities, Logan gives him a safety razor and a toothbrush to "play with." A copy of Stephan King's *Salem's Lot* (a novel about vampires taking over a small town) rests on the table in front of him. Bub quickly holds the razor to his cheek in front of a nearby mirror, a clear indication of his former-life recall. Bub then picks up the book, examines it, and shuffles through its pages. "He remembers!" Dr. Logan exclaims, "He remembers everything that he used to!"

What is remarkable here is how Bub not only demonstrates retained knowledge and intelligence, but he also does not seem to exhibit the drive

to consume human flesh. As Sarah exclaims, "He doesn't see Logan as ... dinner." Even when Rhodes and his henchman Steel arrive, guns drawn, Bub continues to examine *Salem's Lot*. Logan reassures Rhodes that Bub is "docile." Logan then hands Bub a telephone. After fumbling with it for a minute, Bub raises the receiver to his ear. "Say 'Hello Aunt Alicia!'" Logan pleads. When Bub does exactly that, Rhodes drops his weapon and Bub drops the phone. According to Bishop, with Bub "Romero creates a moderately sympathetic zombie, giving one central ghoul a name and asking audiences to see it—him—as a fully formed character and an active participant in the story" (159). But Bub quickly becomes more than a "moderately sympathetic" character, in this scene and in the film's climax.

With everyone looking on in disbelief, Bub raises his arm in salute of Captain Rhodes, signifying that he fully recollects even the social decorum and professional programming from his former life. Logan implores Rhodes to "return the salute [to] see what he does" but he refuses. "How are we going to set an example for them if we behave barbarically ourselves?" Logan asks. He then salutes and slides Sarah's gun, sans magazine, to Bub. Bub cocks, aims, and "shoots" Rhodes, likely for disrespecting him, and thus garnering the respect of the onlookers and the viewing audience. "It's the bare beginning of socialized behavior," Logan explains, "of civilized behavior. Civilized behavior is what distinguishes us from the lower forms. It's what enables us to communicate, to go about things in an orderly fashion without attacking each other like beasts in the wild." It becomes implicit in this scene that Bub is capable of more socialized behavior and civility than Rhodes and his goons. Thus, Bub elevates his rank from an anomalous scientific marvel—an ancillary and sympathetic character—to a true hero-protagonist.

Bub's status as the film's unlikely hero is solidified when he engages Rhodes in *Day's* violent climax. As Sarah and her two pals attempt escape by helicopter above ground, Rhodes retreats deep into the halls of the bunker, abandoning his men in an attempt to save himself. Bub and Rhodes come face to face in an empty corridor. Rhodes rushes to reload his weapon as Bub slowly raises his pistol as if in an old-fashioned duel. Bub shoots once but misses, and Rhodes flees like a coward. Bub's second shot catches Rhodes in the shoulder, causing him to drop his ammo, but he keeps running until Bub shoots him in the leg. Now partially crippled, Rhodes stumbles and lumbers—like a typical zombie—like the absolute monster he has always been. "Come on! C'MON!" he screams, taunting Bub to follow him. Rhodes opens a door at the end of the hall, releasing the throng of zombies behind it. In a reverse shot, dozens of grey hands

reach for Rhodes as they did in Sarah's film-opening nightmare. He turns back to Bub, who shoots him in the chest. Rhodes falls back into, and is literally swallowed up by, the sea of hungry ghouls. By taking down Rhodes, *Day's* real monster, Bub emerges as the first heroic zombie-protagonist.

Romero further advances the role of leading zombie as vengeful hero in *Land of the Dead*. In the film's opening sequence, we meet this formidable creature when the customer arrival bell rings at Big Daddy's Gas and Repairs. A giant, Black male zombie emerges from the shop in a gas station attendant's coveralls as if he is still on duty. He walks tall as he surveys his property, loyal to and prideful of owning and manning his small business even in undeath. Big Daddy is literally and figuratively a working-class monster; this is key when the overarching socio-economic criticism of the film develops. In his discussion of *Land* as a scathing post–9/11 discourse, Terence McSweeney explains:

> Romero takes care to show the zombies as coming, quite distinctly, from a lower social demographic and from a variety of ethnic backgrounds. He presents an oppressed social and racial underclass and offers a critique of one of the quintessential myths that have long stood at the heart of American identity, that of the classless society ["The *Land of the Dead*"109].

The residents, mercenary enforcers, and the creator of the Fiddler's Green (Kaufman, played by Dennis Hopper), a luxury residential and commercial complex at the center of the walled city in *Land*, are the film's actual terrorists.

In *American Zombie*, the monster hordes are cast as an outsider subculture made up of fully distinct undead characters with varying degrees of intelligence, humanity, jobs, desires, and politics. While the satirical and clever premise for the film seems progressive, the final act of the narrative falls back into stereotyping the zombies as cannibalistic savages and thus restores a normative viewpoint. *In the Flesh* features life in Lancashire years after a zombie uprising has been contained. The infected are quarantined, diagnosed with Partially Deceased Syndrome (PDS), medicated, rehabilitated, and then assimilated back into their home towns. The persecution and oppression a PDS sufferer experiences create an opportunity to instruct the real world in its negotiations of difference. *Deadgirl* introduces a single zombie into a typical suburban community to reveal how sickness and violence are not limited to the undead. One undead female, naked and held captive in the basement of a defunct medical facility, raises critical questions about gender performance, psychosexual conditioning, and the depravity of normative masculinity and its assumed entitlements.

The Monstrous-Masculine

More recent contributions to the zombie genre overtly address the eroticism and sexualization of the living dead. Marcel Sarmiento's *Deadgirl* gives us one female zombie who, through her victimization, reveals the sexual monstrousness of the heteropatriarchal male. In the film, teenaged outcasts Rickie (Shiloh Fernandez) and JT (Noah Segan) cut class and venture to the nearby abandoned mental hospital. After drinking alcohol and vandalizing the first floor, the young men decide to explore the underground tunnel system beneath the "nuthouse." Once they break through a barricaded cellar door, JT discovers a naked female shackled to an exam table and covered with a plastic sheath. When he reaches out to test her vitals, the "deadgirl" (Jenny Spain) sharply inhales. Rickie panics and tries to convince JT to "free the girl" and then flee the premises. After slowly peeling the plastic off her body, exposing her face and breasts, JT steps back and contemplates a moment before saying to Rickie "we can keep her." "Keep her?" Rickie whispers in disbelief. JT says yes, they should keep her, just for a night or two. Wide-eyed and lustful, JT licks his lower lip and says "Look at her. Man, I could spend all day lookin' at that body." He tentatively reaches out to poke her breast with his index finger despite Rickie's protests. Her eyes flicker at JT's touch. Rickie freaks out, so JT punches him in the face. As *Deadgirl* continues, we learn that the young woman is not entirely alive but she is impossible to kill. More importantly, the teen males' insatiable lust for sex and violence is revealed to be wholly atrocious.

The dominant heterosexual male urge to view, own, assault, penetrate, and conquer the female body is exaggerated and exposed to be *Deadgirl's* abject horror. The enslaved zombie girl is repeatedly victimized by the teenaged male's monstrous drive. Though JT is the overt perpetrator of misogyny, rape, and abuse in the film, Rickie is not impervious to the conflation of lust and violence, of sex and power, nor to the lust for male dominion over the female body. In some ways, Rickie's desire to vanquish Joann, his "dream girl," is equally disturbing in its subtlety. That is, though Rickie believes his affections and intentions to be pure and good (and when compared to JT's, the audience is primed to agree), it is clear from Joann that those feelings are not reciprocal. "Fucking grow up," she says to Rickie as she struggles against zombie infection.

Rickie's fantasy drive masquerades as true love regardless of Joann's consent and is indicative of the deeply-rooted conditioning to subjugate the female and her body as well as of male entitlement and the indoctri-

nation of rape culture in modern society. As Steve Jones explains in "Gender Monstrosity":

> *Deadgirl* certainly depicts violent heterosexual intercourse, and undoubtedly presents many more problems than it can possibly resolve. Such images may be easy to discount as misogynistic propaganda, but that perception only stresses how vital it is that we scrutinize and understand those representations [535].

Though I take exception with referring to the teen's actions as "intercourse" rather than overt rape (this is an unusual misstep in Jones' essay), the point remains that (despite the writer/director intentions for the film)[1] readings of this zombie-rape-revenge film are necessary and complicated. Jones explains:

> [the] fact that all of the film's central male teens engage in zombie-rape suggests that they are not a perverse minority, but the logical product of prevalent social pressures and/or unquestioned dominant heteronormativity. In that sense, films such as *Deadgirl* implicate the viewer (male or female) as part of an ideological system producing such attitudes in young people [533].

The film's disturbing and graphic content makes it difficult to watch closely. The film's refusal to provide closure is also noteworthy. *Deadgirl* is "thus a call to action" (Jones 534) to interrogate rather than ignore its provocation to grapple with issues of sexual oppression, inequality, and violence.

Though I agree with his larger conclusions about the lessons and value of *Deadgirl*, Jones' analysis of the teen male characters within the film necessitates scrutiny. To some extent, Jones seems to absolve these individuals of their heinous actions by making them out to be equally unwitting dupes of the system rather than fully conscious and complicit performers within it. He illustrates this argument by citing evidence for the lack of positive male role models in the young men's lives as well as their inherent immaturity and need for outside validation. Though Jones admits how "the males actively decide to become monsters, and thus bear the responsibility for that choice," he also seems to excuse their behavior when he argues that "[s]ince their machismo has to be validated by others, and hinges on arbitrary actions rather than principles, the teens not only do not have a coherent notion of masculinity to aspire to, but also cannot autonomously define themselves," and are therefore "zombie-like" (534). Jones herein suggests the teens are essentially infected by the diseased social system in which they have been poorly conditioned and raised. In an attempt to support these claims, Jones writes:

> [a]dolescence is not only a state of flux that brings out the worst in these individuals; it is also a point of vulnerability. As such it connotes a possibility of change. While

they make ugly decisions, there is at least the prospect that the teens can make better choices. Indeed, they seem to revert to stereotypical masculine behaviors (particularly aggression), if the discursive norms surrounding masculinity were amended, their behavior would also transform [534].

The complex assumptions at work within Jones' claims are slightly problematic and warrant unpacking.

Jones' suggestion that JT and his male companions are "zombie-like" initiates the idea that they share essential traits and victimhood with the deadgirl; that the state of their bodies and personhood is somehow thrust upon them from outside sources, just another tragic symptom of heteropatriarchy as is the female zombie. In other words, the teen males are merely the unfortunate byproducts of socially constructed notions of masculinity—who could not be expected to decide or choose to live differently—and thus invite some level of sympathy if not compassion. Even though Jones admits the males have the power to makes these choices, he simultaneously assumes healthier choices would be made if these teens had been raised by a healthier social system and parentage.

By focusing on the age and vulnerability of these males and assuming the choices and decisions they make to be involuntary or even necessary in their attempt to enact normative manhood, Jones deflects attention away from their horrific *actions*. These teens rape the deadgirl. Repeatedly. She is left shackled to the table as she was discovered since the guys know she will attack and/or flee if released. She is unable to verbally consent in her undead state, but she reacts negatively and obviously by moaning, pulling away, hissing, and biting. JT tries to kill her, with his hands and a gun, but fails and finds even more pleasure in the pairing of sex and violence. When the deadgirl's vagina becomes too dry and damaged from repeated assault, JT penetrates her pus-filled gunshot wounds instead. Other classmates need only rudimentary peer pressuring to join in. Though Rickie never rapes the deadgirl, in the end he chooses for Joann to be infected so he can finally have and keep her all to himself. In the end, everyone is infected. Everyone becomes a monster, but only the male teens had a *choice*.

Volition, or at the very least complicity, in monstrosity plays a key role in the analysis of men in zombie films and how their representations complicate classical Hollywood conventions. As Joan Mellen explains in *Big Bad Wolves*, "Hollywood has demanded that we admire and imitate males who dominate others, leaders whom the weak are expected to follow. The ideal man of our films is a violent one" (3). Since Romero's *Night*, the best modern zombie films challenge this notion. The men who exhibit

the mutability of gender and sexuality, who see and break the imaginary bounds of prescribed masculine norms, survive to see another day. Men who choose to uphold the rigid notions of masculinity and power are revealed to be monstrous, and are therefore devoured if not wholly expunged.

This challenge to normative masculinity is the defining and revolutionary aspect of the modern zombie film suggested but never achieved by related horror subgenres such as the slasher film. Though Clover makes a strong case for the empowering feminist project of the Final Girl in these films (which I attempt to challenge), having one pre-sexual and masculinized female protagonist fight off a trans-male antagonist is not sufficient for progressive social protest. In "Masculinity and Monstrosity," Klaus Reiser explains:

> the slasher in my analysis remains quite rigorously hegemonic, indeed often utterly (hetero)sexist, as can be witnessed in the standard punishment of sexually active women, the conflation of femininity with victimhood and fright, or the homophobic recoil from feminine men and other forms of queerness [389].

But when Reiser continues, he makes the mistake of packaging Romero's initial two installments of the *Dead* series in with the slasher genre as he denounces the radical potential of horror film; "In fact, if these films do realize a progressive potential at all, it is more likely to be a critique of the stifling bourgeois family (*Psycho* et al.), [...] racism (*Night of the Living Dead*), consumerism (*Dawn of the Dead*), [...] but is highly unlikely to be a profeminist project" (390).

While both the slasher and the zombie film tend to advance thought-provoking female protagonists and other non-normative gender performances, similarities and limitations end there. Zombie films extol rather than extricate these characters. Zombie cinema also villainizes those, typically white men, who fail to adapt to their radically shifting circumstances. Additionally, male-dominated agencies, particularly law enforcement, are represented as incompetent and needlessly violent. Remarkably, normalcy and order are rarely if ever restored before the final credits roll.

Breaching Brotherhood

After the dysfunctional family unit is dismantled, another male-dominated institution arises to supposedly save the day in *Night of the Living Dead*. At the break of dawn, law enforcement troops and volunteers

scour the countryside in an effort to clear the land of the living dead threat. Ben emerges from his basement hideout when he hears the band of brothers approach, but they assume him a ghoul and lynch him on the spot. Though technically law and order have been restored above ground, the audience is left disturbed by the blind cruelty of man and the violence of his institutions, in the home, and throughout white-supremacist authority.

POLICING *DAWN*

The domestic terrorism of the household and the extremism of law enforcement endure and develop in the opening act of *Dawn of the Dead* (and in the entirety of *Day*, as I detailed earlier). Following presidential orders to remove all citizens from private residences, a chorus of police voices hurls racial epithets as they set up a perimeter around an urban housing complex. Over a megaphone, an officer calls for Rodriguez, the leader of the complex, to open up and surrender. One squad leader, a small white male named Roger (Scott H. Reiniger), ignores the machismo of his brethren as he tries to calm a nervous rookie (Rod Stouffer) by encouraging him to tune out the aggressive and prejudicial attitudes of the veteran officers around them. Immediately, Rodriguez (uncredited) and his armed gang burst outside, and one of the tenants shoots the rookie dead with a perfect zombie kill shot to the forehead. This shootout ensues as SWAT teams rush in.

No one is here to serve and protect, but rather to overpower and win. Once inside, the SWAT team members don dehumanizing gas-masks, throw canisters of tear gas and bust down doors, shooting minority men, women, and children indiscriminately despite their defensive postures. Roger tries repeatedly, without influence, to get both sides to end the violent turf war. Officers and tenants alike murder each other and the innocent women and children in their way without prejudice. They become the clear monsters even when the film's first visualized zombies break free from apartment barricades.

Ironically, the young officers hesitate to shoot the first undead they encounter even though they've slaughtered and been slaughtered by their living opponents for several minutes. In one apartment, two rookies freeze upon seeing a bloody and footless male zombie writhing towards them on the floor. "Shoot it, man. Shoot it in the head!" one screams to the other. The zombie continues to approach, wriggling his way around a doll, an empty laundry basket, and a kitchen chair. The zombified wife appears

out of nowhere and a struggle breaks out. A black male zombie emerges unseen and unscathed behind the melee. He walks slowly back to his own apartment. His living wife/girlfriend frees herself from an officer's restraints to embrace her man as if she doesn't notice any difference in him. He wraps his arms around her, leans in affectionately, then bites off a chunk of her neck. She tears away from him, he gnashes at her elbow, and then he is taken down by a hail of bullets. In the hallway, the young officer who failed to shoot the first footless zombie turns his pistol to his temple and pulls the trigger as Roger looks on.

Even when fully removed from their respective professional affiliations, the band of four survivors establishes a new but familiar dynamic that proves to be equally misguided. The men jockey for power within the group, demoting Fran to an ancillary and dependent position. Once safely ensconced within the mega-mall, officers Peter and Roger colonize the concourse and plunder the shops while Stephen sleeps and Fran sets up house in the private storage area upstairs. When Stephen awakens to the sounds of the other men pillaging the mall, he grabs the only weapon in the upstairs quarters and flees to join in their consumerist revelry, thus robbing Fran of the only means to defend herself.

Materialism and Military Monstrousness *28 Days Later...*

Organized groups of predominantly white men (militaries, scientific conglomerates, religious congregations, media corporations, et cetera) prove to be even more dangerous and grotesque than any lone wolf in the struggle for survival. Rhodes and his goons represent the gross misogyny and violence of the military-industrial complex in *Day of the Dead*, and Danny Boyle's *28 Days Later...* projects this same critical complexion upon Britain's media, materialism, and the military in its post–9/11, post-apocalyptic world.

Violence of apocalyptic proportions suggests that morality and law are corruptible and that established police and military factions prove to be fallible in their attempt to protect both. The world before the outbreak in the film is already plagued with pandemic rioting resulting from violence in the media and mass-consumerism. The mass consumption of media propaganda is the opiate of these masses, doping the global citizens enough to ignore rising tensions and injustices occurring worldwide.

28 Days Later... opens with a choppy sequence of (actual) televised footage depicting police brutality and military violence in various coun-

tries. Throngs of violent protesters gain momentum: setting fires, destroying property, and forcing the military and police to retreat. James A. Clapp explains:

> [i]n plot renderings of these dystopic fantasies of the future, the city is often reduced to some awful primal state in which civilization [has] gone awry. Wiping the slate clean presents some interesting dramatic opportunities for exploring the notion that civilizations contain the seeds of its own undoing and the culprit is [...] the moral failings of its makers [3].

The camera hones in on an adolescent black male beating a battered car with a giant stick. The gaze in *28 Days Later...* then retracts to reveal this news footage is airing on numerous small televisions, an overt commentary on the impact and consequences of violence in the media upon its viewers, and then widens to reveal a distressed chimpanzee strapped to a bed who is being subjected to this graphic broadcast. In essence, the researchers are forcing this grave characteristic of human nature back into our biological ancestors, thus marking how little we have actually evolved. The surveillance camera feed on a closed-circuit TV shows a masked man breaking in to the Cambridge Primate Research Centre.

Various organizations of the living, defending their ideologies, fight against one another and feel justified in doing so. The small group of animal rights activists breaking into the facility, three men and one woman, are visibly disturbed by the inhumane experimentation upon these noble creatures; nonetheless, they too resort to problematic illegal activity and violence in name of their political act. A lab scientist (David Schneider) is startled by the intruders; he defends the scene when he asserts that "the chimps are infected, they're highly contagious. They've been given an inhibitor." After an incredulous pause he argues, much like Dr. Logan does in *Day of the Dead*, that "in order to cure, you must first understand." The scientist is implying that the lab's responsibility is to humans in an attempt to justify this unjust treatment of man's first cousin, the chimpanzee. "Infected with what?" demands one of the activists, to which the tech responds "rage." The lead activist (Alex Palmer) replies, "Listen, you sick bastard. We're going and we're taking your torture victims with us," again solidifying their loyalty to each other and their shared sense of morality which overrides their relationship with those working for the lab. The female activist (Bindu De Stoppani) opens one of the cages and the chimp rushes to attack her. Once bitten, the humans immediately (in approximately twenty seconds) exhibit the Rage infection: reddened eyes and deadly aggression. Ironically, it is clear that mistrust, bigotry, and wrath has plagued humanity long before the release of this manufactured virus.

Modern society's obsession with materialism and consumer goods has interfered with interpersonal loyalty and family relationships, causing this epic destruction. When Jim (Cillian Murphy) finally leaves the abandoned hospital to venture outdoors, the silence and stillness is truly unnerving. The streets are littered with worthless consumer trash: cheap souvenirs and soda containers. Jim continues to call out "Hello?" but nobody responds. He pauses in front of veteran memorial statues, symbolizing that humans have been destroying one another in the name of capitalism for generations. Moments later, he frantically collects paper money abandoned in the streets, clearly not processing its worthlessness. A bright billboard depicting smiling faces is a beacon in the distance. This is the first sign, literally, of any remaining humanity. But an advertisement is only an imitation of a constructed reality, and therefore it offers no substitute for companionship.

Separation of families—caused by war, materialism, and the media—is the root cause for and consequence of this society's decomposition. Jim picks up a newspaper with the headline "EVACUATION: mass exodus of British people causes global chaos" with subtitles including "Military ordered 'Shoot to kill'" and "UN to build giant refugee camps." Soon thereafter, Jim stumbles across a 9/11-like wall for posting notices about missing family members. A few minutes later, Jim enters a church; his desire for companionship defers to God when fellow humans aren't anywhere to be found. Inside he is completely silhouetted, representative of the fact that he is losing his human and social identity, as he passes graffiti that reads: THE END IS EXTREMELY FUCKING NIGH. This marks the end of civilization, an organized society ruled by social norms, morality, and law. A fly buzzing foreshadows the gruesome scene soon to be revealed.

The crowded congregation has committed a mass suicide in the church, demonstrating how their loyalty to each other and their shared but false beliefs; staying together as a unified community trumps their instinct to survive individually. This is an example of conflicting loyalties, to self versus to the community. In this example of a religious congregation, the blind faith and bond in some communities or families is still understood to be dangerous and destructive. Jim calls out "Hello?" again, alerting two infected to stand up in the church, their mouths gaping silently; the loss of language/speech distinguishes the infected from the living human. The infected have neither language nor reason; they have devolved. These zombies have one purpose, one driving instinct, to infect and devour the living.

Survival at all costs is the one remaining link between the living and

the infected, but the living have retained the capacity to understand, shape, and develop relationships with one another. Jim meets up with fellow survivors Selena and Mark (Noah Huntley). Mark is soon infected and Selena kills him on the spot, then she and Jim venture on until invited to join Frank (Brendan Gleeson) and his daughter Hannah (Megan Burns) in their protected high-rise apartment. Only a few days later, however, Frank too meets a gruesome and untimely death, so Selena and Jim take on care for Hannah as they follow instructions from a prerecorded radio message promising sanctuary at a military safehouse. Upon their arrival, Major Henry West (Christopher Eccleston) gives Jim a tour of the compound during which he says "secondary to protection our real job is to rebuild, to begin again." The last stop on their tour is a visit to Private Mailer (Marvin Campbell), an infected Black military man chained up in the yard. "The objective is to learn something," West explains. Jim is visibly appalled to see the military's heartless treatment of one of their own fallen soldiers. West's words mirror what the lab scientist said about the infected chimps at the beginning of the film. Later, when Jim frees Mailer, the action parallels the inciting incident of freeing the enraged chimp at the beginning of the film.

The other military personnel behave like unruly drunken teenagers, suggesting that a group of young men without a woman's guidance will quickly devolve. West acts like a reprimanding surrogate father to these men when everybody sits down to a formal candlelit dinner. West spits out the omelet the current cook (dressed in a frilly apron) prepared, then asks Hannah if she can cook. Jim, Hannah, and Selena seem tense at this gender-assumptive question. The military group reveals their expectations about the subordinate position a woman should fulfill within this pseudo-family. An infected intruder on the premises breaks up the strained dinner reception a few minutes later. A gunfight erupts outside.

28 Days Later... suggests that the notion of family can be misconstrued by those who find the word connotes a unit in which some exert power and others are oppressed. Cut to Selena and Jim in the grand hall. The military men return, from their battle with the infected, raucous and cocky. Mitchell says, "listen sweetheart, you aren't going to need this anymore now that you have me to protect you" and takes the baseball bat out of Selena's hand. He then holds the bat up as a phallic symbol. Selena rushes to take the bat back. The men are laughing. She says, "Fuck you." The man advances and says "Alright, how 'bout right now?" before grabbing and humping her. Jim tackles him. Major West breaks up the commotion and apologizes to Jim and Selena, offering a drink, but an empty apology is not enough to unify these two groups.

Major West quickly attempts to strengthen his bond with Jim by relating to him in private, confessional, man-to-man chats. West asks Jim who he has killed. "You wouldn't be alive if you haven't killed somebody," West insists. "I killed a boy," Jim admits reluctantly. Until now, this has been his (and the audience's) secret. "Survival," West says, "I understand." After a long pause, West confesses that he "promised them [his military men] women." Jim is shocked and disturbed. West tries to justify this promise as a symbol of hope that will curb the men's suicidal tendencies and boost morale. There's no hope, "no future," if there is no possibility of procreation, West argues, "women mean a future." This discussion invites an examination of West as the leader of this makeshift military family. It is imperative to recognize that, in addition to the fact that groups are situated within unjust power relations, similar hierarchical frameworks can exist *within* one particular group.

West soon suffers the consequences of his poor parenting and his inclination to use the two female characters as bribes. Now that Jim realizes his small family is threatened, he feels obligated to protect them. Jim rushes to the ladies to convince them to escape. West knocks him out cold. As Jim comes to, we see Hannah and Selena huddled together. West tries desperately to bargain with Jim. "You can be with us, but I can't let them go," West explains. It is clear that Jim will remain loyal to the women, so West imprisons them. Jim and Sergeant Farrell (Stuart McQuarrie) (the only military dissident) are locked in a basement cell and Hannah and Selena in a bedroom. Shortly thereafter, the two male prisoners are taken to the woods to be shot for their opposition. One of the shooters says "I'm gonna have the black one, and I'm gonna make her squeal." Again, once any member of Jim's new family is in danger, he feels obligated to defend. Jim escapes, handcuffed, and jumps the perimeter. He sees a plane fly overhead, another symbol of hope, and knows he has to return to rescue the Selena and Hannah.

Gender intersections can and will become more unified when sexuality is threatened due to the fact that male aggression is perhaps the most unjust power relation in existence. Inside, a group of men led by West force Selena and Hannah to dress up in the gowns belonging to the former lady of the house. Selena and Hannah scream as the men strip Selena. Selena convinces the men to leave the room so they can get ready as proper ladies should; "it's just polite." After they exit, Selena convinces Hannah to dope up on a handful of her pills so the inevitable sexual assault is easier to endure. "Are you trying to kill me?" Hannah asks. "No, I'm just trying to make you not care." This exchange is disturbing, but ultimately

protective. Like a mother, Selena is trying to preserve their mental health along with trying to protect Hannah's physical well-being. Their intersection of gender and sexuality has confirmed their loyalty to one another at all costs.

Now that their trust and loyalty has fully constricted to form a new family, Jim, Selena, and Hannah are ready to expand their circle to include other altruistic survivors. Twenty-eight days later, Jim awakens bathed in sunlight. He lies in a bed in a cozy countryside cottage. Birds chirp outside, and a plane is heard flying overhead. In another room, Selena sews together huge swaths of fabric. The three characters rush outside to spread their fabric HELLO across the lawn. The plane circles back. Selena smiles and asks Hannah, "Do you think he saw us this time?"

ERADICATING HYPER-MASCULINITY

Ultimately, the men who remain fully steeped in tradition and social constructions (like Mr. Cooper, Roger and Stephen, Rhodes and Dr. Logan, and Major West and his private army) that no longer function in a world with walking dead, who are unable to adapt and evolve as is now necessary, are marked for an inevitable downfall and brutal death. Noteworthy here is how the male characters in these progressive American zombie films need not be wholly horrendous in their actions to warrant eradication. Even those with decent intentions suffer the same fate when they fail to recognize and rise above their prejudices and blind consumption. In this regard, Romero and others' sci-fi zombie films transcend the good versus evil dynamic played out in story-telling since its inception. These films instead develop a new paradigm for gendered representation in film; they suggest new ways for conceiving of family and they promote a radical humanism for living in the real world.

A New Dawn for the Living Dead

The sci-fi zombie genre has evolved the depth and complexity of its unique monster over the decades since we witnessed the first "flesh-eating ghoul" in *Night of the Living Dead*. Romero and his protégés continue to revise and evolve this American monster in ways indicative of a culture progressing to accept and embrace individuality, variety, and difference. *Deadgirl* and its influential brethren have been instrumental to this evolution in their exposure of the monstrosity of conventional masculinity

as well as in their revelations regarding the horrors of hegemony, patriarchy, racism, sexism, misogyny, and rape culture still rampant in the new millennium.

To expose and indict the monstrous-male is to protest it, to raise social awareness of these horrors in the hope of fully transforming our culture into one of acceptance, equality, and empowerment for all beings. Of equal import is how, unlike the slasher and other subgenres of horror, these zombie films do not punish the deviances from normative gender performances. Surprisingly, these works castrate and penalize male characters who perform the conventional ideals of manhood. Furthermore, zombie cinema rarely if ever restores normalcy and order in favor of leaving audiences unsettled and contemplative. Once the zombies have risen, society as we've known it can never be reinstated since its very ideological foundations have been shattered if not entirely obliterated.

It is imperative to understand that the male sex is not depicted as inherently monstrous in any of these groundbreaking presentations of man. Instead, the socially constructed ideals and norms of masculinity are exposed as violent and dangerous, as well as the institutions built upon them. We learn that a balanced partnership between men and women, regardless of biology or race, religion or sexual identification, that embraces differences as strengths, is necessary for an enlightened humanity to survive and thrive in the zombie apocalypse. Fear not the zombies, for they will open us up to our mistakes. Fear not the Others, for they will give birth to a healthy future.

The only thing to fear is forgetting what we've already learned from zombie media.

CHAPTER 4

For the Love of Zombies

The Return of Heteronormativity in Zombie Works

As in the culture, so in the cinema: there are hostile and dissonant rumblings, but they are seldom allowed to enter the mainstream.

—Robin Wood, *Hollywood from Vietnam to Reagan...*

Throughout this project, I advocate the importance of maintaining complex and compassionate representations of both zombies and humans as demonstrated in Romero's *Dead* series. The zombies and the apocalypse they signify have and should continue to unravel Western heteronormative ideals and binaries. As Kim Paffenroth briefly recognizes, "Romero and other filmmakers use the 'fantastical' disease of zombies to criticize the very real diseases of racism, sexism, materialism, and individualism" and the "portrayal is so powerful and compelling in these films, that it is impossible to discount it as some thoughtless anti–American screed: it is a real, if extreme, diagnosis of what ails us all" (*Gospel of the Living Dead* 17–18). This "diagnosis of what ails us all" may be the catalyst for overcoming these grave societal ills, but recent trends on the big and small screen are corrupting this progressive power in favor of restoring a masculine American heroism more frequently associated with common action blockbusters, and of relegating women and characters of color to ancillary and antagonistic roles.

George Romero's original *Dead* series developed some of the most complex and progressive male and female characters, and thus instigated the convention of zombie films being just as much if not more about their living protagonists than the living dead. As Kyle Bishop notes, "Rather than making these protagonists into superheroes or larger-than-life sur-

99

vivalists, Romero shows them to be fallible and flawed human beings—but nonetheless charismatic and likeable" ("The Pathos of *The Walking Dead*" *Triumph* 5). The key here is that Romero did not have to create idealized and infallible characters in order to captivate and inspire viewers.

Recent blockbuster zombie films and television reveal a disconcerting return of heteronormativity and stereotyping as evidenced by such works as Zack Snyder's 2004 remake of *Dawn of the Dead*, *Warm Bodies*, and *World War Z*. Since the mainstreaming influence upon this genre is quite recent, little scholarly attention has yet to turn to these more recent zombie genre mash-ups, and few if any scholars acknowledge how these mainstream zombie films and television shows work to reinstate generic gender and race representations.

My primary aim here is to illuminate the ways in which gender norms and stereotypes in zombie blockbusters of late tend to reinscribe traditional conceptions of masculinity and family. These ever-popular works, masquerading as subversive zombie texts, provide a mass-produced product riddled with reductive representations designed to restore the male as hero and all Others as antagonists. Regrettably, truly complex characters, living or undead, are difficult to find and identify with in the contemporary zombie surge. Instead, in the presence of traditional heroic white male(s) and "scary" zombies, women and people of color are too often positioned as the most dangerous threats in the post-apocalypse.

21st Century Zombie Boom

Most agree that Danny Boyle's *28 Days Later...* was the catalyst for the zombie media renaissance in the 21st century. The film's fast, technically alive, rabid zombies work as a living metaphor representing current culture's growing concerns regarding pandemic viruses and terrorism. This shift from the shambling ghouls in Romero's *Night of the Living Dead* to the terrifically fast zombies seen today is not without controversy. As Peter Dendle explains:

[s]ome argue that in becoming faster and more articulate, zombies cease to be what made them "zombies" in the first place (as opposed to being crazed, virus-infected cannibals, for instance). In this seemingly frivolous debate over the definition of an imaginary creature, enthusiasts are implicitly arguing, to a certain extent, what elements of humanity are most frightening to distort or eliminate ["Zombie Movies..." 176].

As with any deviance from a beloved genre, changes to the classic modern zombies garner criticism. Nonetheless, *28 Days Later...* elicited widespread popularity and critical acclaim.

The film offers a serious social critique of contemporary society marred by endless violence, war, media consumption, and blind consumerism. Furthermore, the role of protagonist in the film is shared between Jim, a sensitive young white male, and Selena, a strong and unsentimental Black woman. Jim's survival throughout the film is wholly dependent upon Selena's strength and cunning. Throughout the film, Selena adapts and modifies her survival strategies to meet the demands of shifting action and relationships. The two become surrogate parents to young Hannah, recently orphaned after losing both parents to the zombie plague. So while *28 Days Later...* dramatically modifies Romero's ghoul, it upholds the complex representations of gender and family and social protest potential of his lasting legacy.

Around the same time, zombies made their literary mark with Max Brook's (son of Mel) *The Zombie Survival Guide* (2003) and *World War Z: An Oral History of the Zombie War* (2006)—the latter spent a month on the *New York Times* Best Seller list. Robert Kirkman and his collaborators started *The Walking Dead* comics in 2003 and hundreds if not thousands of authors have subsequently contributed their zombie tales to the medium. For one prime example, consider Colson Whitehead's *Zone One* (2011), a zombie novel passion project he wrote with his MacArthur Fellowship. Once popular culture is fully saturated with a monster genre, the mash-ups and parodies rise up too. Seth Grahame-Smith's popular *Pride and Prejudice and Zombies* (2009) novel was adapted for screen in 2016. Isaac Marion's mash-up between zombies and Romeo and Juliet, *Warm Bodies* (2010) became a blockbuster in 2013 and gave birth to the sub-subgenre of the ZomRomCom.

While there is no shortage of entertaining and valuable zombie media in the new millennium, the representations of monsters, females, and minorities in the most popular movies and TV shows necessitate close scrutiny. Upon closer examination, disturbing trends towards conservative and oppressive messages emerge from this once-subversive genre starting with Zach Snyder's *Dawn of the Dead.*

Heteronormativity as Antidote for the Undead Plague

Today's most popular and pervasive zombie films and television shows work to restore "normal" as a staple survival strategy; in order to

live in the zombie apocalypse, characters cling to traditional yet problematic relationships and belief systems in an effort to maintain some semblance of control in a chaotic world. In *Warm Bodies*, memories of idealized heterosexual love compel one young male zombie to fearlessly pursue the daughter of the military leader of the living. Through courageous acts of valor and loyalty, the hero in *World War Z* saves both his family and thus the world from total zombie annihilation. In AMC's *The Walking Dead*, survivors unanimously elect a white male Sheriff's Deputy to lead them in all decisions and endeavors (see Chapter 5).

These hyper-current zombie works reinstate heteronormativity as the natural guiding principle for negotiating the zombie apocalypse. Heteronormativity, according to Chrys Ingraham, is "the view that institutionalized heterosexuality constitutes the standard for legitimate and prescriptive sociosexual arrangements" ("The Heterosexual Imaginary" 204). A social byproduct of capitalism and patriarchy, heteronormativity produces "a hierarchy of heterogender divisions which privileges men as a group and exploits women as a group [… and thus] organizes difference by positioning men in hierarchical opposition to women and differentially in relation to other structures such as race or class" (Ingraham 206). This normalized white heterosexual hierarchy reigns supreme in each of the recent popular zombie screen stories.

In this section I focus on two particularly acute examples of how heteronormativity is reinstated as ideal—in Zack Snyder's 2004 remake of *Dawn of the Dead* and Jonathan Levine's *Warm Bodies*—not only through individual character beliefs and biases but also by the dominant narrative structure and ideology. Current feminist film theory and horror and zombie scholarship need to recognize and expose how popular zombie films and shows promote heterosexist norms and character representations as well as punish difference and deviation from them. Snyder's *Dawn* attempts to update Romero's classic for a modern audience but fails to deliver on its vital radical representations. *Warm Bodies* demonstrates how humanizing the zombie monster (another trope initiated by Romero) can be taken too far, thus rendering the progressive monster an agent for hetero-conservatism.

DAWN OF THE DEAD (2004)

Snyder's *Dawn*, like Romero's original, opens with a scene depicting its lead female protagonist at work. Unlike Fran, however, Ana (Sarah Polley) is portrayed in the subordinate position of a disrespected nurse work-

ing one hour beyond her standard shift. Once released, Ana drives to her home in a manicured subdivision, late for "date night" with her boyfriend Luis (Louis Ferreira). She finds him drinking alone in bed. She removes his shoes. They smooch and struggle to reclaim their evening. Eventually, they have sex in the shower which causes them to miss the first emergency broadcast warning of the zombie uprising.

Ana is depicted in service, to her lead doctor and her lover, throughout the opening sequence. Her sexual act is punished, since she and Luis are not aware of nor prepared for an attack by the zombified neighbor girl who appears at their bedroom door early the next morning. Luis rushes to attend to young Vivian (Hannah Lochner) but is quickly bitten. Snapping to action, Ana locks zombie-Vivian out of the room and puts pressure on Luis' fresh wound. She telephones for help, but the circuits are busy. Luis turns quickly, so Ana pushes him off and locks herself in the bathroom. Covered in blood, Ana cries out his name. Luis busts through the wooden door like Jack in *The Shining*, so Ana jumps out the window to find her perfect neighborhood engulfed in flames and chaos. She flees the area in her modest, white vehicle.

Ana's independent adventures are short-lived and end in failure. She is soon awoken in her crashed car by a physically imposing African American police officer. Kenneth (Ving Rhames), in full uniform plus loaded rifle, rescues the barefoot, pajama-clad Ana from the wreckage. They soon encounter a threesome of other survivors, and Kenneth exhibits the brains and brawn necessary to lead them to the relative safety of a nearby shopping mall.

Snyder's *Dawn* remake features fast zombies, men in power, and women in caretaking positions. Unlike Romero's *Dawn*, Snyder's group of survivors exceeds three men and one woman. While this larger character group exhibits diversity in gender, age, race, and sexual orientation, the characters fulfill their socially prescribed roles. Kenneth plays the part of the detached and reluctant leader, much like his predecessor Peter (Ken Foree) in Romero's original, capable of spearheading security and rescue missions during their extended stay at the mall. Unlike Peter, he spends much of the narrative threatening to leave the group to search Fort Pastor even though the other group escaped from there and insists everyone at the compound is already dead or undead. He changes his tune when he emerges onto the mall roof, bug-out bag and rifle in hand, and spots an older white man stranded on the top of a neighboring building. The two men develop a sense of brotherhood through humor, intelligence, and mental acuity as they engage one another in chess and sharp-shooting games using large cue cards to communicate.

Ana shares much of the spotlight in the film, but she never emerges as the formidable and pivotal lead character like Fran (Gaylen Ross) does in the original. Early in their time at the mall, Kenneth is surprise attacked by a zombie security guard, and Ana's quick grab and use of his rifle saves his life. She clearly has previous gun experience and is clearly accustomed with death. Her professional training also equips her with clear and quick decision-making and action. Like Kenneth, she is often called to the task of killing recently turned comrades by whatever available means, whether bullets or fire stokers. Nonetheless, Ana's primary role remains that of a nurturing nurse who tends to the physical and emotional needs of fellow survivors.

Though Ana's professional skills and personal characteristics are well suited to the needs of the group during their extended stay inside the mall, all her wound cleaning and patching does little if anything to stave off infection and eventual death and reanimation. Her grief counselling, though momentarily helpful, fails to impact any ultimate outcomes for her fellow characters. Unlike Fran, she does not demonstrate much capacity for adaptation, growth, or development throughout the narrative. Instead, she falls into a romantic relationship with Michael, the serial ex-husband, and he is the one responsible for saving her life as they make their eventual escape.

Deviances from the conservative agenda of heteronormativity are ultimately punished by brutal death in Synder's *Dawn*. The two main Black male characters, Kenneth and Andre (Mekhi Phifer), represent two unwavering character types: the officer and the criminal. Kenneth is a lone wolf while Andre's primary concern being a better father than his own. Andre, puts everyone in danger when he hides his infected girlfriend from them; when his blind loyalty to his immediate family erases his reason and his concern for the greater good of the community. His girlfriend, Luda (Inna Korobkina), a young pregnant Russian, is inevitably bitten before Kenneth meets up with them. Later, her baby is born a grotesque zombie, as if the narrative of the film is punishing her and Andre for bearing a child out of wedlock. Andre, Luda, and the zombie child jeopardize several lives, in fact. Norma (Jayne Eastwood), the older and masculinized female trucker who saved the majority of the survivors and drove them to the mall, is lethally shot by Andre after she kills zombie-Luda. In turn, Norma shoots Andre dead, which leaves Ana with the horrific task of slaying the monstrous newborn.

Norma is not the only character displaying a non-normative gender performance who is slated with a tragic fate. Later on, Glen (R.D. Reid)—

the former church organist who admits he is gay and can be seen donning and enjoying women's shoes in the film's second act—accidentally hacks the hypersexual and sexualized blonde woman, Monica (Kim Poirier), in half with a chainsaw when Kenneth momentarily loses control of their heavily fortified escape bus.

Snyder's *Dawn* appears at first glance to offer a faithful update of Romero's original vision and politics but instead drastically revises them through dramatic shifts in character and narrative. While its leading lady and black male protagonist tentatively survive the narrative, as did Romero's, these characters do so by upholding rigid gender and racial norms and ideals rather than overtly defying or evolving beyond them. Furthermore, their survival is contingent upon the repeated sacrifices of their white male co-stars, a few of whom give their lives to enable their companions' escape from the overrun mall. Ana's new love interest, Michael (Jake Weber), an older white male with three failed marriages in his past, later commits suicide on the docks to deter the zombie horde from catching the survivors as they flee by boat. White male antagonists to the group—including CJ (Michael Kelly) and Steve (Ty Burrell), who both exhibit narcissism and frequently espouse sexist and racist remarks—redeem themselves by submitting to the zombies, also enabling the surviving group's harrowing escape.

WARM BODIES (2013)

Though an entertaining flick, *Warm Bodies* humanizes the zombie to an extreme that works to reinstate and reinforce dominant, heteronormative ideologies. *Warm Bodies* follows twenty-something zombie protagonist R (Nicholas Hoult) as he evolves back into a living, breathing, beating heart, blood-pumping human. R, like the majority of the zombies in the *Warm Bodies* world, makes his home at the abandoned airport on the outskirts of a major American city. Most of the undead shamble endlessly through their mindless routines: a TSA Zombie (John Topor) waves his security wand over passing bodies, M (Rob Corddry) slouches over the bar, and zombie kids (Clifford LeDuc-Vallancourt and Billie Calmeau) ride the moving sidewalks. It is clear that these zombies maintain some residue from their former lives and habits, making them sympathetic monsters the likes of which haven't been seen in such large numbers since Romero's *Land of the Dead*.

R, who narrates the film in humorous and eloquent voiceover but struggles to communicate through his deteriorating body, exhibits even

more retention of and nostalgia for life lost. He inhabits his own passenger
jet and fills it with memento mori pillaged from the surrounding suburban
sprawl: snow globes, vinyl records, a turn table, and other bric-a-brac.
Occasionally R and M convene at the airport bar to grunt with one another
in some semblance of friendship. R kicks off the film's first action sequence
when he manages to croak "hungry," and they assemble a small troop of
zombies to venture out in search of human flesh. Even thoughtful zombies
need to feast.

In parallel, twenty-something Julie leads a small team of her living
peers on an armed mission for medical supplies, thus marking her as the
film's female protagonist. She is strong, smart, and adept with weapons,
so she appears to be akin to Romero's leading ladies early on in the film.
During this battle between the living and the undead, R kills Julie's
boyfriend Perry (Dave Franco). While savoring his brain matter, R inherits
Perry's love for Julie and immediately jumps to shield her from the vic-
torious zombie horde. Despite her meek protests, R smuggles Julie back
to his plane as if she is just another piece of his beloved menagerie. Once
Julie settles in her seat, R voices his mantra: "Keep you safe." R earns her
reluctant trust, so Julie temporarily surrenders herself to slumber.

Julie quickly loses her autonomy and thus reverts from a potential
Romero-esque radical female protagonist into a classic damsel in distress.
She stays in R's care for a couple days, but then attempts escape while he is
preoccupied in another area of the plane. Within moments, R notices Julie's
absence and rushes to save her from an encircling undead horde on the tar-
mac. The more Julie is saved, the more her affection for R grows. *Warm
Bodies'* heroic undead protagonist "marks the first mainstream feature film
that offers audiences [and onscreen co-star] a zombie they can really fall
for, the sweet and innocent 'R' (Nicholas Hoult), anemically attractive, who
knows how to treat a girl right—when he's not killing her boyfriend, of
course" (Bishop *How Zombies Conquered Popular Culture* 164). They even-
tually hold hands in front of R's zombie friends, and an evolution begins
within them. This symbolic gesture arouses sentimental memories of lives
and love lost for the sympathetic zombies who witness it.

The suggestion that budding romance can overcome great difference
and thus inspire others to embrace their empathy and humanity is perhaps
the greatest, progressive message of the film. Unfortunately, the film's main
storyline relies upon Julie's reversion to the role of a kept woman. Julie
exhibits the traits of a strong and independent leader early in the film.
She lives mostly on her own in her family's stately home, since her mother
was killed in the zombie uprising and her father is preoccupied with his

role as the General of the military guard for the humans' walled city. She leads expeditions into the city and demonstrates her ability to ward off danger (even if she cannot save her boyfriend Perry). Though she attempts several escapes from R, she fails to get very far on her own before requiring his help. This run and rescue game continues throughout the remainder of the film, resolving only when Julie completely surrenders herself—mind, body, and spirit—to R. This act of total submission is the catalyst for restarting R's heart and resurrecting him from his undead state.

Warm Bodies' clever and overt reimagining of *Romeo and Juliet* initiates a literal monstrous-masculine portrayal that could be considered radical if a disconcerting heterosexual romance were not the antidote for society's cannibalistic condition. As Kyle Bishop astutely warns in "The Romantic Zombie: *Warm Bodies* and the Monstrous Boyfriend":

> The problem with paranormal romantic fantasy such as *Twilight* and *Warm Bodies* […] lies in the messages such texts convey to young viewers, both male a female. These stories advocate that stalking a woman is an acceptable form of courtship, that dominant male behavior backed by the threat of violence and bodily harm is a normal expression of love and devotion, and that a woman can find common ground with a potentially dangerous partner by simply loving him enough or by becoming monstrous herself [*How Zombies Conquered…* 179].

Like Bishop, I too acknowledge that it might seem like an overreach to read a far-fetched zombie comedy with logic and concern, but even a genre mash-up like *Warm Bodies* must be held accountable for the potentially dangerous messages it imparts upon impressionable youth.

Since little scholarly treatment of this film beyond Bishop's chapter is yet available, the review of one popular film critic can offer some insight into why this film was ultimately so successful despite its problematic narrative. In his three and a half star review, Richard Roeper says, "I kinda love this movie. 'Warm Bodies' is a well-paced, nicely directed, post-apocalyptic love story with a terrific sense of humor and the, um, guts to be unabashedly romantic and unapologetically optimistic" (RogerEbert.com). Roeper lauds the film for finally showing audiences that there is more to the zombie than a blind drive to consume human flesh. "We almost never get inside the rotted mind of the zombie or see things from the zombie point of view. They're forever penned in as the Big Metaphor," Roeper argues, claiming that "[o]ne of the many exhilarating pleasures of 'Warm Bodies' is the flipping of that script" (January 30, 2013).

The problem is Romero and others have been revealing the greater depths and complexities of the zombie monster for decades. Though *Warm Bodies* issues a transformational shift in how the living characters

understand the residual humanity of the undead, from repulsion to sympathy, it does so by restoring stereotypical gender performances and lauding an oppressive heterosexual union. That is, the film renounces feminism in favor of resurrecting chivalry and male dominance. In other words, this act of "flipping the script" from one dominant narrative (that the zombie is always and only a monstrous Other) to another (the star-crossed heterosexual lovers) fails to fulfill the social protest act of breaking the sexual and gender binaries that continue to oppress on screen and in real life. Rather than blindly consuming regurgitated narratives masquerading as complex zombie texts, viewers need to recognize how the genre is now working against its radical sociopolitical origins. To truly flip the script on the zombie monster, depictions should continue to humanize the zombie without reverting to this misguided heteronormative extreme. Impetuous and abusive heterosexual romance is not the cure for what ails the human race in modern times.

The Return of the Living (White Male) Hero in World War Z

Like *Warm Bodies*, the film version of *World War Z* was also a successful blockbuster in 2013. The film targeted broader audiences with its PG-13 rating, mega-budget, Brad Pitt's lead billing, and action-packed production. The film received vastly divided critic reviews but has yet to garner much notable scholarly attention. Peter Travers of *Rolling Stone* writes, "Tension, not gore, fuels this zowie zombie apocalypse. *The Walking Dead* crowd may be bummed by the relative scarcity of rotting flesh and leaking pustules. But *World War Z* is still as smart, shifty and scary as a starving zombie ready to chow down on you, baby, you" (June 20, 2013). Like many other critics who give this film three or more stars, Travers assumes incorrectly that audiences are driven to zombie media solely by a lust for terror. Additionally, and unlike the *Saw* franchise and other modern torture horror, zombie films have historically issued more political critique and social commentary value and purpose behind their graphic eviscerations and entrails and have thus attracted a socially conscious crowd along with more typical adolescent aficionados.

World War Z, through its conventional gender representations as well as its U.S.-centric ideals, becomes a cookie-cutter American action film rather than the subversive cinema Romero originated. Max Brooks' book *World War Z: An Oral History of the Zombie War*, as the subtitle suggests,

invites characters from around the globe to share their harrowing survival stories, rife with personal conflicts, political conspiracies, psychological insights, and ethical dilemmas. Mark Forster's film adaptation chose instead to revise the tale to focus on one man's heroic race to save the world. Gerry Lane (Brad Pitt), motivated to protect his family and in turn the human species, jetsets from one country to the next in search of strategy or vaccine that will protect the living from the undead threat. Gerry Lane is the quintessential male protagonist on the age-old hero's journey, as film critic Matt Zoller Seltz (RogerEbert.com) recognizes when he explains how he is "every other character played by Robert Redford in the 1970s and '80s: noble, brave, calm in crisis, endlessly resourceful, kind to his spouse and children, respectful of authority but not slavishly so, independent-minded [but] not arrogant"; in other words, "a snooze" (June 21, 2013). Giving the film a terse two-star rating, Zoller Seltz also laments how Mirielle Enos' "talents are wasted" since this "Hollywood movie is content to cast her as a standard-issue Dutiful Wife" Karin Lane. He decries at the end of his review how "Forster has made a zombie movie for people who don't like zombie movies." Forster, however, created something more problematic than a popular film for the non-zombie-fan masses.

World War Z's dominant narrative structure and supremacist representations of men, women, and monsters necessitate careful analysis and disclosure before the zombie subgenre is fully absorbed into safer, more popular genres such as the action-adventure and the Western (as is the case with *The Walking Dead*) produced for the PG-13 masses. Additionally, today's enthusiastic consumers of popular zombie media need to be aware of how this once-subversive, social protest genre has abandoned the progressive political thrust of zombie narratives at their finest.

After an opening montage of news, daytime television, and nature program clips, *World War Z* develops a portrait of the "perfect" American family. Two adorable young daughters rouse Gerry (Brad Pitt) and Karin (Mirielle Enos) Lane from bed, prompting Dad to cook and serve a pancake breakfast to the whole clan. Gerry explains to younger daughter Constance (Sterling Jerins) "I quit my old job so I can be with you." She asks, "Do you miss it?" and after a pregnant pause, Karin looking on expectantly, he says "No, I like my *new* job." "But all you do is make pancakes!" Constance exclaims incredulously. While the former United Nations field agent turned non-reluctant, stay-at-home dad character has potential, the film quickly eradicates this progressive representation of masculinity and fatherhood in the next sequence.

Once the family leaves their suburban nest, the parents' gender roles and contributions revert to a dominant, heteronormative paradigm. Gerry drives as Karin engages in the kids' game of twenty questions. Gerry asks only two questions before guessing the correct answer and ending the game. Karin and Gerry then turn their attention to the traffic, helicopters, and pedestrians streaking past their car. Gerry turns on the radio as the news announcer discusses an outbreak of rabies that began in Taiwan. Karin asks if they can check the BBC station, but Gerry insists "You're not British anymore. Lost your accent a long time ago, except after two bottles of wine." As the streets become increasingly hectic, Gerry jumps out to survey the situation as Karin and the kids cry out in concern after him. Gerry hops back in the car and speeds after a truck that is smashing its way through the gridlock. They eventually crash in an intersection. Gerry checks to make sure his loved ones are okay, then leads the charge to escape the area on foot. He corrals his wife and kids towards an abandoned RV while observing the violent turning of one man into a zombie.

Gerry's immeasurable talents render Karin almost entirely obsolete. He takes charge, makes quick decisions, leads action, protects family, and learns the process of the infectious outbreak simultaneously. As Gerry drives his family away from the city chaos, Karin tries to soothe older daughter Rachel (Abigail Hargrove) as she has an asthma attack. "Gerry," Karin says, "*we* [emphasis mine] left my purse in the car." Gerry says there is a spare inhaler in Rachel's backpack, and as Karin walks toward the front of the RV to locate it, she inquires, "Do you want to be with her?" Gerry abruptly pulls over and rushes to Rachel's aid. Karin can't find the inhaler, but Gerry is able to talk Rachel into calmer breathing while concurrently consoling Connie and directing Karin to the nearest pharmacy. In his service to the United Nations, Gerry has acquired remarkable protection and survival skills. In his short stint as a stay-at-home dad, he has also surpassed Karin's abilities in caring for the children.

Idealized fatherhood becomes an agent for negotiating safety in this zombie outbreak. Gerry grabs a shotgun from the RV, then grabs Rachel's hand, before they run into an NJMart teeming with frantic looters. Inside, the parents split up to grab medication and provisions for the family. In the pharmacy, a hooded and armed man alarms Gerry. He puts his hands up as he backs up to cover Rachel. Seeing this, the Pharmacy Helper (Ruari Cannon) softens, asks what they need, then retrieves several Albuterol packages as well as another medication that works "magic for my kid" who also suffers from asthma. Once again, the power of this romanticized fatherhood saves Gerry's daughter from an external threat as well as from

her pulmonary condition. Gerry's dramatic gratitude is then broken by Constance's screams for "DADDY!" The shopping cart she sits in rattles through the scene unmanned. Gerry rushes to her side only to hear Karin scream "GERRY!" from another aisle.

Implicating Gerry for forgetting her own purse merely commences Karin's extreme character deficiencies. She spends much of her time on screen worrying or sobbing. Gerry drags the kids toward Karin's cries to find her flailing on her back as two men violently mug her. Upon seeing Gerry, one assailant flees and the other Market Attacker (Graham Hornsby) shoots blindly in Gerry's direction. Karin flops to her stomach and reaches for her husband while continuing to screech his name. Gerry manages to dodge the incoming bullet while taking the other gunman down with a shot to the chest. Karin rushes Gerry, throws her arms around him, and weeps.

Gerry's boundless contributions to his family's survival are soon trumped by his value to UN efforts to save the human race. Deputy Secretary General Thierry Umutani (Fana Mokoena) calls to recruit him back into service, pleading "I'll need you. We need you back," over the phone. Thierry offers to send a helicopter to their location in the morning that will carry Gerry's family to the safety of an aircraft carrier anchored offshore somewhere in the Atlantic. In search of a safe haven in the interim, Gerry breaks into an immigrant family's apartment in a nearby tenement housing complex. Father, mother, and son Tomas (Fabrizio Zachare Guido) welcome the Lanes by offering them beer, cooking food, and inviting them to stay overnight. Gerry attempts to convince Tomas' father (Ernesto Cantu) that "movement is life" and therefore his family needs to run from Newark, but the father refuses, choosing to obey the radio broadcaster's instruction to "stay indoors if at all possible" with a few weeks' worth of provisions.

As World War Z's first act nears its close, several racist and sexist lessons are imparted upon the narrative and the characters. In the ultimate only-the-heroic-white-father-knows-best lesson, Gerry and his family manage a treacherous climb to the building's rooftop while zombies break into the Tomas' family apartment a few floors below. Only Tomas escapes with his life. He catches up with the Lanes and is welcomed aboard the chopper as it lifts off. Gerry runs top speed to join them as the zombified father of Tomas chomps at his heels. Not only did Tomas' father fail to protect his own family, but now he is the monster threatening "Tommy's" newly adopted one.

Once again, the family and Tomas owe their lives to Gerry's expertise

and his value to the UN. After they are situated in their bunk on the air-craft carrier, Karin re-adopts the role of the children's caretaker as Gerry is led to a military intelligence briefing. Thierry and Gerry observe Harvard virologist Dr. Andrew Fassbach (Elyes Gabel) from a distance. "He's our best bet," Thierry whispers. "He's just a kid," Gerry responds as if to imply the young doctor is no substitute for his own natural and seasoned genius. When Gerry later asserts that he cannot leave his family to aid in UN efforts elsewhere, the Naval Commander (David Andrews) stresses the ship only has room for "essential" personnel and their loved ones. Moments later, Gerry explains to his daughter that "Daddy's got to go to work." "Okay, tough guy," he then says to Tomas, "take care of the ladies for me." In the first thirty minutes of the film, Gerry has only referred to his wife and daughters by name or more often by "honey" and "baby." His first term of endearment for Tomas shows the boy much more respect than he has given his wife and daughters, as do his parting request and subsequent compliment: "You're awesome." "Daddy's coming back," Gerry promises Rachel as he exits the bunk.

More gender, race, and age-based prejudices and discriminations develop from the narrative as well as from its hyperbolic hero. Act Two opens with Gerry on a jet with Dr. Fassbach and their small Navy SEAL squadron. During a long and dramatic monologue, Dr. Fassbach teaches Gerry what he knows about the zombie virus and related natural forces. "Mother Nature is a serial killer. No one's better, more creative," the young doctor explains. After an affected pause, "She's a bitch," he says, who "disguises weakness as a strength." Later that night, across the globe, the jet lands on a dark and rain-soaked airstrip. The cargo door lowers to reveal an ensuing zombie attack, and the weapons-novice Dr. Fassbach accidentally shoots himself dead before his boots hit the ground. Gerry and the troops carry on with their mission without looking back, as the virologist has already fulfilled his only purpose in the film. In this sequence, the narrative suggests what Gerry had already assumed, that this young albeit highly-educated doctor, played by an actor of Algerian decent, could serve no purpose beyond imparting his virologist knowledge upon the consummate hero of the film. In other words, after listening intently to one monologue, Gerry is capable and wise enough to continue saving the world from this new zombie virus without further insights from the expert.

Gerry's godlike omniscience grows as the film initiates religious readings of the zombie plague alongside its depictions of women as dependent and dangerous. Once they make it safely inside Camp Humphry, where they've landed to refuel and regroup, Gerry is led to an ex–CIA Agent

(David Morse) being held prisoner for selling guns "to the North." The Agent details wild stories of whole countries removing their citizens' teeth so they cannot bite anyone if infected, then manically insists the outbreak is not a virus but instead a revelation, a great reckoning signaling a biblical Armageddon. Gerry is skeptical, but this religious warning lingers into the next stop of their globe-trotting: Israel. For now, though, Gerry blows off the ex–CIA Agent and leads his military detail back towards their plane. Back on the aircraft carrier, Karin snuggles in a bunk with one daughter. She anxiously waits for word from her husband on the SAT phone cradled in her hand. She has not heard from him long after a bad connection interrupted their last conversation, so she frantically dials up Gerry's number. Now out on the dark and rainy field, Gerry's phone rings and thus incites a zombie surge which claims the lives of a few members of his appointed SEAL team. In this instance, one wife's long-distance dependency endangers military personnel overseas. "Israel better pay off," the Navy Commander says to Gerry before sacrificing himself to the zombies as he disconnects the fuel line from the jet, enabling the others to escape and continue on with their mission.

The film's pro–American agenda progresses once its hero lands at Atarot Airport in Israel. Gerry is escorted to meet with Jürgen Warmbrunn (Ludi Boeken) by female soldier/bodyguard Segen (Daniella Kertesz). Israel "is winning" the zombie war due to their finishing (finally, after two millennia) of the wall enclosing the entire city of Jerusalem in advance of the zombie outbreak. Opposite of outsider speculation, Israel is using the wall to let immigrants of various origins enter this safe zone rather than to keep them out along with the zombies. Gerry was sent here by the UN in hopes of learning from Warmbrunn where the outbreak began. "Forget Patient Zero," Warmbrunn says. "I can't," Gerry replies, "it's too late for *me* [emphasis added] to build a wall." Gerry's hubris is growing along with his heroism. Here his character admits that he knows, as the narrative has led viewers to believe, he is the only one capable of and responsible for saving all humanity.

To put it another way, *World War Z* suggests that the world needs a lone-wolf, white-American male hero to rid it of all evils and Others. While they continue their conversation, Gerry and Warmbrunn observe the city through a high vantage point window. On the streets below, they observe the newly-admitted refugees to city. Muslim women in full hijab begin to sing. Other recent entrants, regardless of faith and origin, are soon inspired to join in on the celebratory song and ceremony. The crowd's voice grows loud and joyful, causing a frenzy of zombie activity to erupt

beyond the wall. The throng piles higher and higher as the zombies rush towards the sounds of the living. In no time, the tower of corpses crests the wall's apex and rains down upon the streets of earthly Jerusalem.

This dramatic and emotional scene first depicts how the living can overcome their religious and cultural differences if given the opportunity and a sanctuary in which to do so. But before the audience can indulge in the beauty of this unexpected union, the narrative punishes these revelatory survivors as well as their city asylum. The ensuing escape sequence reinforces the Biblical overtones of the film through visual and symbolic cues. Gerry, under the cover of Segen and a few fellow Israeli soldiers, flees the city on foot. They race through Jerusalem's cobblestone streets as gigantic surge of undead rises up like a wave crashing through the blocks behind them.

World War Z misses this golden opportunity to show how empathy and compassion can overpower prejudice and transcend difference. Instead, the film chooses to express the message that joining Muslim women in song and ceremony is an abominable act that must be washed away as sin in the eyes of a Christian God. The deluging of the ancient and holy city of Jerusalem alludes to the Bible's Olivet Prophecy (as written about in books including Daniel, Luke, Matthew, Deuteronomy, and Revelations). The prophesy explains how, from the mouth of Satan (sometimes in serpentine form), will pour a "river of eyes" flooding Jerusalem (which can also be interpreted as a holy celestial city or as The Church more broadly) after the streets have been repaired and the great wall rebuilt. This return of Satan will occur to eradicate the city of its heathens, false idols, and other abominations, and thus marks the beginning of the Rapture and the second-coming of Jesus Christ. The imagery is stunning and the zombie horde has never been cinematically depicted as so massive and terrific, but it is unfortunate that the unity amongst a diverse group of survivors had to be the catalyst for the scene and its overt allusion to the end times.

Soon after presenting its first strong female character, the bald and fearless soldier Segen, *World War Z* reneges this progressive representation by allowing her to be attacked by zombies and requiring Gerry to save her life. After she's inevitably bitten, Segen looks to Gerry with wide and desperate eyes. Without hesitation, he chops off her forearm with a machete and counts the seconds as she waits and weeps. Once Segen passes his ten-second infection test, Gerry drags her aboard a Belarus Air passenger jet taxying on a runway at Atarot Airport. Gerry scores a seat for Segen in the first row of first-class. He kneels before her with a handful of vodka mini-bottles and bandages he hijacked from the flight attendant's

work station. "You a doctor?" Segen asks as he tends to her bloody stump, marking her first dialogue in the film. "No. I've had some training in the field," he explains. Once again Gerry needs only rudimentary training and experience in order to master complex professions. This brief dialogue provokes a dramatic flashback montage of the key insights Gerry has gleaned from experts and leaders in the recent past. The voice of the deceased Dr. Fassbach closes the series and Act Two, reminding Gerry that "all you can do is hide...."

Gerry's memories of his discussion with Dr. Fassbach inspire his next plan of action to save the world. To clarify, though Dr. Fassbach had no idea how to stop the virus, his final words of warning enable Gerry's to think up an ingenious strategy for protecting people from the infected. Gerry whips out his SAT phone and dials Karin's number. As soon as she answers, Gerry blurts "I love you, but" he demands to speak with Thierry immediately. Gerry asks him for the coordinates of the nearest medical research facility that makes vaccines. Once this information is delivered, the SAT phone battery dies. Gerry commands the pilot to reroute to Wales and the Cardiff World Health Organization (WHO) located there. As the plane changes its flight path, the pilot tells passengers over the intercom that "we are very, *very* lucky" to have Gerry on board since his presence and newly-devised mission are the only reasons why the airplane has been granted permission to disembark in Wales.

While Segen appears to be a gender-nonconforming character equipped with strong military training, her shaved head and military fatigues betray their presumed masculine-power once *Ubermensch* Gerry demonstrates how to use her weapons best. As the plane changes its path to Wales, the lone Flight Attendant (Elen Rhys) checks on passengers and overhead compartments throughout the cabin. Upon unlocking the trap-door to the cargo-hold, she unwittingly releases the zombie hiding within. The infection spreads like wildfire through coach and soon threatens to invade first-class providing the sub-textual indication that zombies are working-class monsters who threaten the lives and freedoms of the West's imperial echelon. Segen shoots oncoming zombies one by one as they rush up the aisle. Gerry spots the grenade attached to Segen's vest and devises a better plan. He pulls the pin and tosses the live grenade at the area of the plane's wall that divides the privileged passengers from the lower-class infected. The explosion creates a vacuum that sucks out all the other passengers in the cabin whether living or undead. Gerry and Segen somehow manage to cling to their seats as the plane hurls toward the ground

Gerry's only failure in his efforts to protect his family throughout
World War Z occurs because the battery on his SAT phone is dead, a prob-
lem likely attributable to Karin's incessant calls for reassurance from her
husband. Back on the aircraft carrier, Navy SEAL Commander receives
word that Gerry's Belarus Air plane is missing in action. Meanwhile, Karin
and the kids eat alone in the ship's galley as an over-intercom voice repeats
the command that all "non-essential" passengers must exit the vessel for
relocation. Since Gerry is now presumed dead, his family is forced to
vacate the ship as well. Thierry reluctantly escorts the Lanes plus Tommy
off the ship as Karin glares at him with a set jaw. Karin and the kids are
extracted because their family's tie to the military's primary objective are
assumed broken. In other words, without Gerry, Karin and the children
are rendered "non-essential" and therefore expendable and valueless.

Even though he is unconscious for three days and thousands of miles
away, Gerry is still on-duty as the protector of his family. Gerry endures
fitful dreams of Karin and the kids in great peril. Finally, he awakens inside
Cardiff World Health Organization (WHO) a few days after undergoing
surgery to remove plane shrapnel and stitch him back together. His eyes
adjust to perceive one thin WHO doctor (Peter Capaldi) sitting at his bed-
side. "You're a tough bastard. And a lucky one," the doctor says in a British
accent. Gerry asks after "a woman" brought in with him and turns his
gaze to another man observing them from the next room. "Why do you
keep looking at him?" the British Doctor asks. "'Cause he's the one in
charge," Gerry states plainly, referring to the Italian-looking man beyond
the glass. Even upon wakening from coma-like slumber, Gerry's powers
of perception are razor-sharp.

The other WHO doctor's (Pierfrancesco Favino) eyes widen, and he
stands and walks around to enter Gerry's room. "This is important to
you," the head doctor says as he pulls the SAT phone from his pocket.
Gerry commands the doctor to give him the phone, but he refuses repeat-
edly. Gerry tells him to call the phone's only programmed number to verify
his "bona fides." When he complies, Thierry answers, escalating Gerry's
concern for his family. "We thought you were dead," Thierry says in an
attempt to justify why Gerry's family has been sent to a refugee camp in
Nova Scotia. Gerry soon hands the phone over to the lead doctor. When
he hangs up, Gerry induces more argument. After demanding confirma-
tion that Thierry told the doctor who he is and what he does, Gerry shouts
"then trust me when I tell you they're *not* safe!" Once again, the white–
American father/professional knows more and better than anyone else in
his presence.

The final act of *World War Z* solidifies how Gerry's UN training and intelligence work in service to his more vital and invaluable role as the father and protector of a family. If his family was not under the threat of the zombie apocalypse, Gerry would not have agreed to rejoin the UN efforts. At the WHO Institute, Gerry willingly takes great personal risks with his own safety and health in his attempt to discover a deadly pathogen that will camouflage humans from the zombies. Alone, Gerry breaks into the biometric vault and collects vials of contagions into a bin. Soon, his only exit door is blocked by a zombie doctor (Michael Jenn). They study each other through the glass, then Gerry picks a contagion at random and prepares it for injection. He writes "TELL MY FAMILY I LOVE THEM" on a sheet of paper and holds it up to the closed-circuit camera, then plunges the syringe into his arm.

Gerry's blind faith and tireless sacrifice for his family pays off, as he is soon reunited with his family in Nova Scotia while his ingenious cloaking strategy is broadcast around the world. Karin and the three kids smile and wave from the shore as his boat taxies in, and they wrap him in an exuberant embrace as the Gerry's closing monologue begins. Over a piano music montage of smiling close-ups, Gerry warns, "This isn't the end. Not even close…. Be prepared for anything. Our war has just begun." The film ends on a freeze-frame of Karin and Gerry hugging. It is implied that the "war" here isn't necessarily with the zombies, but against anyone and anything that threatens the traditional, patriarchal family unit as well as conservative American idealism more broadly.

World War Z's promotion of one white American male, lone wolf hero and its diehard preservation of the patriarchal family as an unbreakable institution are disconcerting. It must be noted, however, that not all zombie scholars view this dramatic and loose adaptation so harshly. In "The New American Zombie Gothic: Road Trips, Globalism, and the War on Terror," Kyle Bishop explains that the film's sweeping, international travails are indicative of the current trend towards mainstreaming and globalizing the Gothic. While Bishop recognizes that "the movie's core emphasis on a normal family struggling to remain safe and together in the midst of an inexplicable and unknown catastrophe is more reminiscent of Spielberg than Romero" (49), he reads Gerry's world travels and multicultural aids more optimistically. Bishop recognizes the film turns away from Romero's example of "female and African American protagonists" but nonetheless contends "the film is certainly more ethnically and culturally diverse" in its supporting cast and shooting locations "than most mainstream Hollywood productions, zombie-themed or otherwise" (52).

Nonetheless, I argue that Marc Forster's adaptation of Brooks' *World War Z* exemplifies an ironic and unfortunate twist away from Romero's scathing critique of patriarchal institutions, toxic masculinity, the home, and the family.

Seeing as how the reinstatement of white heroic protagonists and conservative ideals is honored and upheld through several seasons of AMC's *The Walking Dead*, the trend should be recognized and considered with caution.

CHAPTER 5

Heteronormative Heroics in AMC's *The Walking Dead*

> Once, this sort of thing was the subject of second-rate comic books and no-budget films starring any warm body willing to show up. Now it's on a mainstream television channel. That which was once thought of as gross and taboo is now weekly fodder for family, to be watched between bites of popcorn and slurps of a soda pop.
>
> —Joe R. Lansdale "Foreword" *Triumph of the Walking Dead*

> *The Walking Dead* has come to resemble the fictional zombie plague it documents: relentless, bloody and always getting bigger.
>
> —David Peisner "Blood, Sweat & Zombies" *Rolling Stone*

If one needs proof that zombies are more popular now than ever before, consider the fact that AMC's *The Walking Dead* has garnered more viewers than *Sunday Night Football* on multiple occasions over the past several years. To date, *The Walking Dead* is the most popular basic cable television show ever amongst the adult demographic (18–49); over 17 million viewers flocked to the season five premiere. In addition to the show itself, which is adapted from Robert Kirkman's popular comic series by Frank Darabont and others, *The Walking Dead* has a talk show (AMC's *The Talking Dead*, with Chris Hardwick), a video game, a Facebook page, Twitter fodder, fan forums and contests, merchandise, memes, and much more related media. In short, *The Walking Dead* is a marketing monster with a rabid fan base. Scholarly journal articles and anthologies devoted the program are emerging rapidly, many attempting to uncover what exactly attracts these hordes to the once-repugnant genre.

The general consensus regarding *The Walking Dead*'s popularity, as

119

suggested in recent scholarship, highlights the narrative focus upon and the likeability of its characters. In "The Pathos of *The Walking Dead*," Kyle Bishop suggests the only real problem with recent zombie films and television is that the zombie just isn't scary anymore. In fact, he argues, too much of the audience's pathos is sacrificed when the zombie becomes "bizarrely lovable" (*Triumph of* The Walking Dead 2). As earlier chapters have illustrated, zombies need not be one-dimensional threats in order to be valuable. Bishop contends that Frank Darabont, creator of *The Walking Dead*, "knows the only way a zombie can frighten an otherwise benumbed audience—especially in this era of oversaturation and parody—is if the viewers actually care about the human characters" ("The Pathos" 2). Most other scholars in *Triumph of* The Walking Dead, as well as in *We're All Infected: Essays on AMC's* The Walking Dead *and the Fate of the Human* agree with this final assertion.

AMC's *The Walking Dead* attempts to capitalize on this trope, but initially fails to produce dynamic and original characters in favor of reinstituting stereotypes of heroic men, dependent woman, and disposable characters of color. Nonetheless, the majority of *The Walking Dead* critics and scholars argue character likeability as the show's greatest strength and fundamental reason for its unprecedented success. As Bishop asserts, "[w]hat makes the series such an important contribution to the zombie canon, then, is how *The Walking Dead* ups the ante on screen horror by making the characters so well developed, likeable, and imperiled" ("The Pathos" 9). I argue, however, that each character in the inaugural season of *The Walking Dead* is an archetype; that is, a hyperbolized character-type that represents one perspective/reactive personality in the wake of the zombie outbreak. The characters within the show exhibit sexist, racist, classist, ableist, and other prejudicial attitudes, yet the show fails to provide a progressive challenge to these oppressive classifications. In fact, though *The Walking Dead* is often heralded for having one of the most gender-balanced and ethnically diverse casts on television, the narrative continues to uphold a white, patriarchal supremacy and repeatedly insults, rescues, and/or kills off women and people of color.

Through several seasons of *The Walking Dead*, I have watched in horror as each female character, young and old, Black and white, screams, cries, falls, and fails to exhibit physical fortitude, emotional depth, intellectual insight, and lasting psychological strength. The rare occasion when an ancillary female character fends for herself is inevitably followed up with the need for male heroism and rescue. Later in the series, the few strong female characters develop into Final Girl types capable of wielding

weapons and imitating masculine traits but are never elevated to the main-stage status of the show's leading men. As millions of viewers flock to the latest episode of this saga, I hope that I am not the only one hungering for socially conscious and dynamic females and characters of color to be featured in the forefront of the program.

Piloting AMC's The Walking Dead

The pilot episode of *The Walking Dead*, "Days Gone By" (October 31, 2010), introduces the show's hero—Sheriff's Deputy Rick Grimes (Andrew Lincoln), whom critics and scholars taut as a sympathetic every-man—calls attention to the differences between men and women, and ini-tiates a classical Western masquerading as a subversive zombie apocalypse tale. Driving back roads alone, uniformed Rick arrives upon an aban-doned, multi-vehicle crash site just as he runs out of fuel. He exits his sedan, retrieves a gas can from the trunk, and hoofs it to the nearest gas station. Makeshift campsites block the streets, dead bodies rot in cars, and a handwritten NO GAS sign swings in a gentle breeze. Rick steps around abandoned detritus: toy trucks, clothing, and laundry baskets. Much like the scene inside the tenement complex early in *Dawn of the Dead*, these symbols of domestic life appear eerie and threatening. Rick spies from behind an unkempt little girl (Addy Miller) in a pink bathrobe. As she reaches down to grab a tattered teddy bear,[1] Rick calls out to her: "Little girl…. It's okay…. I'm a police officer." She pauses then turns towards him, revealing a gaping, chomping, and decaying mouth. Upset, Rick hesitates then raises his duty weapon and strikes her dead.

In flashback we meet Rick's partner, Shane Walsh (Jon Bernthal), and the classic dynamic between "good cop" and "bad cop" is established through a discussion of the differences between men and women. Over a fast food lunch in their patrol car, Shane complains about how all the women his gives his house keys to leave all his lights on. Using language such as "chicks," "pair of boobs," and "bitch," Shane implies all women are the same and that they must be responsible for global warming, and thus reveals his womanizing, sexism, and general disrespect for the opposite sex. Rick merely chuckles and eats until the conversation and tone shift to his family. Rick admits reluctantly that his wife Lori (Sarah Wayne Cal-lies) "is pissed at me all the time, and I don't even know why." Shane sug-gests he needs to open up and talk to her more. Rick admits how hurt he is that Lori said "Sometimes I don't even know if you care about us at all"

in front of their young son. This is "the difference between men and women," Rick says, "I'd never say something that cruel to her. Especially not in front of Carl." The discussion is interrupted when a call for "all units" erupts from the police radio. They speed away to an active shooter scene during which Shane fails to provide proper cover and Rick takes two bullets. While this scene is intended to establish Rick as protagonist and the opposing attitudes and lifestyles between him and Shane, the undercurrent of their conversation reveals both men to be negative and judgmental toward the women in their lives.

This negative attitude towards women is carried throughout the episode, by the show's male characters as well as its narrative. The first zombie encountered is a young girl. Later, after Rick awakens in and escapes from an abandoned hospital, he studies another female zombie as she drags her mangled torso towards him. When he spots the same torso-zombie several scenes later, Rick says, "I'm sorry this happened to you," and shoots her in the head. While these acts seem to reveal Rick's sensitivity and compassion for the undead, it actually launches his position as the heroic male responsible for doling out mercy kills to the pathetic, literal monstrous-feminine he repeatedly encounters. Rick holes up for a few days with an African American father Morgan Jones (Lennie James) who reveals that his wife was infected and tried to attack him and their son Duane (Adrian Kali Turner). Later that night, Duane cries "She's here!" prompting Rick to watch the zombified Jenny Jones (Keisha Tillis) from a window while Morgan comforts his traumatized son. Jenny climbs the stairs and pounds on front door as if trying to return to her family. "I should've put her down, I just didn't have it in me," Morgan admits apologetically, "She's the mother of my child." Though Rick does not kill this zombie mom, he equips Morgan with the weapons and ammo to do the job before he leaves in search of his own family. Once again, the female/mother figure is rendered monstrous and deadly while fatherhood is held up as the last bastion against the zombie threat.

The living female characters in the pilot are depicted as subordinate to and dependent upon their male companions, and they do not appear until the final minutes of the episode. As Rick drives toward Atlanta, we cut to a camp of survivors somewhere in the countryside. A young blonde woman attempts to answer a call over the CB radio, but she does not know how to work the controls. "Come on, son," a grey-haired man calls to someone offscreen, "you know how to work it better than anyone." In response, Shane approaches the radio as Lori and Carl Grimes (Chandler Riggs) look on, but he doesn't have any luck either so he shuts the machine

off. Moments later, Shane and Lori argue briefly and it becomes clear that they have been romantically involved in Rick's absence. When Lori offers to post a sign on Highway 85 to warn travelers against going to Atlanta, Shane automatically dismisses her plan. She grabs Carl and stomps off, muttering "yessir" under her breath. In a private conversation between Shane and Carl, Shane addresses the boy as "Bud" and refers to his mother as a "girl." When they continue their quarrel in privacy of their tent, Shane commands Lori with what needs to be done "for Carl," she acquiesces to his authority, and then they kiss passionately. Unlike what we learned about Lori yelling insults and Rick shutting down in their marriage, here she eagerly submits to Shane's brutish leadership and offers her sexuality in gratitude.

The show's Western theme, along with its associated conservative dogma, is solidified in the final sequence of the pilot. Rick rummages through a farmhouse littered with the suicides of its inhabitants. Outside, he searches for keys to the family's truck when a horse chortles at him. After sweet-talking it for a minute, Rick loads up his police duffels filled with weapons and ammo and mounts the horse. As Philip L. Simpson explains in "The Zombie Apocalypse is Upon Us," "Rick Grimes is the American everyman, whose hands have become of necessity 'grimy' as he fights foreign [zombie] and domestic [living] enemies" (*We're All Infected* 29) throughout the series, and therefore "*The Walking Dead* interrogates what it means to be a leader during the downfall of civilization" (29). The heroic leader of *The Walking Dead* is one we have encountered often in other genres since the Golden Age. In a long shot, we watch Rick ride up the empty side of an abandoned highway towards the Atlanta skyline. This becomes the iconic poster image for *The Walking Dead*, a lone-wolf Sheriff (replete with police-issued Stetson hat) riding horseback into town.

Cowboys and Zombies

The downfall of society and its institutions in the zombie apocalypse certainly invites comparison to how life in the Wild West is depicted in Hollywood cinema. While Romero uses the collapse of societal institutions and order in the zombie apocalypse as an opportunity to critique their inherent prejudices and oppressions, Darabont chooses to uphold and develop this genre parallel and its politics throughout *The Walking Dead* series. In "Walking Tall or Walking Dead?" P. Ivan Young writes, the "western tropes of *The Walking Dead* are pervasive—cowboy hat and boots,

six-gun, lynching, saloon showdown—and it was clear even before the series that [Kirkman's] story was steeped in cowboy lore" (We're All Infected 59). Rick represents the idealized Western hero who works to restore law and order and to protect citizens from foreign threats. He, along with other father-figures such as Dale Horvath (Jeffrey De Munn) and Hershel Greene (Scott Wilson), strives repeatedly to uphold Christian moral codes, to defend the safety and sanctity of the home, and to restore the family unit within several symbolic locations over the first few seasons: in the countryside, at Hershel's family farm, and within the fortified walls of a state prison.

Though walkers and other corrupt bands of survivors eventually push Rick's group out of these places where they try to make their home, the lone-wolf cowboy figure is held up as the highest standard for protection and longevity in The Walking Dead zombie apocalypse. The family unit and the home (wherever it is reconstructed across this bleak Georgia land-scape) are also represented as sacrosanct. Challenges to these ideals and institutions, and deviations from them, are punishable by excommunica-tion or death. As Kim Paffenroth notes in "For Love Is Strong as Death":

> [t]his new, postapocalyptic community, which relies on family as its only source of purpose, can tolerate bigots and other undesirables—in the name of both unity and safety for the group—but it cannot overlook intrafamily violence or unattached males who threaten to disrupt an already established family unit [Triumph 227].

Theodore "T-Dog" Douglas (Irone Singleton), one of the only Black men in the original group of survivors, is a character of few words who is marked as expendable by his skin color as well as his he lack of fatherly attributes and family affiliations. He mainly serves as the target for Merle Dixon's (Michael Rooker) racial slurs and violence. T-Dog typically acts in accordance with Rick's or Shane's directives and assists fellow (often female) members in the slaying of walkers on several occasions, but his clumsy mistakes frequently put him and the group in danger. He often requires the rescue and support of other leading men. T-Dog is eventually devoured at the hands of two zombies in season three, and his self-sacrifice saves Carol Peletier (Melissa McBride) from the same fate. Dale, the older white man who plays father-figure to the Harrison sisters but was unable to have children with his wife pre-apocalypse, is a pacifist voice of reason at times but is killed off in season two. Daryl Dixon (Norman Reedus) mercy-kills him when he is overtaken by zombies. Ed Peletier (Adam Minarovich) shares Rick's family-man status, having a wife and one child, but his egregious psychological and physical domestic abuses warrant his

death early in the series. Even Hershel, the god-fearing father of the farmhouse family, though beloved by characters in and fans of the television show alike, is eventually murdered by the malevolent Governor (David Morrissey) after uttering last words "Dear God, just kill me" in a midseason finale (December 1, 2014).

Since we follow him surviving alone through the majority of show's first episode, each living person Rick encounters is offered up in comparison to his heroic traits and leadership style. No character is ever elevated above Rick's position as ideal leader, though a few compete, even when he temporarily loses his handle on the group and collapses into pathological grief over the death of his wife during childbirth. Shelley S. Rees argues in "Frontier Values Meet Big City Zombies" that the show "invite[s] us to identify with the good characters against the bad ones and to take voyeuristic—and guiltless pleasure—in the violence" (84). Police partner Shane works as primary foil to Rick's leadership style as we see later in the series when the men are reunited. They subsequently fight each other for control over the group of survivors. Young states "[b]oth are cast in the cowboy image, but Rick is mythic cowboy while Shane is cowboy stripped of moral pretense—or at least his sense of morality is more pragmatic and self-serving" (60). As Young mentions, "*The Walking Dead* erupts [… in] a struggle between Rick and Shane about who is most fit to protect Lori and Carl" (63). As the tension between Rick and Shane escalates, Lori flounders between both men as they continue to vie for her loyalty and affection. Carl also struggles to negotiate the conflicting treatment and advice he receives from his actual and his surrogate father-figures.

This struggle for influence and control over the Grimes family (and consequently of the whole group of survivors) pits Rick's fair and level-headed style of governance against Shane's more selfish and aggressive form of dark charismatic leadership. Young articulates that "Shane's obsessive love for Lori Grimes [is] a catalyst for much of the violence that erupts, particularly in the second season" (59). In all fairness, Lori is equally if not more culpable for inciting conflict, danger, and violence throughout the first two seasons of *The Walking Dead* (as I explore later in this chapter). In the third episode ("Tell it to the Frogs"), Rick is reunited with his family and the other members of their camp. The group unanimously elects Rick as their leader. Once unseated from his position as the alpha male, Shane's behavior becomes more erratic and dangerous.

The battle between Rick and Shane, indicative of the standard standoff between good and evil common in the conventional Western, culmi-

nates in "Better Angels" (March 11, 2012). Young details how, in "the penultimate episode of season two Shane leads Rick into the woods to murder him. Instead, Rick stabs Shane, killing the killer" (64). Unbeknownst to Rick, Carl witnesses this violent encounter from afar. When Shane reanimates as a zombie and attacks Rick again, Carl raises the gun Shane taught him to shoot with and viewers momentarily question whether Carl will protect his biological father or avenge the murder of his surrogate parent. Young contends that "Carl mirrors his father's act of violence a second time. He has taken his place within the cycle of violence; he has killed the man who taught him to kill" (65) in order to defend the hypocritical man who taught him killing is wrong.

Once unpacked, Shane's dramatic double-death sequence reveals one of *The Walking Dead*'s most conservative and controversial lessons. Young and a few others hint to the disturbing ethics at play in Shane's murders (and throughout the series), but believe the show raises critical questions regarding justice and violence within the American system and human nature. Angus Nurse argues that the "central metaphor [in season two] is that of the failure of law-and-order structures to protect the vulnerable, notably children [and women], who suffer from particular forms of violence such as abduction and unwanted sexual attention" ("Asserting Law and Order Over the Mindless" 74). While these types of questions and interpretations may be elicited from zombie scholars and socially conscious viewers, *The Walking Dead* preaches its own doctrine about how violence and murder (against the living and the undead) are justifiable, moral even, when committed by the survivors privileged within its narratives. In other words, killing is permissible if not obligatory when idealized characters like Rick fight and kill to save themselves and protect their families. This legacy of privilege and violence is passed down from father to son.

Rick's unsullied image as peace officer, leader, father, and protagonist, though temporarily blemished by his murderous act and Carl's subsequent inheritance and replication of it, is repaired early in season three. The first few episodes are dominated by psychopathic men (like Merle, Tomas, and The Governor) and overrun by zombies. Once surrounded by hyperbolized antagonists, living and undead, Rick's character and position are again elevated as the ideal. After watching three full seasons of *The Walking Dead*, Nurse argues how "[c]rime in *The Walking Dead* is a socially constructed notion that changes according to the situation occupied by its protagonists" and thus interprets that the show's overarching argument to be "the necessity of employing aggressive law enforcement and deadly

force to eliminate not just an actual threat but also the potential threat represented by the zombie" (77). Rick evolves to embody this law enforcement style, and his success and, according to Simpson:

> victory, in the narrative's terms, represents the moment that he proves himself worthy enough to be the lawfully-sanctioned agent responsible for the group's continued safety, a move that includes, to some extent, a repudiation of the thoughtfulness and collaborative style that had earlier marked his leadership [33].

Symbolic exchanges between Rick and Carl reveal "the generational transfer of patriarchal power. [...] Rick bestows his deputy's hat upon Carl, a signifier of the passing of the crown from father to son" (Simpson 34). The legacy of the white supremacist patriarchy and its violences and oppressions, as seen in the classic Western and experienced in real life, carry on.

Darabont and the show's writing team relinquish the opportunity to use the zombie apocalypse genre as a medium, primed by Romero, for critiquing authority and breaking free from gender stereotyping and racial prejudice. While the fusion between the zombie and the western genres is not inherently problematic, it becomes troublesome when the social and political protest opportunities Romero pioneered are denied in favor of reinstituting classical good versus bad, lawful versus criminal, cowboy versus Other enemy, black-and-white-type oppositions. Disconcerting dichotomies arise between the living and the undead, between men and women, between white and Black/Latino/Asian characters over the course of the first few seasons of *The Walking Dead*.

Walking, Dead Women

After some fan and critic complaints arose during the first two years of the show, the writers of AMC's *The Walking Dead* attempted to diversify and improve the quality and depth of its character representations. As Kyle Bishop notes in his conclusion to *How Zombies Conquered Popular Culture*, "not all the character development in *The Walking Dead* has been positive or represents evolutionary progress, but the series affords those types of developmental explorations nonetheless" (184). Though a few females (Carol particularly) and characters of color (Glenn, Michonne, and a few others) are given more screen time and more dynamic capabilities as the series advances, none yet match the impressively radical and nuanced characters in Romero's *Dawn* and *Day*. In a few hours of screen time, Romero manages more in depth and progressive character devel-

opment than *The Walking Dead* has on offer in well over 100 hours of episodes to date. Unfortunately, much of the scholarly criticism regarding gender and racial stereotypes in *The Walking Dead* remains remarkably thin, and is often relegated to short editorials and the far corners of the internet, in feminist e-zines and activist blogs writing primarily for like-minded audiences.

Romero and his conscientious successors recognize the zombie apocalypse as an opportunity to break free from oppressive institutions and out of socially scripted gender and race performances. As Kay Steiger acknowledges in "No Clean Slate," "In theory, the zombie apocalypse is the ultimate meritocracy, a do-over for humanity in which survival skills—whether they belong to men or women—top other traits such as race, gender, and class" (Steiger *Triumph* 106). And yet, Steiger elaborates:

> Much like the world in which we live now, the post-apocalyptic zombie world of *The Walking Dead* isn't always good for women. Women are portrayed as victims of sexual assault, trapped in situations of domestic violence, and subject to stereotypical attitudes about gender roles. Likewise, racism doesn't disappear the minute zombies arrive on the scene: characters like Merle Dixon still fling racist remarks at T-Dog, black people are still stereotyped as hypersexual, and interracial sexual violence still exists [112].

Steiger finds it strange for "[c]haracters [to] exhibit behavior based on traditional gender roles" (104), but recognizes that "a common theme in the series itself seems to be that a postapocalyptic zombie world is no clean slate when it comes to these issues" (99). To be clear, the zombie apocalypse is not an automatic fix for a flawed society, but it certainly invites survivors to devise their own roles, rules, and codes of conduct.

Romero's depictions of the zombie post-apocalypse also include characters who try to hold on to their beloved patriarchal institutions and dominance, but he allows the narrative to eradicate these oppressors. *The Walking Dead*, on the other hand, seems to reward characters who refuse to evolve beyond their prejudices and stereotyping with longevity. While the men fight for control and leadership in the group and discuss critical strategies for its safety and protection, the women tend the camp, cook, do laundry, and care for the children. The men secure perimeters, train with various weapons, and assert themselves as the women's father-figures and/or lovers. Rick and Shane fight for Lori's loyalty and affection. Dale imposes himself as the caretaker of sisters Andrea (Laurie Holden) and Amy Harrison (Emma Bell), since they are the first people he has cared about since his wife's passing and he feels a sense of duty to keep them safe.

In the first few seasons, the men and women of *The Walking Dead* fulfill stereotypical gender roles, conversation topics, and activities. The men are the leaders with decision-making power, and are often justified in their violence. The women are their valuable property: kept at "home," in need of protection, and utterly dependent. These sexist roles and limitations apply to the characters roles and mobility as well as to their topics of conversation. As Steiger details:

> conversations more generally among women in the group often turn to domestic matters: What should the group eat? What should they do to pass the time? What are the challenges of caring for the children in this environment? The men, on the other hand, converse about long-term survival: gathering supplies, group organization, and protection [105].

In "Tell It to the Frogs" (S1; E 3, November 14, 2010), for example, the women do laundry throughout the camp as the men clean weapons, hunt, rescue Carl, kill a walker, and strategize and implement their plan to retrieve Merle from Atlanta. "Tell It to the Frogs" typifies well the extreme positive and negative typecasting of both genders in *The Walking Dead*. Lori drags a comb through Carl's unkempt hair as Shane watches on while he cleans his rifles. "Get through this with some manly dignity," Shane says when Carl complains, "and tomorrow I'll teach you" to catch frogs. "You and me will be heroes" for feeding frog legs to the group, Shane says, "Heroes, son, spoken of in song and legend." To Carl, his mother is the pesky caretaker and surrogate father Shane is a knight who promises training, adventure, and celebrity. When a convoy carrying Rick and others rescued from Atlanta returns to the camp, sisters Andrea and Amy reunite in a tearful embrace. Rick saunters up in uniform as the survivors look on in silent awe, as if in automatic salute to the man in uniform. Later that night, Rick demands validation from his wife and son; "I found you, didn't I?" Lori calls him "cocky" a couple times, but rewards him with passionate lovemaking. The next day, Rick and his chosen men leave for Atlanta, Shane teaches Carl how to trap frogs, and the women endlessly wash, hang-dry, and fold clothes.

Throughout the episode, men are depicted in active and decision-making roles while the women (somewhat reluctantly) fulfill their domestic responsibilities. Rick emerges from his tent, after sleeping in late, to discover Carol has already washed, dried, ironed, and folded his police uniform and underclothes. Rick (redressed in his symbolic costume), Shane, and a few other men run into the woods with weapons after hearing Carl scream for "Dad! Mommy!" Andrea and Amy recoil in horror as the men bludgeon a zombie feasting on a dead deer.

The men exhibit increasingly disturbing violence in the episode while the women vocalize their displeasure with the gendered labor distribution at the camp. Daryl throws multiple fits, first upon seeing that a walker has contaminated the deer he's been tracking for hours. He lunges at Rick after hearing his brother Merle has been abandoned in the city, but Shane and Rick swiftly restrain him as they have been professionally trained. After Rick and his rescue team leave for Atlanta, Shane and Carl play in the quarry while Carol and Amy wash garments in the blurred background. Seeing this scene, Jacqui (Jeryl Prescott)—the one Black woman with a speaking role (in this episode and much of the season)—says to Andrea, "I'm beginning to question the division of labor here." Nonetheless, they join Carol and Amy laundering at the shore, and Carol explains "It's just the way it is." The ladies commiserate about what they miss from life before the zombie apocalypse. "My Maytag," Carol shares. "I miss my coffee maker," Jacqui chimes in. Amy misses her technology, and Andrea her "Benz and SatNav." Through these admissions, the women's roles, ages, social and economic statuses are revealed. Carol longs for the machines that assisted her in her domestic duties as a wife and mother. Jacqui longs for simple pleasures and Amy for the technology that marks her youth. Andrea, formerly a successful attorney with material wealth, then admits missing her vibrator. When Carol whispers "me, too," the group bursts into hysterics, spurring Carol's abusive husband Ed's attention.

The women pay the price for vocalizing their desires and displeasures, and for exemplifying both passive and assertive reactions to masculine threats. Simpson notes that the "show so far has consistently raised the possibility of female empowerment only to decisively shut it down" ("The Zombie Apocalypse is Upon Us!" 35). Ed confronts the women for being disruptive while they should be working. "What's so funny," Ed demands to know, and Carol averts her eyes to focus on her washing. Andrea, the bolder, better-educated, and independent female of the group answers: "Just swapping war stories, Ed." When he encroaches further, she asserts, "Problem, Ed?" "None that concerns you," he replies. "You sure sound like some uppity, smart-mouthed bitch," he continues before commanding Carol to leave with him. When Carol stands, her head and gaze bowed, Andrea steps between them. Amy looks on in horror, her mouth agape, while Jacqui, who prompted the episode's whole gender inequality theme, is visually cut out of the scene. "Please," Carol pleads to Andrea quietly, "it doesn't matter." "Don't think I won't knock you on your ass just cuz you're some college-educated 'cooch,'" Ed warns, then he and Andrea play tug-of-war with Carol. Ed slaps his wife hard across

the face. As she falls, Shane jumps into the melee and brutally beats, kicks, and stomps Ed until he's unconscious. Shane walks off his rage while Andrea and her sister stand frozen and speechless. Carol collapses at Ed's side, sobbing and begging for his forgiveness.

This narrative penalizes the women for enjoying their private and confessional conversation, and likely for having sexual drives and preferring self-pleasure. Though Ed is physically punished for his abuses of the women, Shane is the scene's heroic rescuer and Carol is its true victim. Andrea's attempt to protect Carol, in the interest of her own feminist politics and self-validation as much as for Carol's sake, results in grave consequences. Andrea must bear the guilt of escalating the situation. Carol suffers from both men's violent behavior, in the present as well as the potential future when her abusive husband reawakens.

Surviving Stereotypes

Hyper-masculinity is rewarded while resistance to submissive-femininity is punished in "Tell it to the Frogs" and the show-at-large. Though Ed is literally brutalized for his abuses of women, other male violences in the show are depicted as justified and regarded as acts of heroism. Women in *The Walking Dead* suffer for acting in accordance with their scripted gender limitations. Simpson stresses how the "women in the narrative also suffer greatly for transgressing traditional gender roles" ("The Zombie Apocalypse is Upon Us!" 36). In his online article on gender issues in *The Walking Dead*, Stuart Baker admits, "[t]o be fair, all the characters in the show are deeply flawed as individuals, and at times the cast seems to be made up more of stereotypes than individuals at all. There's the good cop, the bad cop, the loner, and the redneck. For the women: the abused wife, the cheating wife, the rebellious daughter..." (October 11, 2013). Even here, the men are categorized by profession and personality type, but the women are reduced to their relations to men.

Each character can and should be flawed, as Romero's protagonists are known to be, but needs to evolve beyond sexist and racist pigeonholing. Given the unprecedented time and space *The Walking Dead* has to reveal and develop its survivors, these characters need to progress beyond generic and unjust representations of gender and race. The group also deserves to grow to include variations in sexual orientation, religious beliefs, physical stature, attractiveness, and ableism, to rise above such fixed and problematic categorization.

Slowly, the stereotyping of *The Walking Dead*'s leading men opens up as they begin to express more emotion, complexity, nuance, and transformation. The cast of women on the show also shifts and changes, but some new and arguably more problematic stereotypes of women and racial minorities are introduced. *The Walking Dead* issues two strong female characters assumedly as correctives for the widely criticized depictions of Lori (the cheating wife) and Carol (the abused wife) in season one. Steiger is complementary when "the creators of *The Walking Dead* give vitally important gun and sword skills to two female characters [Andrea and Michonne respectively] in a world in which such skills are needed most— a move that flies in the face of many stereotypes of women in postapocalyptic fiction" (107). While postapocalyptic fiction is the perfect venue for piloting progressive female characters, as Romero and others have been doing for decades, these two *Walking Dead* characters offer only limited correctives.

Andrea Harrison (Laurie Holden) is promoted as the show's first outspoken and independent woman, and her character deserves attention and credit beyond her sidearm. In spite of her self-appointed, father-figure Dale Horvath's (Jeffrey DeMunn) protests, Andrea fully rejects domestication and demands of Shane access to and training with a weapon. She quickly becomes a proficient shooter and joins the men on hunting and walker-killing missions, but always in a supporting role. Nonetheless, Andrea proves she has the physical aptitude to match her verbal and intellectual acumen. The bond between Andrea and Shane, the two most powerful and prominent single adults at the camp, deepens and intensifies during this transformative training process. The sexual tension between Andrea and Shane becomes palpable.

More remarkable than her feminist politics and physical capabilities is Andrea's choice of autonomy over companionship. The survival skills she demands and acquires, along with her advanced education and privilege, enable her to remain liberated and to make empowered decisions. Rather than relinquishing her independence for a relationship with the increasingly sociopathic Shane, Andrea chooses to divorce herself from him. Nonetheless, her powers prove to be fallible when she fails to keep her little sister safe. Amy Horvath (Emma Bell) is infected by a walker one night even though Andrea and others congregate nearby. Andrea cries and cradles Amy until she turns, then insists it is her responsibility to deliver the killshot to her sister's skull. After the grave loss, Andrea retreats into herself and grows distant from other members of the camp. She loses affiliation with the survivors when the Greene family farm becomes over-

run with zombies, but Andrea manages her own escape and eventually hooks up with Michonne (Danai Gurira), the show's second powerful woman who appears at the opening of season three.

Fans celebrated the emergence of Michonne on social media, missing the fact that her character is initially fraught with problematic gender and racial stereotyping. Admittedly, she makes a strong first impression in "Seed" (S 3; E 1, October 14, 2012). A few walkers are swiftly dispatched from the entrance to a general store by a deftly swung sword. The shot retreats to reveal Michonne—a muscular Black woman with long dreads, donning fierce warrior attire—as the masterful wielder of blade. She snatches medicine from a shelf and returns to her forest hideout. We discover Andrea resting inside, and eventually learn that Michonne rescued and cared for her after her harrowing escape from the overrun farm.

Michonne can be commended as a character who embodies both masculine and feminine-coded traits. She exemplifies great skill, strength, and self-sufficiency. She also demonstrates a sensitive and nurturing nature in her care for Andrea as well as her later protection of and bonding with the young Carl Grimes.

While some fans and critics vehemently believe her to be the ultimate "badass" female the show desperately needed, a handful of zombie scholars and film critics voice necessary concern over the troubling racial and gender stereotypes her scripting perpetuates. In "Is Feminism Still Alive?: Gender and Gender Roles in 'The Walking Dead,'" Stewart Baker labels her as representative of "a stereotypical angry black woman" (October 11, 2013). She is tense, tight-lipped, and inaccessible through most of her early onscreen appearances. In her editorial for *Bitch Flicks*, Megan Kearns explains, "[w]hen we first meet Michonne, she saves Andrea, serving as a "black caretaker," perilously playing out the "Magical Negro" trope" (May 1, 3013). The first image *The Walking Dead* delivers for Michonne (though we don't know it's her until a later episode) is backlit at night in dense trees. The long dreads and muscular frame silhouetted in eerie blue light certainly enhances this "Magical Negro" symbolism. Even more disturbing is the fact this ghostly figure drags two Black-male walkers, their lower jaws cut off, shackled in chains, behind her. These zombie mules are later seen posted outside her cabin in the woods. Their overt slave imagery and status are inherently unsettling. More concerning is how their presence insinuates the negative stereotype of Black women emasculating their own men.

As should now be clear, phallicizing women with weapons is not sufficient for producing realistic— let alone radical—representations of

women on screen. Though creators of *The Walking Dead* attempt to build the diversity of its characters over the seasons, the scripting too often steps out of one reductive stereotype into another. In her follow-up article for Salon.com, Lorraine Berry laments:

> [i]f anything, gender and race have become even more problematic in this past season than they were in seasons one and two. Where before, I argued that in this new world, women were to be protected while men of color occupied a liminal space, it now appears that the white men have closed ranks and cemented their power [April 1, 2013].

Worse than its depictions of women, Berry insists, are the show's egregious representations of racial minorities; "Race has become a mess—an offensive mess—where African-American men have become interchangeable, replaceable parts" as we see with T-Dogg, Tyreese Williams (Chad L. Coleman), Bob Stookey (Lawrence Gilliard, Jr.) and countless others. When a new Black male character joins the survivors, another one is soon killed off as if to make room. Glenn, the Asian-American male who initially saves Rick from in Atlanta in the series opening, is still relegated as ancillary to the leading white men through several seasons. His boundless love for girlfriend Maggie Greene (Lauren Cohen) comes off as selfish, close-minded, and often imperils the safety of the surviving group.

While imprisoned in the Governor's compound, Glenn forfeits information about the group's location in an attempt to rescue Maggie from captivity, but she is nonetheless sexually humiliated and threatened by the Governor as his henchmen look on. While Maggie is the actual victim of this heinous assault, Berry aptly criticizes how "the writers made the sexual assault all about Glenn—*his* failure to protect Maggie, *his* anger that this had happened to her—to the point where he was unable to offer to her the comfort she sought from him" (no pag.). In other words, his subsequent shame for his failure supersedes Maggie's trauma and requests for support. Within the relationship, Glenn fails to be man enough to protect Maggie. Within the narrative, Glenn's shame garners more time and attention than Maggie's coping and recovery.

Rick and Carl and Daryl continue to survive and evolve into the show's most complex, albeit white and hyper-masculine, leading characters through several seasons. Andrea eventually enters into a romantic relationship with the show's most prominent antagonist, the Governor (David Morrissey) of Woodbury. Even after she discovers the true depth of his psychopathy, her affections render her incapable of fulfilling her promise to Rick to kill the Governor while he sleeps, endangering everyone residing in Woodbury as well as her entire group back at the prison.

She later commits suicide to save herself from inevitable zombiehood. Michonne and Glenn and other women and men of color survive for a while, at least as the show closes its sixth season. Their futures remain unknown but not favorable unless more diverse, politically progressive, and socially prescient writers step on board.

Sexuality, Intersectionality and Dis–Ability

Emerging scholarship on AMC's *The Walking Dead*, both the comic and television series, is increasingly optimistic about the development and diversity demonstrated by new and surviving characters. In "Laid to Rest: Romance, End of the World Sexuality and Apocalyptic Anticipation…," Emma Vossen delights in the soap opera melodramatics of Kirkman's comic (2003–present), asserting the series "offers readers a fantasy that is as liberating as it is unimaginable in that it "depicts a world without capitalism, without traditional social structures and the designations that go along with them" and thus issues forth a "new kind of American Dream, one of self re-creation" (*Zombies and Sexuality* 100). Vossen cites the comic's characters' sexual drive and partnering as the main distinguishing factor between the living and the dead, and celebrates the example set by the self-sufficient interracial coupling of Maggie (white) and Glenn (Asian-American) (also depicted in the television show) as cause for hope in the post-apocalyptic American frontier.

Though Michonne's introduction to the television series was initially fraught with racial archetyping and subsequent prejudice, one must admit that the mere presence of a leading Black female in a zombie narrative is cause for appreciation and attention. Even Romero's progressive casting featured solely white women and Black men as protagonists. In fact, Danny Boyle's *28 Days Later…* was arguably the first high-quality zombie film to include and elevate a Black woman as a main survivor-protagonist. In "The Importance of Neglected Intersections…," Kinitra D. Brooks calls upon horror and zombie scholars to read these texts beyond a monolithic white womanhood and femininity and to acknowledge the importance of intersectionality in feminist film critique of gender and genre. One major issue is how a Black "woman's displays of strength can be read pejoratively even as the strength [and masculinization] of the [white] Final Girl is read as positive, plucky" (464), as was initially the case with Michonne.

In time, Michonne grows beyond the original and problematic first impression of the closing scene of season two and the limited scope and

depth of her character in season three. As Cathy Hannabach articulates in "Queering and Cripping the End of the World...," Michonne thereby offers a significant counter to the The Walking Dead's heteronormative agenda. She does not fit into the extreme feminine coding of the (primarily white, though a few Black) women in the narrative, and thus her body and coding can be read as queer and disabled in direct contrast. Hannabach explains that "it may seem surprising to read Michonne as disabled" and queer since she is incredibly strong, capable, and relatively unscathed—and since she is revealed to be heterosexual in her romantic relations through several seasons of the show—yet "disability studies reminds us that disability [like most other social labels] is constructed by culture" and the dominant culture of society and the show "'disable' particular bodies through constructing them as 'other'" (Zombie and Sexuality 120). It must be noted that at the time of Hannabach's writing, the show offered zero "self-identified queer characters" (117). Therefore, Michonne is the one character who stands against the heteronormative politics of the show and its seasonal narratives (particularly the Governors constructed culture within Woodbury).

Michonne deserves special credit since she perseveres and refuses to allow anyone to threaten or control her identity, her body, or her loved ones. She supersedes her role a "strong Black woman" throughout the remaining seasons. Brooks also recognizes that Kirkman, in the comics, "begins constructing Michonne as a racially gendered stereotype, but then he begins to complicate her characterization by allowing her to explicitly express vulnerability" (470). Michonne's character and her developing relationships—with men, women, and children—continue to afford limitless opportunities to explore the nuances, complexity, and depth of humanity previously unseen from a Black female lead in zombie (and horror) narratives on screen.

The Walking Dead continues to diversify its cast in later and ongoing seasons when its first queer character is introduced in season four. The show later depicts, if not normalizes, homosexuality and same sex relationships by adding more queer characters in prominent roles. Tara Chambler (Allana Masterson), who was in police academy training prior to the zombie outbreak, is first introduced in season four, "Live Bait" episode. The Governor rescues her from being bitten by her recently turned father. The next couple episodes reveal she is in a relationship with fellow survivor Alisha (Juliana Harkavy), as they are seen holding hands and sleeping side by side. Their romantic engagement is implied but not explicitly addressed by the characters via dialogue. Alisha dies during the Governor

groups' assault on Rick's prison encampment. Tara survives, eventually joins up with Rick's group, and emerges as one of the show's central characters, particularly when the group joins the relative peace of Alexandria. A gay couple, Aaron (Ross Marquand) and Eric (Jordan Woods-Robinson), cohabitates in their own home within this walled town. Though Eric remains an ancillary character who primarily stays home, Aaron develops into a key character of the proactive survivor group.

Tara's story also deepens during their stay in Alexandria. There, she meets Denise (Merritt Wever), a young woman who was training to be a doctor before the world collapsed. Their deepening companionship in due course turns romantic and is eventually consummated. Unfortunately, however, Denise is callously murdered at Negan's (Jeffrey Dean Morgan) instruction, the leader of the latest rival faction called the Saviors. Negan has his lackey shoot Denise through the eye with an arrow to punish a heterosexual male character, Eugene Porter (Josh McDermitt), in an effort to shift his allegiance and further his narrative. Much of the tragedy's aftermath is devoted to watching Eugene struggle with his culpability and guilt. Tara, on the other hand, is given very little if any on-screen time to process and grieve her immense loss. Denise was never afforded the opportunity to tell Tara she loved her.

Herein lies one of the more disconcerting tropes concerning LGBTQ+ character representation on screen. All too often, non-normative characters suffer extreme consequences and untimely deaths. Their deaths too often follow positive developments in their character and their relationships, and therefore seem retributive. Moreover, their unfortunate fates serve the purpose of furthering the story line of heteronormative characters. To date, Tara has lost two of her partners. Lesbians suffer this loss at a much higher rate than gay (particularly white) males. Though GLAAD reports that LGBTQ+ representations have been steadily increasing on the big and small screens in recent years, the "Bury Your Gays" trope continues to threaten these beloved characters and their invested fans ("Where We Are on TV '16–'17").

At the tail end of the latest season (S7 Ep. 14) of *The Walking Dead*, newer fan favorite Jesus (Tom Payne) outed himself as gay in a tender exchange with Maggie. He casually slipped into the conversation how difficult it has been for him to connect with others, and to find "boyfriends." "For the first time," Jesus admits with emotion, "I finally feel like I belong." Here's to hoping that Jesus finds a partner, and that Tara has time to heal and enter into another authentic partnership, and that their relationships will flourish for the long term.

Back to the Future for Zombie Media

The most popular zombie works of the decade continue to uphold the arcane model of the white male hero as the savior of humanity in the monster-apocalypse. Despite the society-shattering effect of a zombie invasion, works like *World War Z* and AMC's *The Walking Dead* continue to propagate the stereotypes of masculine power and autonomy and female weakness and dependency. At issue here is the fact that hyperbolizing character-types trap each character in a stereotype built upon binaries that perpetuate essentialism, patriarchy, misogyny, and racism. In this regard, *World War Z* and *The Walking Dead* series become morality plays or allegories that reinforce traditional Western (American) values, heteronormativity, and neo-conservative ideals regarding family, gender roles, as well as proper moral codes and standards. Put simply, *World War Z* and *The Walking Dead* work to reestablish the dominant ideologies and practices that Romero's *Living Dead* series and its successors worked so hard to radically subvert.

Recognizing that the zombie genre has relatively recently bridged the gap between cult status and commercial success, I must acknowledge that today's widely popular (albeit more conservative and reactionary) zombie blockbusters potentially invite new, larger audiences to return to Romero and others' more progressive zombie predecessors. The broadening reach of this unique subgenre also invites more diverse creators, creations, and consumers of zombie media.

AMC's *The Walking Dead* is trending in the right direction—with its latest and most progressive character representations and story lines—so let's hope the dominant narrative doesn't punish them. That said, there remains much space and optimism for a new generation of zombie media that offers fresh conceptions of the zombie, the genre, and social commentary potential.

CHAPTER 6

Zombie Women
Take the Lead

All human societies have a conception of the monstrous-feminine, of what it is about woman that is shocking, terrifying, horrific, abject.
—Barbara Creed, *The Monstrous-Feminine*

Every zombie has its own story to tell ... and sometimes the zombie itself can best tell that story. And, of course, not all zombies have to be the hungry, reanimated dead.
—Kyle William Bishop, *How Zombies Conquered Popular Culture*

The modern zombie complicates existing theories about the gender of monstrosity. Much has been written about male and female coded monsters in horror cinema over the decades. In the monster films of the classic Hollywood era, monsters were mostly sympathetic male figures like Dr. Frankenstein's creature, or virile and attractive masculine monsters like Dracula. In the age of slasher films, starting with Hitchcock's *Psycho*, the monster became a male with sexual deviance and/or trans-identification, as we see with Norman Bates, Michael Myers of the *Halloween* franchise, as well as Buffalo Bill from *Silence of the Lambs*. That is, the male monster becomes threatening through real or figurative castration, by becoming more female/feminine, arguably in direct conservative response to the women's liberation movements of the era. In her famous contribution to horror scholarship, Barbara Creed calls attention to the female monster and coins the phrase the "monstrous-feminine." As Creed explains:

[t]he reasons why the monstrous-feminine horrifies her audience are quite different from the reasons why the male monster horrifies his audience. A new term is needed to specify these differences. As with all other stereotypes of the feminine,

139

from virgin to whore, she is defined in terms of her sexuality. The phrase "monstrous-feminine" emphasizes the importance of gender in the construction of monstrosity [3].

This issue of "the importance of gender in the construction of monstrosity" is particularly intriguing when considering the zombie.

The modern zombie is at times an utterly sexless and genderless being (according to Paffenroth and many others) and therefore wholly unlike vampires and aliens, and at other times fully embodied and entrenched in gender. Romero's original *Night of the Living Dead* ghouls closely resemble the humans they once were, with minimal make-up and tattered clothing, but their blind and seemingly mindless drive to consume the living somewhat erases their sexuality and gender.

Though recognizably male and female bodies gather around the modest farmhouse in various states of dress, these creatures are the objects of the film's gaze primarily for their aberration, regardless of gender. In *Dawn*, the zombies are nearly impotent in their pursuit of the living and thus become sympathetic to the film's survivors. One notable exception to the sexless and genderless zombie prevalent in early modern zombie cinema appears in Dan O'Bannon's *Return of the Living Dead*, a comic spin-off from the Romero franchise. Trash (Linnea Quigley) is a redhaired punk who strips naked during a forest party when she gets turned on thinking about being consumed by an undead old man. Later in the film, she gets her wish when she becomes a zombie, and she dances and gyrates naked in the street for the viewing pleasure of a male character and, assumedly, the viewing audience.

Contrary to Paffenroth's assertion that zombies, "being utterly sexless beings, are as immune to sexism as they are to racism" (*Gospel* 19), Steve Jones argues that though the "zombie has been traditionally formulated as asexual, offering no clearly gendered traits" … the "typically soft-bodied, and largely passive" and "opportunistic" attacker reads as feminine/female-coded ("Porn of the Dead" 42). Therefore, "in accordance with dominant ideological norms, the zombie is a creature that may be gendered female, and the binary opposite (human) gendered male" (42). Italian zombie filmmakers like Lucio Fulci further augment the relationship between sexuality and undeath in the 1970s and 80s. Bishop notes how the "disturbing confluence of sex and death, pleasure and pain, arousal and repulsion—only hinted at by Fulci's voyeurism—is explored so thoroughly by other Italian filmmakers as to constitute a specialized subcategory of the zombie movie" (*American Zombie Gothic* 165), Italian zombie pornography, which has since developed into its own fully-fledged genre in the United States and elsewhere.

More recently, an overtly gendered and sexualized female zombie has been pulled from these pornographic fringes and into the popular spotlight of both big and small screens.

Today's Female Zombie Is (Mostly) Alive and Well

George Romero first encouraged the idea of the zombie as a wholly pathetic and somewhat relatable monster, at least to Fran, in *Dawn of the Dead*. He featured countless female-coded zombies, as early as the naked and the nightgown zombies in *Night of the Living Dead* and the undead nun in *Dawn*. It was not until the likes of Bub in *Day of the Dead* and Big Daddy in *Land of the Dead* that Romero provided a window into this modern monster as a well-developed, sympathetic character turned heroic in the final act of each film. In one of his most poorly received contributions, *Survival of the Dead*, Romero introduced audiences to his first female zombie character with a name—the free and horse-riding Jane O'Flynn (Kathleen Munroe)—who, at least to her father (O'Flynn; Kenneth Welsh), exists somewhere beyond the standard diegetic living/undead dichotomy. Nonetheless, the full development of a leading, protagonistic, humanized zombie woman was left for future creators.

Over the last few years, female cannibals and/or zombies have risen to the role of lead protagonist in genre-bending feature films including but not limited to writer/director Jeff Baena's *Life After Beth* (2014), director Henry Hobson's *Maggie* (2015), and television series like the CW's *iZombie* (2015–present) and Netflix Original *Santa Clarita Diet*. Whether dark and dramatic or comical and satiric, these notable additions to the ever-adapting zombie genre elicit the revisiting and updating of foundational theories regarding gender, genre, and the female monster.

The issuance of the modern female zombie as protagonist raises critical questions regarding Linda Williams' understanding of body-genres, Julia Kristeva's theories of the abject, and Barbara Creed's "monstrous-feminine," and thus impacts our understanding of the role of the monster and the Other in cinema. It also reflects if not challenges the current cultural climate surrounding body-politics and the patriarchy.

Perhaps the prominence of the female zombie protagonist suggests a reemergence of patriarchal fears regarding female sexuality, liberation, and power. As Creed famously argues, the "presence of the monstrous-feminine in the popular horror film speaks to us more about male fears than about female desire or feminine subjectivity" (7). Drawing from

Susan Lurie's work, Creed explains, Linda Williams asserts that "classic horror films [...] frequently represent 'a surprising (and at times subversive) affinity between monster and woman' in that woman's look acknowledges their 'similar status within patriarchal structures of seeing'" since "[b]oth are constructed as 'biological freaks' whose bodies represent a fearful and threatening form of sexuality" (6). Referencing Julia Kristeva, Creed further details that "food loathing," human waste, and "the corpse" are a few of the most fundamental abjections that symbolically and literally threaten the subject and life (9). The female zombie is therefore extremely well-suited for threatening if not obliterating the delicate demarcation between human and inhuman, female and monster, between "normal" and abject, and between life and death.

The female zombie literally embodies the abject and monstrous-feminine, overtly threatens social order and the status quo, and thus far exceeds the mere suturing of the female victim/viewer and the male-coded monster presented in classic horror cinema and discussed by Williams, Creed, and Kristeva. In Jones' understanding of the zombie as a living human doppelgänger, it "is thus clear that the zombie is apposite to represent facets of our own social identities that require cultural 'processing' in order to work through the horror they represent" (41). Jones contends that the "gendering of zombies is a matter that has received little scholarly attention, but one that [...] offers important insights into the cultural climate that spawned representations of gendered zombies" (41). He also agrees that the female-coded zombie "threatens to overturn the ordinances of human (coded male) dominance, leading to the apocalypse; the zombie may then embody patriarchal fear of increasing female liberation, suffrage, and the rise of feminism" (42), now more than ever. Beyond being a mere representation of these fears, a thoughtfully constructed female zombie protagonist can potentially expose and expulse their oppressive domination. The prominence and impact of the monstrous-feminine protagonist is evolving in popular culture. Adaptation and hybridization of the zombie genre will likely provide more radical representations of the monster and should prove fascinating and primed for continued study.

Today's female zombie leads are fully-fledged embodiments of the monstrous-feminine. They are deeply relatable and humanized characters who invite audiences to identity with a "monster" who is wholly familiar and nearly human. She is nuanced and flawed, as are Romero's greatest living female protagonists. She is often depicted overtly and unapologetically indulging her appetites for food and sex. She tends to uphold a reasonable, if necessarily revised, code of ethical conduct. In some ways, she

mirrors the romanticized figure of the Gothic vampire, and yet her bodily (mal)functions reveal that she is certainly not immortal or supernatural in the same sense. She maintains loyalty to friends, family, and lovers. A closer examination of a few new and notable female zombie protagonists will best illustrate these contentions.

RAW (2016) *DIET* (2017–PRESENT) TRENDS

Writer-director Julia Ducournau's film debut *Raw* rattled audiences across the 2016–2017 film festival circuit much in the same way as Romero's *Night of the Living Dead* did in the late 1960s. According to multiple sources,[1] several viewers at the Toronto International Film Festival (TIFF) fainted, vomited, exited early, and required paramedics on scene. The dark and dramatic French-Belgian body horror film, about young female vegetarian who turns cannibalistic after a gruesome carnivorous hazing ritual at veterinary school, also received mixed and passionate reviews from critics. Catherine Bray, writer for *Variety*, predicts that "[o]nly a handful of foreign-language films without marquee names cross over to cult success in English-speaking territories each year. This deserves to be one of the handful" (Film Review: *Raw*" no pag.). Katie Rife, film reviewer for the notoriously critical *A. V. Club*, asserts that "Ducournau's beautifully realized, symbolically rich, and disturbingly erotic meditation on primal hungers," *Raw*, (to which she assigns an "A-") is "the strongest of the female-led films" she screened at Austin's Fantastic Fest ("Jason Manoa and Keanu Reeves Rule…" no pag.). Though its main character is not technically undead, the film grapples with many of the zombie genre themes and tropes through the lens of the monstrous-feminine incarnate.

The parallels between *Raw*'s opening sequence and its zombie genre predecessors are overt: the locale, the mysterious and ominous character who roams it, and the dangers awaiting unwitting visitors. *Raw* opens upon a Gothic rural landscape. The first shot, which harkens to Romero's in *Night*, reveals a long and empty stretch of road that cuts through the countryside. A lone car careens into view. Suddenly, a human figure lurches into the street. The car swerves, its brakes squeal, and it crashes straight into a nearby tree trunk. The figure, seemingly dead and flattened on the pavement, slowly sits up, stands, and then approaches the driver's side window. Though it is unclear if this character is undead, it is clearly both difficult and driven to kill.

The scene abruptly cuts to Justine (Garance Marillier), a polite young woman depicted behind glass, who orders only a serving of potatoes from

a cafeteria line. When asked if she wants protein, she replies, "No. No meat," and moves along. Slouched over while dining with her parents, Justine shakes her head, moans in protest, and spits out her mouthful of mashed potatoes. A hunk of sausage plops onto her plate. Her mother (Joana Preiss) swears and demands to know whether or not her daughter inadvertently bit into the meat. Justine insists no, she did not. Despite Justine's attempts to stop her, her Mother grabs her plate, says, "Seriously. What if you were allergic?" and stomps off to complain. This family is staunchly vegetarian, mother explains to a manager in the background. The father (Laurent Lucas) offers his own food to his daughter, but she has lost her appetite.

Within just two scenes, *Raw* introduces opposites—a murderous character and a strict vegetarian—and initiates inquiries about appetites and consent that bridge the remainder of the narrative. Netflix Original satirical comedy series *Santa Clarita Diet* tackles these same topics, though their territories, tones, and cast attachments differ dramatically. The star-studded American-set show opens on a wealthy, homogenized subdivision, and thus insinuates its interest in the horrors of home and family as initiated by Hitchcock and carried by Romero and other modern zombie filmmakers. Inside the master bedroom of one cul-de-sac home, realtors Sheila Hammond (Drew Barrymore) and Joel Hammond (Timothy Oliphant) stir from sleep. Joel immediately attempts to initiate sex with his wife, but she explains that a morning romp counters her preferred romantic prelude. Joel continues his efforts, but Sheila shuts him down by recalling the stray dog who humped a child at a convenience store recently. The remainder of the morning sequence reveals that Sheila is stuck in middle-aged conformity to diet and other lifestyle trends. She laments her wish that she was between twenty and eighty percent more "bold." Teen daughter Abby (Liv Hewson) enters and interrupts, trying to manipulate her parents into getting or giving her a car. Sheila doubles over with abdominal pain. Abby demands to know if her mom is dying, but both parents brush her off.

Both featured female protagonists, Justine and Sheila, are suppressed in their appetites and trapped in their habits of conforming to the status quo. Justine does not want to make a scene at the cafeteria even though it has violated her strict dietary demands. Though Sheila verbalizes an interest in being bolder, she clearly lacks the drive and courage to defy social mores. She automatically declines an invitation from the neighboring wife to join "the girls" on a wild night out.

Only through dramatic, nonconsensual, and gruesome transforma-

tion are these characters liberated. The meek and mild-mannered Justine is driven to and dropped off at her family's alma mater, a veterinary college her older sister Alexia (Ella Rumpf) currently attends. She is abruptly roused from bed on the first night by her self-ascribed gay male roommate Adrien (Rabah Nait Oufella) just before a masked mob breaks in and ransacks their dorm room. Both are kidnapped and thrown into a line of pajama-clad freshman. The gang of upperclassmen forces new students to their hands and knees. They crawl toward a warehouse. A door opens and they are swept into a raucous, drug-fueled college party. Justine seeks out her sister. Alex is admittedly wasted; she hugs Justine and drags her to get "some fresh air." They end up in a dark and quiet room filled with grotesque animal specimens. Alex walks her little sister through a gallery of new pledge classes who survived this hazing "game." When Alex encourages Justine to go back to the party with her, Justine tries to decline. "I'm going to bed, I'm dead," she says, but Alex won't allow it. Hazing continues through the week as classes resume. The rush ritual nears its finale when the new students are drenched in buckets of animal blood, recalling the famous prom humiliation of De Palma's *Carrie* (1976). In bloodied white lab coats, each pledge heads single-file up an outdoor staircase to their final challenge. Adrien and Justine step up to a table at the top together. There, each is supposed to slurp down a raw rabbit kidney. Adrien complies without hesitation. Justine refuses, as she is a vegetarian. She calls on Alexia to verify that their family is "veggie." When confronted, Alex says she is not a vegetarian, pops a kidney into her mouth to prove it, and then shames Justine into following suit. Alex shoves the organ into her little sister's mouth. Justine leaves with Adrien. She soon bends over and retches as her roommate attends.

The act of vomiting, in *Raw* and *Santa Clarita Diet*, seems to signify a purging of the former, reserved self and an initiation into a freer, albeit corrupted, lifestyle. Sheila and Joel are showing a house to an interested couple and their real estate agent. While touting the benefits of a laundry chute, Sheila suddenly doubles over and projectile hurls buckets of pea soup consistency vomit. She apologizes and promises to have the mess cleaned up, as the others stand in shock. Sheila excuses herself to the restroom as Joel feebly attempts to continue to tour. The couple soon leaves, and Joel returns to the master bath. Sheila is collapsed on the tile floor and the room is awash in vile sick. Joel rushes to his wife and wails her name. She startles awake and asks "Did we get the offer?" Sheila insists she's okay, that she just "threw up a fair amount." "And that came out of me," she notices and points to a small, round, and reddish organ near her heel.

Whether by ingesting or regurgitating a small mammalian organ, each leading female becomes more impetuous, hungry, and sexually charged. Sheila's senses are heightened. She sniffs Joel's shirt and admits that she is okay with his pot-smoking habits. She simply wants him to be himself and live his best life. Later, as Joel leans in to check for her missing heartbeat, Sheila indulges in rubbing his hair and then casually pushes his head towards her groin. "Yeah, like that," she sighs in delight, forgoing any foreplay. She commands a repeat performance later the same day. Joel and Abby faint as she demonstrates that she can cut herself without bleeding. As they drink orange juice afterwards, Sheila mindlessly shovels raw ground beef into her mouth. Less than a day into this confounding illness, her sexual and carnivorous drives are already full-throttle.

Justine's changes are more gradual, reluctant, and against her will. Shortly after being forced to consume rabbit flesh, Justine enters into a heated discussion with her bloodied peers over a meal at the school cafeteria. On the topic of what animal-human act incited the AIDS epidemic, Justine argues that animals have rights and that an act of bestiality between a human and monkey constitutes rape. Fellow classmates are upset by her claim that a monkey likely experiences similar trauma as a woman victim, since they too are intelligent and self-aware creatures. Later, she wakens from a fitful sleep scratching at an angry, red rash that has spread across her skin. The next morning, an examining physician questions Justine about her period and birth control as she peels off sheets of her enflamed skin. Justine reveals she is virgin. The doctor diagnoses her with food poisoning, prescribes a cream, and launches into a story of a former female patient who refused to submit a complaint against interns because she wanted to remain "average" and invisible. Justine also sees herself as average and tries to deflect unwanted attention from classmates, but the desire is futile.

When pressured to admit what she ate, and why, Justine tells the doctor but sheepishly admits she was not "forced" to do so. Justine once again submits to peer pressure when she is forced by an elder peer to don a diaper to class, and later to change from her lab clothes into Alex's "night club" appropriate dress and heels. "It's not me," Justine says, but Alex ignores and kicks her out. At another buffet, Justine serves herself veggies, looks over her shoulder, and stuffs a beef patty in her pocket. She is forced to out her act by the cashier. Adrien tells Justine to "own it." At a remote gas station, she stuffs lamb shawarma into her mouth and tells Adrien to look away. She scarfs raw chicken from the dorm fridge. She learns soon, as does Sheila, that raw animal meat will not suffice.

Justine's unusual hunger is endless and escalating. Her sexual arousal

and interest is amplifying as well. She eats and retches her own hair. She walks in on Adrien receiving fellatio from another man. He slams the door in her face, but she leans in to listen to his moans of pleasure. She gets drunk with Alex, who shows her how to pee standing up, plucks her eyebrows, tells her to shave her arm pits, and tries to give Justine a Brazilian wax. When the wax fails to peel off properly, Alex wields a giant pair of scissors. Justine bucks and accidentally chops off her sister's middle finger. Alex faints. Before help arrives, Justine cannot stop herself from sucking blood and gnawing flesh from the severed digit.

As is true of many women with unusual and invisible afflictions, Sheila denies and Justine hides the seriousness of her condition from friends and family. Sheila refuses to pursue medical treatment. "I'm fine," she tells her husband and daughter, "I feel good." She feels alert, alive, and more focused than ever, Sheila explains. Besides, that would "be bad for you," Sheila says as she points to Joel, "because we're having spectacular sex," prompting an emphatic "Eww" from their teenaged daughter. Abby suggests she knows a "creeper," Eric Bemis (Skyler Gisondo) the neighbor boy, who is "kind of a nerd who specializes in disturbing, weird, or gruesome shit" whom they can consult in private. After a brief examination, Eric determines that Sheila is a zombie (though he doesn't care for the label's connotations) who is now primarily driven by her id. He worries that they "may have to ... bash her brains in" when she loses higher order control and starts to "deteriorate, show aggression," and needs to eat people. By the end of the pilot episode, when new colleague Gary West (Nathan Fillion) tries to sexually assault her, Sheila devours her first human victim in the Hammond's suburban backyard.

Much in the same vein as Showtime's *Dexter* and other genre shows that feature monstrous protagonists, murder becomes acceptable, justified, championed even, when the victims are depicted as complicit or more hideous and loathsome than the main killer character(s). In an effort to protect their family and the secret of Sheila's condition, the Hammond family and Eric pull together to cover evidence and rewrite their code of ethics. "Your mom is a monster," Sheila tells Abby at the remote site where they are burying what is left of Gary. "I ate someone. And if you want me to go away, I will." "No one's going anywhere," Joel assures his wife and daughter, and they smile and nod in agreement. Though the family unit struggles to adapt to and cope with Sheila's disease in *Santa Clarita Diet*, they pull together as a unit, bonded by relations and bound by their immense secret. They face each upcoming challenge with humor and compromise and clever cover ups.

The female zombie figure seems equally driven by sex as she is by hunger, and the two urges for human flesh appear to be inextricably linked and difficult to suppress. In the delirium of her awakening desires, Justine's sexual lust for Adrien surges, as does her desire to taste his flesh. Her face and posture turn predatory when watching him play ball. She seems intoxicated by her own sexuality. Like Sheila, Justine takes a literal bite of the first male who is sexually aggressive towards her. Justine savors the small morsel of flesh with eyes closed and an elevated breath, as did Sheila when she suckled Gary's fingers before chomping down. Titillated and unsatisfied, Justine hops into bed with Adrien, who is masturbating to gay porn. They engage in intercourse, and Adrien has to keep physically and verbally thwarting Justine's bites. In the throes of her climax, Justine sinks her teeth into her own arm until she draws blood. The next night, in a shot reminiscent of Alex DeLarge (Malcolm McDowell) in Kubrick's *A Clockwork Orange* adaptation, Justine licks her lips and smiles with sinister eyes as she watches a woman tongue the eyeball of her lover at a party.

Zombiehood, whether symbolic or literal, looks to be a family disorder. Once Justine's newfound cannibalism is consummated and exposed, Alex tries to support her sister's growth and development. Alex brings her sister to the lone road that opened *Raw* and shows her how to catch a proper meal. Alex darts out in front of another oncoming car and it smashes into a tree. Justine rushes to her sister's body and is relieved to discover that she is okay. They embrace. Justine then heads for the car to find a bloody and unconscious man slumped over the wheel. Alex saunters up, leans in, and chews on the man's exposed brain. Sickened, Justine screams and commands Alex to spit it out. They wrestle. "I did this for you!" Alex shouts, "You need to learn." Justine retreats and tries to find her own way.

Though Sheila and Justine have family support as they learn to cope with and adapt to their conditions, the transition process is not without resentment and other hardships. In *Raw*, sibling rivalry ratchets up as each cannibalistic sister indulges in their natural, animalistic pursuits. Both young women exhibit jealousy and competitiveness, particularly when it comes to Adrien. In a serious act of humiliation, Alex brings a severely intoxicated Justine to the morgue and invites in other drunken partygoers to witness how she instinctively chomps after the arm of cadaver dangled in front of her. Once a sober Justine sees a video of this event on Adrien's phone, she attacks Alex in front of a crowd on the quad. They wrestle one another to the ground before Alex bites off a chunk of her little sister's cheek. "You taste like shit," she growls and spits the flesh

on the ground. When she regains her footing, Justine charges Alex again, and they simultaneously chew each other's arms until wrangled apart by horrified onlookers. The sisters buck and thrash, like the trapped animals they study in lab, against their restraints. They finally settle, leave together, and tend to one another's wounds. Though they share this tender moment, it is clear that Justine remains unsettled as she contemplates locking a slumbering Alex in her dorm room.

Sibling rivalry appears to be the greatest sickness in *Raw* for the majority of the narrative. Justine awakens in bed with her roommate only to discover that Adrien has been slaughtered and feasted upon in the night. She panics, assuming that she lost control during their lovemaking. "Why didn't you hit me?" she screams, "Why didn't you stop me?" In horror, Justine discovers a puncture wound on Adrien's back. In the ultimate act of revenge and betrayal, Justine realizes, Alex stuck Adrien with a ski pole and devoured his thigh. She finds her sister bloody and huddled on the floor. Justine helps her up, strips her down, and scrubs her clean in the shower. Crimson water pools at their feet. In the next cut, we see Alex behind glass, imprisoned for her gruesome crime. The family visits, and the sisters exhibit understanding and affection upon departure.

The onset of monstrousness for these female protagonists is sudden, messy, powerful, and provocative. Unlike the traditional horror story, with its male monster and female victims, works like *Raw* and *Santa Clarita Diet* challenge notions of family, gender, sexuality, consent, and victimhood in new and fascinating ways. Sheila and Justine must figure out for themselves—along with the acceptance, patience, and guidance of their families—how to navigate their futures without wholly denying their senses of self and abandoning their ethics.

In the closing scene of *Raw*, Justine returns home and to a vegetarian diet with her parents. After her mom forbids her from leaving the table before finishing her vegetables, Justine looks deflated and depressed. In an attempt to comfort Justine, her father says "It's not your fault." "I know, Dad," she replies. "Or your sister's." Justine glances up in surprise. Her parents overindulged Alex as a child and should take responsibility for her lack of self-control, her father explains while thumbing a scar on his upper lip. In a startling reveal, he unbuttons his shirt to show Justine that he is covered in scars, old and fresh. He is confident Justine too will find someone who consents to partner with and fulfill her needs as well.

For the remainder of season one of *Santa Clarita Diet*, the Hammonds grow stronger in their bonds and ability to work together. Joel and Sheila murder and store only despicable people to keep Sheila fed. Sheila and

Abby grow closer in their shared loved of behaving badly. Joel continues to research the disease's origins and to search for a cure. Sheila's condition worsens rapidly; her body is deteriorating and her impulses are getting more difficult to manage. The couple makes a pact that Joel will have to kill her if their proactive plans prove futile. Fringe virologist Dr. Coda Wolff (Portia de Rossi) arrives at the Hammond household to study her new subject and to pilot her experimental injection that, at best, will halt Sheila's decline. In the final shot, Sheila conducts business over the phone as she is chained to a bed in the basement until further notice. We will have to wait for season two to see what the future holds for the Hammond family.

Justine and Sheila are shy, private, and "average" women suddenly afflicted with an unknown, cannibalistic condition. They are unwittingly thrust into a transformation from reserved, conscientious, and self-conscious women to lustful, cannibalistic monstrous-feminine embodiments. Once infected with their new condition, each woman denies that she is sick, disabled, or in need of medical attention. Though their monstrous nature is emerging and flourishing, Sheila and Justine continue to craft their own moral and behavioral codes. They remain sensitive to issues of consent as they learn to navigate the world with deviant drives. They remain dependent upon their families for support and guidance. In short, though marked as monstrous, these radical female protagonists are liberated from their former social constraints without vilifying their gendered bodies and appetites. They are active. They are powerful. They are sexual. They are well-fed.

They are family, and they are loved.

Embodying the Zombie
In the Flesh

> Life and death are not properly scientific concepts but
> rather political concepts, which as such acquire a political
> meaning precisely only through a decision.
> —Giorgio Agamben, *Homo Sacer*

> My stories are about humans and how they react, or fail
> to react, or react stupidly. I'm pointing the finger at us,
> not at the zombies. I try to respect and sympathize with
> the zombies as much as possible.
> —George A. Romero

Zombies are finally coming home.

In the world of the BBC's *In the Flesh* mini-series, however, zombie is a pejorative term and home is an unwelcoming place. Politically–correctly coined "Partially Deceased Syndrome" (PDS) sufferers are returning to their families after years of rehabilitation at government-sanctioned facilities. They are medicated, make-upped, and as equally traumatized as the living for the unspeakable acts they committed in their "untreated states." The show itself bears witness to the horrors of bigoted, fanatical, and repressed living townspeople as the medicated undead struggle through the problematic re-assimilation process.

This final chapter calls much deserved attention to one of zombie television's most recent installments, the BBC's *In the Flesh*. The series offers a compelling antidote to the misguided heteronormative shifts in recent zombie media, but has yet to receive any notable critical or scholarly analysis save for a few insightful pages in Bishop's recent *How Zombies Conquered Popular Culture*. *In the Flesh* is, to date, a two season mini-series with a run of only nine episodes. Nonetheless, its brilliant bending of genre (from zombie-horror to politically-conscious sci-fi drama) and

the use of zombification as symbolic of social stigmatization and intolerance demand timely scholarly attention.

Romero's binary-breaking heroines and humanized monsters paved the way for radical zombie film protagonists, but recent works have been working to restore heteronormative representations. While *In the Flesh's* most popular contemporaries like *World War Z* and *The Walking Dead* issue the zombie apocalypse as a mandate for safeguarding traditional family values and institutions, writer Dominic Mitchell's mini-series exposes the literal and figurative horrors of the home and the family as Hitchcock and Romero pioneered in the 1960s.

Furthermore, *In the Flesh* critically challenges heteronormativity when its narratives endorse the characters who brazenly defy conformity. As David Gauntlett explains, "popular media has a significant but not entirely straightforward relationship with people's sense of gender and identity. Media messages are diverse, diffuse and contradictory" (*Media, Gender* no pag.). Central protagonist Kieren Walker (Luke Newberry) is gay and Partially Deceased, but his character develops well beyond these confining categories and into the role of a progressive protagonist. Amy Dyer (Emily Bevan) is empowered by her femininity and her undead status, and these qualities give strength and influence to her character. Since neither aspect of her character is portrayed as monstrous, as is common in zombie and horror media, she defies stereotyping and stigmatization by embracing these visually-obvious aspects of her complex identity. Kieren's sister Jem (Harriet Cains) is visually marked early on as a typical Final Girl, dressed in masculine attire and adept with weapons, but her character is only redeemed once she sheds these masculinizing traits and reconciles with her beloved brother. The unconventional relationship between Philip Wilson (Stephen Thompson) and Amy, once made public, catalyzes an unraveling of stigmatization in Roarton and begins to bring Amy back to life. After witnessing new boyfriend Simon Monroe (Emmett J. Scanlan) endanger himself to save Kieren's life, the Walkers finally break out of their fear and repression to embrace their queer son and his chosen partner.

In the Flesh evolves the zombie genre beyond Romero's more pessimistic indictments of family, society, and culture. By offering a world in which "the meanings of gender, sexuality and identity are increasingly open" (Gauntlett no pag.) and evolving, the series Queers the zombie genre and thus invites viewers to grapple with their own identities, assumptions, and prejudices. Remarkably, *In the Flesh* also advances progressive performances and politics without wholly condemning flawed

characters and eradicating traditional institutions. Mitchell's radical take on the zombie apocalypse narrative restores faith in the genre and its social protest potential moving forward, and reveals how a newly emerging generation of zombie-themed film and television may be more radical and insightful than ever.

Undead Is the New Black

Despite its widespread fanbase, critical acclaim, and scholarly attention, the public might be growing weary of the undead media onslaught. For this reason, Simon Horsford of *The Telegraph* had initial doubts about the potential of the BBC's new contribution to the zombie genre:

> [m]y heart sank when I heard it was about zombies—again. Surely we weren't going to have to endure a low-budget version of the US comic book drama *The Walking Dead*? Is there nothing else to captivate TV writers other than vampires, werewolves and the undead? ["In the Flesh, BBC Three, review," March 18, 2013].

After watching the series pilot, however, Horsford's concerns waned. "But *In the Flesh* has more on its bones than flesh-eating monsters," he writes, "and, instead, uses themes of fear, small-mindedness, forgiveness and intolerance to gets its message across. It's a clever idea, well worked by newcomer [writer] Dominic Mitchell" (no pag.). Now, at the apex of zombie resurgence and popularity, is the perfect time to refresh the genre by returning it to its radical roots and updating its progressive politics for present and future generation of viewers.

In the Flesh contributes a socially conscious and politically enlightened take on the living dead in the present day world. Everyone who died and was interred in 2009 mysteriously rises from the grave to stalk human prey, an event referred as "The Rising." Unlike traditional modern zombies, though, these "rotters" cannot transmit their condition via bite nor blood, so the undead uprising is quickly, relatively contained. Doctors develop a remedy, Neurotriptyline, which restores their brains' neurotransmitter functioning. When administered properly, daily, to biologically receptive PDS sufferers, Neurotriptyline effectively returns the undead to their "right" minds and original personalities. The drug also halts bodily decay, though physical damage already incurred will never heal. Rotters who survived the makeshift militia during "The Pale Wars" are captured, quarantined, medicated, and rehabilitated before they are repatriated to their families. Nonetheless, they carry deep physical and

mental scars. Though they try to hide their corpse complexions under make-up, their colorless irises under contact lenses, and their garish scars under clothes, these PDS homecomings are understandably loaded and complicated.

The Modern Zombie, Artfully-Turned

Hitchcock's *Psycho* (1960) and *The Birds* (1963) and Romero's *Night of the Living Dead* developed the foundation for highlighting the overt violences suffered within isolated communities, inside the traditional home, and amongst the patriarchal family. *In the Flesh* expands these premises to include the multiple violences and oppressions perpetuated by fanatical faith, inherited through repressive culture, and suffered by marginalized people. The pilot episode traces Kieren Walker's journey from the grave, into brain consumption, through rehabilitation, and finally upon return to his rural hometown of Roarton, England.

Through deliberate camera direction—as object of the gaze as well as owner of key point of view shots—Kieren is immediately marked as the show's main protagonist. Through an unsteady handheld camera we watch the teenaged Lisa Lancaster (Riann Steele), dressed in military fatigues marked with a blue HVF (Human Volunteer Force) armband, as she playfully rides a shopping cart through an abandoned supermarket. Distracted by the female voice she banters with over a walkie-talkie, Lisa careens toward the gruesome takedown of another HVF member by a rabid female in a dramatic yellow dress. After tumbling to a prone position on her back, Lisa shoots the doll-like rotter in the gut with a rifle and black goo splatters on the shelving behind her, but the zombie advances nonetheless. As Lisa stumbles in retreat, the power fails, and a jarring reverse-shot reveals a twenty-something blonde male zombie waiting in the darkness. As he reaches out and aggressively grabs Lisa by the shoulders, an authoritative male voiceover commands "Kieren! It's all right," and the flashback ends as Kieren is shaken out of it by Dr. Shepard (Stewart Scudamore).

In the Flesh briefly plays upon the stereotypes and tropes of the zombie genre before it deviates from these standard depictions and challenges audience expectations. Episode 1 opens with customary graphic violence and gruesome images, close-ups on corpse-fleshed fingers and blackened mouths tearing away at blood-red brains, but soon snaps away from this emblematic zombie scene to reveal a vastly different present-day reality.

Kieren slumps forward gripping the doctor's white labcoat lapels. He tosses his head up, revealing a powder-pale face with chapped lips and wide, white-marbled eyes. In a lightning match cut, we see his former dark and visceral visage before Kieren settles down and trembles a sigh of relief.

The high quality direction, acting, and cinematography—on evidence early in the first episode—work to visually and thus emotionally align the audience with Kieren throughout his transformation from rabid rotter into misunderstood young man. The mood and atmosphere of the current world is depicted in stark visual contrast to that of the remembered past. Kieren's flashbacks are individualized, graphic, bright, crisp, and saturated with deep color. His present reality is homogenous, anesthetized, dark, dull, and painted in muted neutral tones. The vivid rendering of these memories symbolizes their power over and impact upon Kieren once he is treated with Neurotriptyline, and alludes to Kieren's talents and personality revealed once he is back home.

In the Flesh initiates its first social criticism, of government healthcare and its failure to recognize and respect individual patient's psychological needs, and the linkage between PDS and mental health disorders is aptly established. This doctor and patient exchange reveals the first of many power imbalances between authority and minority statuses confronted throughout *In the Flesh*. Dr. Shepard diagnoses Kieren's involuntary recollections as entirely normal and scribbles in his notepad as Kieren admits, "They're getting more vivid." The doctor relaxes and retreats to his seat on the other side of the nondescript desk. The shot widens momentarily to display the sterile and washed-out office cast in an artificial, pale-green glow. Dr. Shepard explains this is a good sign; it means the meds are working to restore brain function "like a computer rebooting." Kieren believes it means he is not ready to be reintegrated into society, but the doctor asserts the opposite is true. Dr. Shepard insists Kieren should consider himself "lucky" since he responds well to Neurotriptyline. When pressed about what happens to those who do not, the doctor states plainly, "we take care of them," then shifts the conversation to Kieren's parents. "They looking forward to seeing you again?" Dr. Shepard asks, to which Kieren shakes his head emphatically. When asked why, Kieren says "Because I'm a *zombie*, and I killed people." The doctor condemns his language usage and demands Kieren reword his condition and the crimes he unintentionally committed during his "untreated state." The doctor then leads Kieren out of his office and calls out "*Next*" to the endless line of PDS suffers herded in the hallways.

Kieren's isolation and loneliness are compounded as he is ushered

through the impersonal PDS sufferer exit process, further enmeshing the audience in his character and journey. An impatient medical tech provides Kieren a box of brown contact lenses (his eye color before his condition deteriorated his irises) without making eye contact with him: "*Next!*" Kieran washes his face in a small basin surrounded by other silent sufferers obediently doing the same. Rather than listening to and validating his patient's mental health concerns, Dr. Shepard (as his name suggests) and his callous staff merely push Kieren out of the institutionalized healthcare system and into his unprepared family's hands.

In the Flesh merits attention for introducing a remarkably sympathetic male monster as its main protagonist.[1] Compassion and empathy for Kieren grow as the audience learns first that Roarton has become a desolate and dangerous place since The Rising. As the title credits roll, a series of shots of Kieren's hometown unfurls: overcast sky, one horse grazing in a patchy field, an imbalanced shot of "GOD BLESS THE HVF" graffiti on a brown brick building-side, a dog barking offscreen, a rusted out pickup truck shrouded in weeds. In voiceover, a preacher bellows an impassioned sermon about the "righteous" and the "wretched." A funeral procession marches through a cemetery led by HVF color guards. Simultaneously, Sue (Marie Critchley) and Steve Walker (Steve Cooper) try to sell their house to another set of bereaved and befuddled parents of a returning PDS sufferer when loud Goth music roars from a room down the hall. Sue storms into her daughter's bedroom which is decked out in punk rock posters and other subversive accoutrements. Jemima "Jem" Walker reads in bed, her died-red and black hair tied in a high ponytail and her combat-booted feet crossed on top of the covers. She acts out a violent play with her hands and shouts "fuck off" as she raises her middle finger, which scares away the potential buyers. After Jem storms out of the house moments later, Sue admits disdain for her daughter's HVF involvement. Steve attempts to console his wife by saying "she'll come around." This detailed preview of Roarton puts viewers on edge in anticipation of Kieren's forced return to a now-divided, militarized, and radicalized community and immediate family.

Piloting an Empathetic Zombie for a New Era

Both on-trend with *Warm Bodies* and true to Romero's Bub and Big Daddy, *In the Flesh* produces an individualistic and empathetic zombie character who challenges perceptions of self and the Other in powerful

ways. As I have previously detailed, Romero and others have developed the zombie into a radical protagonist in an effort to challenge characters and viewers to expand their social awareness and acceptance. The ability to see beyond marked difference is a key step towards equality and social justice regardless of race, gender, and alternative embodiment and identification.

Kieren is positioned as an outsider to his own family as well as within the company of fellow sufferers. He watches from a remote window as his parents are escorted into the heavily fortified grounds of the PDS treatment facility. In his final group therapy session, Kieren confesses his flashback is always of the last kill he committed during his untreated state. "The guilt is crippling," Kieren admits, inciting a heated argument amongst fellow patients who disagree about the rights and responsibilities of the undead. After the living group leader (James Foster) quashes the quarrel, Kieren offers that he is most excited to reunite with "little sister, Jem." The scene cuts over to Jem as she enters the local pub to join her HVF comrades, whose middle-aged leader Bill Macy (Steve Evets) greets her as "the Rambo of Roarton" before ordering up a pint for the "trigger-happy honey." Back at rehab, Kieren's roommate Alex (Alexander Arnold) snorts Blue Oblivion—a black market drug that kicks PDS sufferers back into their rabid state—and viciously attacks the medics meant to give him his daily dose of Neurotriptyline.

Violence is depicted as inherent within survivors on both sides of The Pale Wars—whether living or undead, young or old, male or female—but apparently not within our treated Kieren. Willing to do whatever it takes to be accepted back into his family and village, he covers up his corpse-complexion with healthy-skin-toned "mouse," pops in his brown contacts, and sits nervously on the edge of his cot awaiting release. When Kieren emerges from his dorm room with shoulders slumped and eyes downcast, his parents jump to their feet and freeze, stunned for a moment. Sue sobs and Steve's mouth slacks before stuttering an explanation for their reaction: "You look. I mean, you hear stories … your doctors said to be prepared, but … you look *well*." Kieren sheepishly explains that the cover-up makes him look "better." Then, another cutaway to Roarton reveals an unruly congregation learning about the government-mandated repatriation of PDS sufferers, who their Vicar Oddie (Kenneth Cranham) vows "are vicious killers" regardless of medical treatment. Tensions are elevated, and everyone is anxious.

Kieren's position as an oppressed outsider, though now exaggerated, is not at all new for his character. As a precaution, Kieren is forced to hide

under coats in the backseat as the Walkers drive through Roarton toward home. Once inside, Kieren fears his parents will banish him to the attic loft but is soon told by Sue that his room has been kept "just as you left it, love." Through Kieren's unsteady eyes we survey the bedroom, its walls adorned with his paintings of his own likeness, projected alone or alongside another male figure. Later, Kieren joins his parents seated at the dining table. "I don't eat anymore," he reminds them, but his dad replies "it's lamb, your favorite" and his mom pleas with Kieren to "pretend for me, eh?" Briefly, the camera hones in on the grotesque tied-lamb shank centerpiece, alluding to the equally appalling and carnivorous appetites of living humans. Not much separates hungry living from the rabid undead besides table manners. Sue and Steve Walker carry on pretending everything is normal, preferring appearances over actualities. They also tend to avoid direct discussion in favor of euphemisms and alternative topics.

Denial is a deeply-conditioned coping mechanism of repressive culture, and it makes Kieren become a silenced son estranged in his own home. As he dutifully, absurdly pantomimes cutting and eating the meat on his plate, sister Jem bursts through the front door in full fatigues and stops dead in her tracks. "I'm not coming in until *that*," she says pointing at Kieren, "disappears." Kieren sulks off to his room. There he retrieves a shoebox from under the bed and peruses the pictures and letters preserved inside. Again through Kieren's point of view, we too gaze wistfully at an image of him and the other young man from his paintings as his finger gently fondles the edge of the aged photograph. We know our protagonist more intimately now, as this shared gaze enables us to feel a deeper connection to Kieren's life, love, and obvious losses. Kieren's physical, psychological, and social complexities are fully developed and displayed by the close of the pilot episode. In him we have a unique and nuanced male protagonist who defies the stereotypical scripting of masculinity and monstrosity in horror, broader media, and society-at-large.

Queering the Undead

By situating life and death on a spectrum rather than as fixed opposites, PDS sufferers existing as something/somewhere in-between, *In the Flesh* effectively challenges other rigid assumptions regarding socially constructed binaries—old and young, healthy and sick, righteous and wretched, female and male, gay and straight—and thereby enables its character representations to become fluid, free, and Queer. As Harry M. Ben-

shoff explains in "The Monster and the Homosexual," "Queer can be a narrative moment, or a performance or stance that negates the oppressive binarisms of the dominant hegemony [or what critic Robin Wood labelled 'normality'] both within culture at large, and within texts of horror and fantasy" (*Dread of Difference* 119). "Queer is by definition *whatever* is at odds with the normal, the legitimate, the dominant," theorist David Halperin explains, "It is an identity without essence" (*Saint Foucault* 62). The modern zombie (in all of its incarnations since Romero's *Night*), by defying neat categorization as either alive or dead, is unquestionably Queer in these terms. "Queer also insists," Benshoff continues, "that issues of race, gender, disability, and class be addressed within its politics [...] further linking the queer corpus with the figure of the Other" (119), and thus suggesting intersectionality as a critical component of Queer, gender, and film theory.

In the Flesh, the show itself as well as its characters and situations, thus demands engagement with Queer Theory in an effort to fully grasp its social protest power and its potential impact on the expanding zombie canon. As Bishop explains, the "hatred many in Roarton feel towards PDS sufferers results largely from a powerful religious rhetoric of hate and intolerance, a rhetoric that hauntingly mirrors that often used against the LGBTQ community today" (187). The show depicts and condemns this dangerous rhetoric and promotes empathy for and allegiance with its targeted victims. *In the Flesh*'s Queering of the undead is a progressive political act that overtly exposes how the heterosexist norm is not an ideal natural state but instead just another social construction used to oppress those (in the media and in reality) who identify or exist in other embodiments.

Kieren Walker is represented as both literally homosexual and symbolically Queer protagonist. By the end of the pilot episode, visual images and point of view shots add up to reveal that Kieren lost and now longs for the romantic companionship he had with another young man. Over the next two episodes of Season One, the identity of the other character as well as their shared backstory and their related deaths are revealed. In Episode 2, HVF leader Bill Macy's son Rick (David Walmsley) returns home from military service in Afghanistan literally and figuratively scarred. Blinded by hubris, Bill blatantly denies Rick's PDS condition and demands venerable treatment for his veteran son. Rick also acts as if all is normal, drinking pints and hiding the violent vomiting caused by this unnatural consumption. Despite the Walker parents' efforts to thwart their reunion, Kieren stumbles upon Rick's homecoming party at the local pub.

Through their ensuing interactions, we learn how their feelings for one another caused Bill Macy to forbid their interaction. Rick joined the service to prove and uphold the heterosexual and masculine ideals demanded by his father. Upon learning that Rick was killed in combat, Kieren's guilt and heartbreak proved too much to bear. Kieren ran away to their cave hideout in the woods and slit his wrists under graffiti expressing their forbidden love.

In the Flesh is politically progressive in part for featuring a gay male protagonist without allowing the narrative to punish him for his sexual orientation.[2] Kieren needed to conceal his true identity his entire living existence, to avoid negative attention from his repressed family as well as judgment and aggression from the larger prejudicial community. As is clear in the pilot, Sue and Steve Walker have difficulty acknowledging tough topics and accepting uncomfortable truths, but it seems as though they silently tolerate his homosexuality. In his second "life," Kieren gains the strength to challenge his parents to speak directly and to confront complex realities.

Though depicted as initially quiet, subservient, and ashamed, Kieren emboldens the longer he is undeniably marked as an Other by his Partially Deceased condition. He begins to command acknowledgment and acceptance from his immediate family, for being himself in spite of his syndrome, and for being gay. Kieren also challenges Rick to defy his father Bill's orders, first to kill a rabid father-daughter duo in the woods and later to kill Kieren to prove his allegiance as a soldier and as a proper Macy male. In the final dramatic scene of Season One, Kieren provokes his father Steve to finally vocalize his story of finding and trying to save his son from suicide. This outpouring of honest emotion strengthens the father-son relationship and develops Steve's voice and character in Season Two. So while Kieren and Rick died as a consequence of their forbidden love in the show's backstory, the present narrative gives them (and their loved ones) another chance. By resurrecting these two characters and others, In the Flesh potentially unites and elevates those who were previously rendered invisible while alive.

Kieren—as a Partially Deceased Syndrome sufferer and as a gay male—is clearly Queer and significant in relation to the Western heterosexual norms dominant in media and the real world, but Halperin and others stress that Queer is not simply a state of being but rather a position or action in defiance of the normal, dominant, and ideal. To clarify, Queer is not static nor essential but rather active, fluid, and performative. Cherry Smith further elucidates that Queer "articulates a radical questioning of

social and cultural norms, notions of gender, reproductive sexuality, and the family" ("What is this thing called Queer?" 280). In this regard, *In the Flesh* is Queer for promoting homosexual characters to protagonist roles. Several living and undead characterizations, relationships, and situations throughout *In the Flesh* are also intentionally positioned to question and challenge normativity and to expose its innumerable prejudices and oppressions. In this regard, the show and its stories Queer character representations, the zombie genre, and the media at a large.

In the Flesh uses the zombie apocalypse to first call into question the customs and ethics typical to small Western communities. A rural upbringing is often steeped in traditional family values (in England as well as the United States). Since The Rising the village of Roarton, Lancashire, has become a hotbed for religious fanaticism, overt violence, and conservative politics. Members of an unsanctioned militia, the Human Volunteer Force (HVF), have been killing off the "rabid" undead without prejudice, and continue to do so long after treatment and rehabilitation is available. For their protection services, the HVF is showered with praise and free pints by other townsfolk. In preparation for the return of local medicated undead, Vicar Oddie stirs his congregation to fear and to fight those he believes to be godless abominations.

While the state government offers modest protections and provisions for PDS sufferers, local leaders mandate shame and segregation. Roarton elects Maxine Martin (Wunmi Mosaku) as local MP knowing she is an outspoken member of Victus, the "pro-living party" bent on eradicating the "PDS problem." Under the leadership of the Vicar and MP, Roarton's PDS population is banned from travel and forced into mandatory community service as repayment for suffering they caused during their untreated state. Marked in orange vests like prisoners, the PDS population constructs a gate literally designed to keep rotters out but symbolically reinforcing how these undead are actually incarcerating themselves. The show's main protagonists face increasing discrimination, danger, and death in this radicalized Roarton, eliciting outrage from its viewing audience.

By exaggerating prejudices common to small town beliefs and practices, *In the Flesh* exposes the horrors of home and incites viewers to identify with and rally behind the oppressed outsiders. Amy Dyer is the first character in Roarton to embrace her outsider status as a PDS sufferer. Amy is the doll-like zombie companion of Kieren's from the supermarket memory that continues to haunt him in vivid flashbacks. She and Kieren reunite after treatment when Kieren returns to his gravesite to survey and

contemplate the scene of his rising. They reveal their hidden scars to one another: Kieren's slit wrists, Amy's from Leukemia. Amy truly believes that killing was instinctive and necessary for survival during their rabid phase, so she attempts to assuage Kieren's immense guilt. Their bond as BDFFs ("Best Dead Friends Forever," Amy explains) is born.

Amy emerges as secondary, though equally-unconventional and well-developed, protagonist of *In the Flesh*. She is outspoken, unabashed, and ironically more vivacious than any other character (living or undead) throughout Roarton. Amy too is Queer, much to Kieren's initial discomfort, in her refusal to hide her undead identity—under make-up, with colored contact lenses, or in drab clothes—for the benefit of the living characters' comfort. She instead dons colorful vintage dresses, embellished with fluffy petticoats, and adorns her hair with giant flower barrettes. Her performance of femininity is neither monstrous nor sexualized, as is too often the case for females in horror and science fiction. She instead exemplifies a character of great artistry, agency, and independence. Without shame, she visits the Walker household unannounced, plops down at the dinner table, and forces the family to confront and accept her in her unmasked condition. She enters into all environs, however hostile, without fear or apology. Amy soon becomes an inspiration to Kieren, and to viewers, as she helps him to accept and celebrate all facets of his own complex identity. She also has a similar, though more startling, impact upon another man from Roarton.

Amy's character and lifestyle eventually have a transformative impact upon the living culture in Roarton. Though the HVF members and other conservative citizens are outraged by her PDS flamboyance, she gains the attention of Philip Wilson, the town's aspiring young politician. Despite his professional allegiance to the Vicar and MP and their political principles, Philip and Amy have a one-night stand after a late gathering at the local pub. Fearing career consequences the next morning, Philip insists this indiscretion be kept secret and is relieved when Amy insists (contrary to her character) that she is too embarrassed to divulge their secret. Philip cannot deny his growing affection for very long, however, so he frequents the illicit undead brothel at the edge of town and resorts to roleplaying with a sex-worker who pretends to be his girlfriend named Amy. When he is later put in charge of the mandated PDS reparation work, Philip assigns Amy to be his personal assistant. She is nonplussed and resistant to Philip's mysteriously restored attention, but he refuses to cower. When the brothel is exposed to authorities by a nosy, neighboring curmudgeon, MP Maxine leads a protest to its doorstep. She commands her volunteer

troops to raid the joint. They force half-dressed undead prostitutes and their shamed male clients to stand exposed, in separate lines, in front of the outraged mob. Philip arrives to the scene late, notices Amy watching from afar, then musters the courage to march up the lawn and join the line of patrons with his head held high. The crowd is stunned silent.

Philip's act of outing his sexual affiliation with the undead garners Amy's attention, but more importantly speaks to another level of the social protest agenda of *In the Flesh*. Amy inspires Philip, despite his conservative upbringing and threats to his political aspirations, to open his mind and his heart up to a socially stigmatized Other. As returning PDS sufferers and their living allies become increasingly more developed, publically vocal, and politically active, the status quo of the living population of Roarton is greatly challenged. The struggle between the living and the undead is polarizing, and members in both camps radicalize rather than negotiate their differences. The characters who manage to accept, adapt, and evolve—rather than resist and fight against the changing culture—emerge as truly progressive and memorable protagonists. Viewers are stirred to follow suit.

In the Flesh's keen acknowledgment of identity as performative rather than natural is overt in the final episode of Season Two, when key characters are depicted as deliberate in their costuming and actions. According to Judith Butler, a pioneer in the feminism and gender theory which informs Queer theory, gender (and identity more broadly), "is the repeated stylization of the body, as set of repeated acts within a highly rigid regulatory frame that congeal over time to produce the appearance of substance, of a natural sort of being" (*Gender Trouble* 25). During a dramatic montage, Simon carefully lays out the suit he was buried in; Maxine, her blouse and blazer; Gary Kendal (Kevin Sutton), his HVF uniform. Once dressed, Simon prays on bended knee. Sitting upon the edge of her bed, head bowed, Maxine also prays, "Lead us not into temptation, but deliver from evil." Gary recites his HVF credo, "Give me the courage to do my duty. To protect and defend my community from all harm, so help me God," then crowns himself with his beret. Each of these characters, living and undead, deliberately performs the customary dressing and recitation ritual the morning of December 12th, when the Second Rising is prophesized to occur. These routines are indoctrinated yet voluntary, and emblematic of identity affiliations and performances. While gender and other identity markers are not fixed, as key scholars have argued, society, culture, and the media continue to impose expectations and limits upon them.

In the Flesh *in Context*

As *In the Flesh*'s characters and narratives become more developed and complex, it is difficult to reduce its representations to any specific parallels or singular metaphors regarding the real world. Depictions of the zombie apocalypse are too often assumed to be caused by—and therefore automatically representative of—one consequential social issue from the real world context. Romero's *Night* offers a metaphorical critique of the American family in the 1960s. *Dawn*, of blind consumerism in the '70s. *Day*, of the military-industrial complex in the 1990s. *Land*, of the Bush administration's war-mongering in a post–911 world. When character representations and relationships are sufficiently fluid and dynamic, as is the case in *In the Flesh*, these overarching metaphors fall short.

In the Flesh is even more significant when considered as a corrective to the conventional heroes and narratives dominating the most popular contemporary zombie films and television programs. *World War Z* positions a white, lone wolf, American family man as the ultimate hero who can save mankind from a universally evil Other in this action-adventure spin on the zombie apocalypse. Sheriff's Deputy Rick Grimes is a classical everyman capable of leading survivors through the wild Western-themed world of AMC's *The Walking Dead*. R, the romantic lead in the Shakespearean tragedy of *Warm Bodies*, returns to life when his love for Julie is reciprocated. While each of these prominent contemporary texts adapts the zombie narrative via a genre mash-up, it reverts to conservative patriarchal conventions rather than advancing and evolving the modern zombie's social protest roots.

Unlike the heroic everyman leading 2013's most popular zombie works, Kieren Walker is presented as conscientious, complex, and conflicted protagonist throughout *In the Flesh*. Like R in *Warm Bodies*, he's positioned as a sympathetic zombie with the potential to revert back into his humanity. If the zombies were always and only utterly monstrous, the genre would easily fall into the traps and tropes of other horror monsters; that is, the zombies would become metaphors for any and all evil Others depicted to antagonize traditional heroes and the status quo. However, advancing Romero's evolution of the zombie, *In the Flesh* challenges the notion that not all those who are vastly different, who defy social norms, are necessarily villainous. In fact, the undead of *In the Flesh* are more vivid and evolved than the majority of their living neighbors.

Humanizing the zombie is a political act that holds a mirror up to human characters and viewing audiences and asks both where their human-

ity has gone. The Partially Deceased Syndrome sufferers of *In the Flesh* provoke us to question our rigid assumptions, fears, and faults in an effort to teach us imperative lessons: about life and death, about gender and sexuality, about violence and victimhood, and about oppression and marginalization. Kieren's character and narrative expose how a radical dismantling of media representation and stereotyping is necessary in our efforts to transcend the prejudicial powers of our conservative, white-supremacist, patriarchal society, both on screen and in our present-day reality.

In the Flesh *Suffers Another Premature Death*

In the Flesh effectively reinstates and extends the social protest thrust Romero established for the modern zombie genre—on a modest budget and with a relatively unknown cast (sharing both in common with the original *Night of the Living Dead*)—but with the political and social prescience befitting its potentially perceptive audience in the new millennium. This British mini-series is one of the only contemporary installments of the modern sci-fi genre to fulfill this project's calls: for complex and radical representations of the living and the undead on screen; to challenge Western heteronormative ideals, to expose the horrors of the traditional heroic male figure and its oppressive patriarchal institutions, and to contribute media designed to transform our mindless and consumptive culture into one of conscience, acceptance, empathy, equality, and empowerment for all creatures on this great, blue-green planet we call home.

Tragically, and in spite of a spirited outpouring from its avid fanbase on social media, the BBC decided to cancel the BAFTA award-winning *In the Flesh* after only two seasons, citing budgetary constraints. Change.org even started its own campaign for another outlet, like Netflix or Amazon, to pick up the show. Nonetheless, a new program called *I Survived the Zombie Apocalypse* (Season One), a reality-TV game show in which contestants attempt to survive zombie-infested simulations while hiding out inside a megamall, took its place on BBC Three in 2015. In the end, an artificial "reality" television contest (clearly inspired by Romero's *Dawn of the Dead*) triumphs over the socially conscious and affective zombie drama *In the Flesh*. At the time of this writing, there is still hope that the show can be successfully resurrected elsewhere.

Nonetheless, in case the lesson isn't already clear, capitalism and media are the real monsters of the modern age.

Conclusion:
Zombies Past and Future!

> Where does it go from here? Can the subgenre of the walk-
> ing dead continue to survive without changing and adapt-
> ing to new cultural concerns, new social anxieties, and
> the ever shifting preferences of popular taste?
> —Kyle William Bishop,
> *American Zombie Gothic*

> I like my zombies. I won't stay dead!
> —George A. Romero

As of this writing (summer 2017), there is no foreseeable end to what Bishop and Dendle have dubbed the "zombie renaissance" in the new millennium (see "Preface," *American Zombie Gothic*). The genre, like the zombie plague, continues to spread, fast and far, traversing decades and cultures. These post-apocalyptic narratives typically depict zombies driven to consume humanity, one person at a time, until their horde overwhelms the living and civil society collapses. Zombie media infects human audiences similarly, though not exactly, by driving viewers to seek out and consume more zombie media, seemingly without end.

The unprecedented success of *World War Z* (Brad Pitt's highest gross-ing film and the most profitable zombie film to date) and AMC's *The Walk-ing Dead* propels this ongoing zombie-boom. Innumerable zombie spin-offs, sequels, subgenres, and spoofs are hitting big and small screens almost daily. Elijah Wood and Rainn Wilson star in *Cooties*, a 2014 Sun-dance Film Festival selection depicting zombie-kids terrorizing their teachers, hit the theater last year. According to online magazine *Movie Pilot*'s "New and Upcoming Zombie Movies (Coming Out in 2017 and Beyond)," the following zombie features are already available or on their way: *World War Z 2, Patient Zero, An Accidental Zombie (Named Ted),*

The Forest of Hands & Teeth, *The Third Wave*, and *Cargo*, more than half of which are directed or co-directed by women. *The Walking Dead* continues to draw record numbers, so creators launched a sister series set in the same post-apocalyptic world—*Fear the Walking Dead*—in summer 2016. Season Three of Rob Thomas and Diane Ruggiero's popular *iZombie* (loosely based on the *iZOMBIE* comic series by writer Chris Roberson and artist Michael Allred)—in which a young female zombie (Liv Moore, played by Rose McIver) who works for the medical examiner's office eats brains and absorbs memories that enable her to help police solve murders—on The CW Television Network, wraps soon. Dir. Colm McCarthy, and Writer M. R. Caray's (novel and screenplay) film *The Girl with All the Gifts* (2016) affords a surprising glimpse into the post-human world.

Other countries around the globe are also joining the zeitgeist; Korean director Sang-ho Yeon contributed 2016's violent zombie drama *Train to Busan*, and a Bulgarian remake of Romero's *Day of the Dead*, directed by Hector Hernandez Vicens, is purportedly (according to IMDb.com) due later this year.

As zombie films and television shows proliferate at an alarming rate, I intend this project to highlight the genre's humble origins, to illustrate its exceptional social protest influences, to expose the loss of this progressive potential in recent times, and to acknowledge that room remains to evolve the genre for future generations. George Romero deserves reverential regard for creating this lasting modern sci-fi zombie genre which defies Hollywood's conservative conventions and inspires other to follow suit. Robin Wood argues that "[o]nly the major artist—or the incorrigibly obsessive one, which sometimes amounts to the same thing—is capable of standing against the flow of his period" (*Hollywood* 85) as Romero did in the late 60s and continues to do today. This is a "truism," Wood explains, "greatly compounded by the commercial nature of cinema and the problems of financing and distribution" (85). Much of the artistry of *Night of the Living Dead*—the black and white film, hand-held documentary style, isolated locales, and the unknown actors—stemmed from lack of studio support and subsequent budgetary constraints. Romero's refusal to censor his vision, however, facilitated the radical representations and progressive politics that qualify *Night* as a vital contribution to cinema and constitute its lasting relevance and resonance.

Romero's *Dead* series initiated key shifts in how we represent and conceive of monsters and humans. Horror of the 1960s and 70s tended to cast the monster as an evil outsider threatening American ideals and the status quo. Romero's monsters, like Hitchcock's, are instead domestic

byproducts of modern American society. The modern zombie plague erupts from human error, ego, and ignorance. Bishop notes how "Romero establishes audience connection and subjectivity not only with the human characters of *Night of the Living Dead*, but also with the abhorrent zombies that mirror them, thus breaking down the barriers that separate 'us' from 'them'" (*American Zombie Gothic* 95). Yet these monsters are not only us, but they are our fault and our responsibility alone. As the *Dead* series progresses, the scales tilt further to reveal how humans may be more irrevocably monstrous than the increasingly humanized zombie hordes.

Given enough time and space to develop, both human survivors and zombies can be sympathetic and protagonistic even when their goals and motivations seem at odds. The living and the undead are potentially nuanced, complex, flawed, and justifiably motivated, to persevere to see a new day and to shape a new age. *The Girl with All the Gifts*, Mike Caray's 2014 novel and its 2016 film adaptation, suggests a future in which these natural enemies merge and evolve into an entirely new species uniquely suited to inherit an inevitably devastated planet.

Similar to Romero's *Day of the Dead*, *The Girl with All the Gifts* invites audiences deep into a world ravaged by zombies and living antagonists. Scientists and military factions cohabitate a heavily-fortified base replete with experimentation labs, underground bunkers, and prisoners. These prisoners are startling and unique: dozens of human-zombie hybrid children are housed in individual cells. They are fed one meal of grubs per week, subjected to harsh chemical showers, and confined to wheel chairs with head and appendage restraints. Each day, soldiers ferry these chairbound children to a classroom for educational lessons and observation. Occasionally, a kid or two is pulled from class, never to be seen or heard from again.

Though the scientists and soldiers maintain that these captive kids are monsters known as "hungries"—or "little abortions" as Sgt. Eddie Parks (Paddy Considine) often dubs them—viewers are afforded a more complicated perspective. In the classroom, particularly when led by their favorite teacher Miss Helen Justineau (Gemma Arterton), a handful of the children exhibit inquisitive, intelligent, and wholly human characteristics. Star pupil, Melanie (Sennia Nanua), elicits the most interest and sympathy.

For much of the narrative, Melanie demonstrates more human and humane qualities than any of the main living characters. She politely greets her guards each morning, undeterred by their lack of care and compassion. Unlike her classmates, who wear blank expressions, downcast eyes, and

use monotone voices, Melanie observes her surrounding with wide, active eyes. She offers correct answers with enthusiasm. She smiles and brightens when Miss Justineau enters the room. With clever logic, she persuades her instructor to teach the great myths even though they did stories last time since "it counts as history" as well. As Justineau's voiceover narrates the myth of Pandora, we watch the parallels between this famous allusion and the daily strife of our titular girl with all the gifts. Even when the night guards—whom Melanie addresses with proper titles, names, and respect—steady their automatic rifle scopes at her head, Melanie's humility and humanity do not waiver.

Human-hungry behavior protocols are broken when Miss Justineau reaches out to affectionately stroke Melanie's hair. The moment is poignant, powerful, and immediately punished by Sgt. Parks. Though Miss Justineau and the audience see this gesture as a natural, human response to Melanie, Parks demonstrates that a mere thin layer of body scent concealer is the only line of defense separating the living from the hungry undead in these children. Just a hint of human scent in the air triggers rows of chomping mouths in the classroom. It seems as though Melanie, however, has the ability to maintain some semblance of impulse control even when under duress.

Melanie is intelligent enough to deduce that the peers head scientist Dr. Caldwell (Glenn Close) brings to her lab will never return, so when prompted, she volunteers herself. Melanie takes this opportunity to not only protect her fellow hungries, but also to observe and explore the base beyond the confines of their underground bunker. In doing so, Melanie exhibits the same courage and curiosity to study and experiment as does the doctor and her colleagues. In her powers of observation and mapping, we also see that she shares the military leaders' attention to detail and protective strategies.

Melanie is remarkable in part for ability to embody and act upon the strengths and interests of her captors. She is also able to quell her monstrous instincts unless they are needed to protect herself and her beloved teacher. While Melanie is strapped to an exam table in Dr. Caldwell's lab, the military base's border walls are breached. During a harrowing escape sequence, Miss Justineau saves Melanie from Dr. Caldwell's scalpel. In turn, Melanie conjures her inner zombie to attack any human or hungry who threatens their successful departure.

The relationship between Miss Justineau and Melanie is reciprocal and remarkable, and leads the way in negotiating a more nuanced understanding of humanity and monstrosity and their similar, overlapping qual-

ities. They join Sgt. Parks, Private Gallagher (Fisayo Akinade), and Dr. Caldwell in a Humvee that flees the military base in search of safety at Beacon, the territory's governing agency. Parks wants to kill or release Melanie back into the wild for the safety of the people in his charge. Miss Justineau and Dr. Caldwell, for vastly different reasons, both refuse to relinquish their star subject. The group compromises and chooses to allow Melanie to stay so long as she remains gagged, shackled, and secured to the outside of the vehicle. During rest stops and overnights, Melanie is released away from the camp to fend for herself and find food. Melanie complies, feasts upon stray animals, and secures her own restraints upon her return to the group.

Throughout their journey through villages and across the country-side, Melanie and her humans teach and learn from one another. Sgt. Parks continues to call out orders to his crew, but starts to listen to others' ideas and opinions. From him, Melanie absorbs and contributes military tactics and survival strategies. Dr. Caldwell teaches Melanie about her kind as well as about the fungus that catalyzed the zombie outbreak. Pvt. Gallagher allows Melanie to share stories from her education with him. Miss Justineau's care of and compassion for Melanie grows.

Melanie teaches everyone, including her viewing audience, that not all Others are monstrous, and that not all fears we have regarding the monster are justified. On one of her reconnaissance missions, Melanie is terrified to discover an enclave of feral, nonverbal hungry children. She sees herself in them when she discovers that they are intelligent, social, somewhat self-sufficient, and potentially dangerous to her human counter-parts.

Melanie must face the troubling facts of this dire world. She finds herself conflicted and wanting to protect both human and feral children factions, but she recognizes that there is only one feasible outcome for everyone. Dr. Caldwell, dying from an infected injury and futile in her attempt to find a cure for the zombie outbreak, is rendered obsolete. Sgt. Parks, cut during a fight with the feral children, chooses Melanie to shoot him dead when he turns. He does not want to become a monster, and he finally realizes that Melanie is anything but one.

Melanie torches a giant forest of fungal pods in order to hasten global release of the spores responsible for unleashing the zombie condition. Miss Justineau awakens from a concussion to discover that she is the lone surviving human in a world blanketed by the grey fungal snow. Melanie arrives, instructs Miss Justineau to stay inside the sterile environment of their commandeered trailer, and to ready her lesson for the day. Outside,

following Melanie's growled orders, dirty hungry-kids sit cross-legged and ready to learn.

The Girl with All the Gifts suggests a shifting, if not a wholesale shattering, of the human-zombie paradigm. Not only are they us, and we're them, as Romero's characters frequently espoused. Melanie teaches us that a symbiotic fusion between these creatures and their dominant characteristics might just be necessary for survival in a post-apocalyptic world. Both humans and zombies have powerful and valuable traits that can aid in our adaptation and evolution as a species that will inevitably be confronted with environmental destruction, rampant disease, global terrorism, and the myriad of other societal fears and consequences the zombie outbreak signifies.

Melanie sees, thinks, feels, remembers, learns, adapts, and fashions a new world order. In the end, Melanie ushers in a new, hybrid species of living zombie youth capable of expedient and fast civilization. She also inspires a burgeoning hope for a fruitful and thriving future on a post-apocalyptic planet. *The Girl with All the Gifts* demonstrates that there is no end in sight for radical, imaginative zombie characters and narratives able to challenge preconceived notions, to subvert an oppressive social order, and to teach us all how to better comprehend, cope with, and navigate a confounding world.

* * *

I began this lengthy investigation into zombie media with a few questions in mind: What made the original modern zombie genre so shocking and subversive? What can we learn from Romero's *Dead* series? Why can't I simply sit back and enjoy *The Walking Dead*? What makes zombie narratives so compelling and empowering to me? Before I could conceive of this project's scope and focus, I first needed to venture far and deep and across mediums. I reread the most sophisticated zombie novels of the new millennium—Max Brooks' *World War Z: An Oral History of the Zombie Wars*, Robin Becker's *Brains: A Zombie Memoir*, Colson Whitehead's MacArthur-funded *Zone One*—and then discovered Bennett Sims' Nabokovian *A Questionable Shape*. I reviewed early Hitchcock horror, pre–Romero voodoo-zombie films *White Zombie* (1932) and *I Walked with a Zombie* (1943), *Invasion of the Body Snatchers* (1956), and then meandered into the weird world of *The Incredibly Strange Creatures Who Stopped Living and Became Mixed-Up Zombies!!?* (1964). I thoroughly enjoyed revisiting Dan O'Bannon's *Return of the Living Dead* (1985), Peter Jackson's *Braindead* (aka *Dead Alive*) (1992), Edgar Wright and Simon Pegg's *Shaun*

of the Dead (2004), *Zombieland* (2009), and Tommy Wirkola's *Dead Snow* (2009) and *Dead Snow 2: Red vs. Dead* (2014), before surviving an endless lurch of low-budget knock-offs including *Colin* (2008), *Bong of the Dead* (2011), *Detention of the Dead* (2012), and *Zombie Strippers!* (2008).

I didn't come close to finding the answers I sought until I returned to Romero. His original *Dead* series provided the opening I needed for this project, and rethinking *Night of the Living Dead* proved to be my first critical task. I had always remembered Ben for his heroism and tragic takedown, and Barbra for her whining and weakness, but after watching *Night* for the umpteenth time, I softened to Barbra. I finally recognized her resourcefulness while alone, and grew to sympathize with her victimization—Johnny's torment, the graveyard ghoul's assault, Ben's dominance, and Harry's disregard—before her inevitable syncopic collapse. These discoveries led to Chapter 1, in which I explored Romero's indictment of hyper-masculinity, patriarchal institutions, and white-supremacist authority in an effort to uncover the social protest roots of the modern zombie genre.

Repeated viewings of *Dawn* and *Day*, alongside careful examination of zombie scholarship regarding these two films, revealed how Fran is too often over-looked and under-valued as Romero's greatest feminist force. Her character is too dynamic and round to read with existing feminist and horror film theory. She resists Mulvey's male-gaze objectification and Clover's Final Girl masculinization. She speaks up for women's rights and overcomes the consumer temptations of the megamall. She demands survival skills training, learning to shoot weapons and pilot a helicopter, without denying her compassionate drives. Fran rescues herself, her unborn child, and Peter from certain death. Together, they form their own unconventional union and thus revise notions of the family institution. Not as much can be said for *Day*'s Sarah, though she still gets majority credit as Romero's strongest female lead. Nonetheless, Fran and Sarah prove to be the most fully-realized feminist representations of women in horror. Therefore, these two Romero films prove to be the most effective social protest texts contributed to the zombie film canon to date.

By humanizing the zombie figure in *Dawn*, *Day*, and *Land of the Dead*, Romero evolves the genre and elevates its social protest potential. I demonstrated how this flipping of the script on monstrosity also enables more scathing criticisms regarding the violent and oppressive impacts of hyper-masculinity and heroism in zombie narratives. Films such as *28 Days Later…* and *Deadgirl* advance these insights in an effort to expose the grave social impact of male-entitlement and rape culture in the modern age.

Revisiting *The Walking Dead* with eyes wide open, I saw clearly how this current and most-popular installment in the zombie subgenre fails to employ the complex representations of gender and monstrosity—and therefore fails to fulfill the social protest potential—Romero's *Dead* instigated. I attempted to illustrate how the few women on the show who defy feminine-stereotyping are subsequently punished by the narrative, typically with exile or death. Male heroism repeatedly triumphs. Law enforcement and other patriarchal authorities are held in the highest regard. While characters occasionally express reluctance and guilt for killing zombies, particularly infected women and children, they justify doing so as necessary acts of mercy. *World War Z* too favors white-male lone-wolf heroics, but also promotes American idealism as the best defense against the global, terrorizing Other. *Warm Bodies*, on the other hand, humanizes the zombie to an extreme that works to restore heteronormativity as an antidote for the zombie plague. Each of these examples masquerades as a subversive zombie text while upholding the conservative conventions of more dominant genres: the traditional western, the action blockbuster, and the Greek tragedy/romantic comedy, respectively.

To close the project on a note of hope, I illuminated the immense social protest value of the BBC's *In the Flesh*. This mini-series also broadens the parameters of the zombie genre in its blending of zombie-horror and character-driven drama, but nonetheless evokes keen awareness regarding issues of prejudice, marginalization, and oppression that still plague the Western world today. The Partially Deceased "zombies" and their allies are the clear protagonists of the show; their sophisticated scripting enables the conservative culture of rural Roarton to evolve and progress, and inspires viewers to follow suit in the real world. *In the Flesh* moves me, deeply—in ways unparalleled by other popular culture—much like Romero's original *Dead* series did when I first encountered it decades ago. And I trust I am not alone.

The zombie monster and its post-apocalyptical scenarios work as more than mere metaphors for societal ills, as so many zombie scholars contend. The genre certainly does provide necessary and scathing critique of our real world concerns and fears, but its value exceeds critique and contemplation about contemporary society and thus becomes social protest art with the ability to activate real change. The zombie monster provokes us to contend with our mortality as well as our inherent monstrousness, but also offers practical lessons for accepting if not embracing otherness and difference, a point which few scholars acknowledge. In "Ztopia: Lessons in Post–Vital Politics in George Romero's Zombie Films,"

Tyson E. Lewis asserts that "we need a new 'postmodern bestiary' of monsters in order to understand the dialectical figure of the monster as not simply apocalyptic but also a revolutionary force" (*Generation Zombie* 91). Lewis' chapter goes on to argue that the modern zombie, and our culture's current obsession with this monster, typifies this radical and "revolutionary force" he believes is capable of invoking "social and political transformation beyond the human and into the post-human, post-vital world" (91). The zombie can function as an excellent philosophical thought-experiment, but better serves its audiences as a practical catalyst for social change.

I have argued throughout this project, the finest zombie narratives work as social protest texts with the potential to spur social and political transformation (both personal and communal) viable in our present, incarnate world. Wood recognized as early as the mid-eighties how horror "becomes in the 70s the most important American genre and perhaps the most progressive, even in its overt nihilism—in a period of extreme cultural crisis and disintegration, which alone offers the possibility of radical change and rebuilding" (*Hollywood* 76). In the decades since, the preeminent zombie films in particular continue to support this progressive schema in their defiance of Hollywood representations and conventions, as well as with their condemnation of the status quo. Wood's speculations about the possibilities for radical horror cinema to spur change has come to fruition in the new millennium, even if this revolutionary force is being curtailed by the repressive turn in recent, reactionary zombie cinema.

Emerging developments in the zombie genre reveal a disconcerting resurrection of static and prejudicial representations of gender and monstrosity. These narratives, masquerading as subversive zombie works, model the more conservative conventions of the action blockbuster and the soap opera and thus espouse pro–American politics, masculine heroics, and neo-conservative ideals regarding institutions, authority, and family. The white American male is elevated to savior status in *World War Z* and *Warm Bodies*. The white male sheriff assumes a position of authority in *The Walking Dead*, and is elected to lead a diverse band of survivors. The characters who fail to embody these ideals, and those who attempt to defy their own stereotypical scripting, are inevitably punished and expelled.

It is more important now than ever to advocate for the zombie genre as an agent for personal transformation and a catalyst for social justice efforts. In the new millennium, the zombie has leapt off the screen and into the city streets. Whether with or without specific political purpose,

zombie walks and other public events attest to the ability of the zombie narrative to call its fans to action in the real world. I believe public zombie arts and activism are evidential of the actual social impact of this radical protest genre, yet some scholars studying this phenomenon tend to downplay their significance. Sarah Juliet Lauro suggests this sort of "zombie mob only play[s] at: community, action, (r)evolution" (230). In "Playing Dead," Lauro explains her primary interest is studying zombie-themed "demonstrations that communicate nothing but the participants' embrace of the zombie as a legible cultural signifier," and argues that these events "attest to the possibility of organized rebellion" made possible via technology and social media that allows for communal planning and engagement without intervention from law enforcement agencies (*Better Off Dead* 227).

I believe these grassroots zombie assemblages—motivated not by commercial gain but rather a punk–DIY identity and enlightened community engagement—have not only potential but a great and tangible power to affect real social change. Zombie-inspired activism is burgeoning and no doubt demands its own critical study, but it is worth introducing here nonetheless as I hope this project can help bridge the gap between zombie films and the social impact and activism seen in today's society. Zombie stories and their progressive politics have stimulated hordes of enthusiasts to create subcultural communities, nonprofit groups, and charity events. Zombie activism spawned in North America in the early 2000s and has since spread around the globe. Zombie Walks are staged in city centers as communal (dis)organizations or performance art, sometimes to raise awareness and often monies for important causes. Zombie Proms are held for adults who were outcast from this rite of passage during their high school days. The Zombie Squad is a nonprofit organization dedicated to teaching disaster preparedness to communities in need. According to their website, the group was founded in St. Louis but now has chapters and volunteers worldwide (see https://www.zombiehunters.org/ for more information). Zombie film narratives inspire fans to band together in politically productive ways, and this is a remarkable and exciting development not seen from other film genres and popular culture more broadly.

Foreboding current events capable of inspiring new generations of zombie apocalypse narratives hit the headline news almost daily. The repercussions of climate change are feared second only to terrorism. Catastrophic weather events are occurring with great frequency around the globe. Fracking provokes earthquakes. The inevitable eruption of a "Super Volcano." The Ebola outbreak If the earth doesn't eradicate our species

first, we will: the ongoing War on Terror, crises in Yemen and Libya, civil wars in Syria and South Sudan. Boko Haram. ISIS. Death tolls are rising. United States police are indicted for shooting unarmed Black men dead. Transgender people are being violently beaten and murdered. Dylann Roof's racially-motivated massacre of nine faithful parishioners inside Charleston's historic Emanuel AME Church. The subsequent arson attacks on several additional Black churches in the area. Extremist hate groups like the alt-right are radicalizing online.

We still have so much to fear and fight against, and too many to mourn, so the walking dead metaphor will not atrophy in the foreseeable future. The good news is that zombie films can continue to spark social consciousness, inspire community activism, and ignite personal growth.

Rise up, fellow zombie enthusiasts, before it's too late!

Chapter Notes

Introduction

1. See Kain's "How Technology Is Making 'The Walking Dead'" and numerous other articles on this topic in *Forbes*, *Time*, and *The Daily News*.

Chapter 2

1. As critics are often wont to disagree, it is important to note here that Robin Wood, in his discussion of the repression of female sexuality in horror, asserts that the "definitive feminist horror film is clearly De Palma's *Sisters* (co-scripted by the director and Louisa Rose), [which is] among the most complete and rigorous analysis of the oppression of women under patriarchal culture in the whole of patriarchal cinema" ("The American Nightmare" 68).

2. For an astute discussion of the shortcomings of this revised version of Barbra in the 1990 remake of *Night*, see Cynthia Freeland's "Victim or Vigilante: The Case of Two Barbras" (2008) on *PopMatters*.

Chapter 3

1. Jones and I both take issue with the fact that, in interviews, *Deadgirl*'s writer Trent Haaga too easily conflates zombie-rape with necrophilia and "suggests that *Deadgirl*'s moral ambiguity is centered on the viewer[s] asking whether they are 'JT or Rickie' (or 'probably both')" when they should be learning to not identify with either male teen in favor of "imagining what it is to be Deadgirl" (Jones 529).

Chapter 5

1. This image of an abandoned child with teddy bear harkens back to Timmy in Philip K. Dick's "The Second Variety" and therefore issues a warning of danger.

Chapter 6

1. See Tatiana Siegel's "Toronto: Multiple Moviegoers Pass Out...." *The Hollywood Reporter*, September 13, 2016. msn.com.

Chapter 7

1. At this juncture, Kieren can be likened to R in *Warm Bodies* (2013). More importantly, Kieren offers a stark and critical alternative to the male protagonists of other current zombie films and shows.

2. Another science fiction cult favorite, *Orphan Black* (2013–present), also features prominent queer and trans characters without gimmick.

Works Cited

Benshoff, Harry M. "The Monster and the Homosexual." In *The Dread of Difference: Gender and the Horror Film*, edited by Barry Keith Grant. Austin: University of Texas Press, 1996, 116–141.

Bishop, Kyle William. *American Zombie Gothic: The Rise and Fall (And Rise) of the Walking Dead in Popular Culture*. Jefferson: McFarland, 2010. Print.

_____. *How Zombies Conquered Popular Culture: The Multifarious Walking Dead in the 21st Century*. Jefferson: McFarland, 2015. Print.

_____. "The Idle Proletariat: *Dawn of the Dead*, Consumer Ideology, and the Loss of Productive Labor." *The Journal of Popular Culture*, Vol. 43, No. 2, 2010. 234–248. Print.

_____. "The New American Zombie Gothic: Road Trips, Globalisation, and the War of Terror." *Gothic Studies*, Vol. 17, No. 2, University of Manchester Press, November 2015, 42–56. 20 June 2017. Online.

_____. "The Pathos of the *Walking Dead*." In *Triumph of the Walking Dead: Robert Kirkman's Zombie Epic of Page and Screen*, edited by James Lowder. Dallas: BenBella Books, 2011, 1–14. Print.

Boluk, Stephanie, and Wylie Lenz, eds. *Generation Zombie: Essays on the Living Dead in Modern Culture*. Jefferson: McFarland, 2011. Print.

Bracher, Mark. *Lacan, Discourse, and Social Change: A Psychoanalytic Cultural Criticism*. Ithaca, NY: Cornell University Press, 1993. Print.

Bray, Catherine. "Film Review: *Raw*." *Variety*. Variety.com, May 14, 2016. 11 July 2017. Online.

Brooks, Kinitra D. "The Importance of Neglected Intersections: Race and Gender in Contemporary Zombie Texts and Theories." *African American Review*, Vol. 47, No. 4, Winter 2014. Johns Hopkins University Press. 461–475. 18 June 2017. Project Muse. PDF.

Butler, Judith. *Gender Trouble: Feminism and the Subversion of Identity*. New York: Routledge. Anniversary Edition, 1999. Print.

Caray, M. R.. *The Girl with All the Gifts*. New York: Orbit Books, 2014. Print.

Christie, Deborah, and Sarah Juliet Lauro, eds. *Better Off Dead: The Evolution of the Zombie as Post-Human*. New York: Fordham University Press, 2011. Print.

Clapp, James A. "'It was the city killed the beast': Nature, Technophobia, and the Cinema of the Urban Future." *Journal of Urban Technology* 10.3 (2003): 1–18. Web. 30 July 2012.

Clover, Carol J. *Men, Women and Chainsaws: Gender in the Modern Horror Film*. Princeton, NJ: Princeton University Press, 1992. Print.

Cranny-Francis, Anne. "Feminist Futures: A Generic Study." *Alien Zones: Cultural Theory and Contemporary Science Fiction Cinema*. Ed. Annette Kuhn. New York: Versa, 1990. *Google Books*. Web. 11 March 2015.

Creed, Barbara. "Horror and the Monstrous-Feminine: An Imaginary Abjection." In *The Dread of Difference: Gender and the Horror Film*, edited by Barry Keith Grant. Austin: University of Texas Press, 1996, 35–65.

_____. *The Monstrous-Feminine: Film, Feminism, Psychoanalysis*. New York: Routledge, 1993. Print.

Dawn of the Dead. Dir. George A. Romero. 1978. Anchor Bay, 2004. DVD.

Dawn of the Dead (remake). Dir. Zack Snyder. 2004. Universal Pictures, 2004. DVD.

Day of the Dead. Dir. George A. Romero. 1985. Starz Media, LLC, 2007. DVD.

Deadgirl. Dirs. Marcel Samiento and Gadi Harel. 2008. Dark Sky Films, 2009. DVD.

Dendle, Peter. *The Zombie Movie Encyclopedia.* Jefferson, NC: McFarland, 2001. Print.

Diary of the Dead. Dir. George A. Romero. 2007. Genius Products, 2008. DVD.

Ebert, Roger. "Night of the Living Dead." RogerEbertwww. 5 January 1968. Web. 14 February 2014. http://www.rogerebert.com/reviews/the-night-of-the-living-dead-1968

Freeland, Cynthia A. *The Naked and the Undead: Evil and the Appeal of Horror.* Boulder: Westview Press, 2000. Print.

Friedan, Betty. *The Feminist Mystique.* New York: W.W. Norton and Company, 1997. Print.

Frymer, Benjamin, and Tony Kashani, et al., eds. *Hollywood's Exploited: Pedagogy Corporate Movies, and Cultural Crisis.* New York: Palgrave Macmillon, 2010. Print.

Gagne, Paul R. *The Zombies That Ate Pittsburgh: The Films of George A. Romero.* New York: Dodd, Mead & Company, 1987. Print.

Gauntlett, David. *Media, Gender and Identity: An Introduction.* New York: Routledge, 2002. Web. 23 May 2015. www.theoryhead.com/gender.

_____. "Media/Gender/Identity Resources." *Theory.Org.Uk.* Web. 23 May 2015.

Gerlach, Neil, and Sheryl N. Hamilton. "A History of Social Science Fiction." *Science Fiction Studies* 26.2 (1999): 161–173. Web. 30 July 2014.

The Girl with All the Gifts. Dir. Colm McCarthy. Wr. (novel and screenplay) M. R. Caray. Saban Films, 2016. Amazon Prime Video.

GLAAD. "Where Are We on TV '16–'17: GLAAD'S Annual Report of LGBTQ Inclusion." PDF. 22 June 2017.

Grant, Barry Keith. "Taking Back the *Night of the Living Dead*: George Romero, Feminism, and the Horror Film." In *The Dread of Difference: Gender and the Horror Film*, edited by Barry Keith Grant.

Austin: University of Texas Press, 1996, 200–212.

_____, ed. *The Dread of Difference: Gender and the Horror Film.* Austin: University of Texas Press, 1996. Print.

Grossberg, Lawrence. "Foreword." In *Hollywood Speaks Out: Pictures That Dared to Protest Real World Issues*, by Robert L. Hilliard. West Sussex: Wiley-Blackwell, 2009, xiii–xiv.

Halperin, David. *Saint Foucault: Towards a Gay Hagiography.* New York: Oxford University Press, 1995. 62. Print.

Hannabach, Cathy. "Queering and Cripping the End of the World: Disability, Sexuality and Race in the *Walking Dead*." In *Zombies and Sexuality: Essays on Desire and the Living Dead*, edited by Shaka McGlotten and Steve Jones. Jefferson, NC: McFarland, 2014, 106–122. Print.

Harper, Stephen. "*Night of the Living Dead*: Reappraising an Undead Classic." *Bright Lights Film Journal*, Issue 50. November 2005. Web. 20 March 2013.

_____. "'They're us': Representations of Women in George Romero's 'Living Dead' Series." *Intensities.Org.* Web. 20 March 2013. http://intensities.org/Essays/Harper.pdf.

_____. "Zombies, Malls, and the Consumerism Debate: George Romero's *Dawn of the Dead*." *Americana: The Journal of American Popular Culture.* Vol. 1, Issue 1. Fall 2002. Web. 12 March 2014.

Hilliard, Robert L. *Hollywood Speaks Out: Pictures That Dared to Protest Real World Issues.* West Sussex: Wiley-Blackwell, 2009. Print.

Holtzman, Linda, and Leon Sharpe, eds. *Media Messages: What Film, Television, and Popular Music Teach Us About Race, Class, Gender, and Sexual Orientation.* New York: M. E. Sharpe, 2014. Print.

Hubner, Laura, Marcus Leaning and Paul Manning, eds. *The Zombie Renaissance in Popular Culture.* New York: Palgrave McMillan, 2015. Google Books.

In the Flesh. Dir. Jonny Campbell, et al. Wr. Dominic Mitchell. TV Mini-Series. BBC Three, 2013–2015. Television.

IZombie. Dev. Rob Thomas and Diane Ruggiero-Wright. Based on *IZOMBIE* comic by Roberson and Allred. The CW, 2015–present. Television.

Jancovich, Mark, ed. *Horror, the Film Reader*. London: Routledge, 2002. Print.

Jones, Steve. "Gender Monstrosity: *Deadgirl* and the Sexual Politics of Zombie-Rape." *Feminist Media Studies* (13:3), 525–539. Print.

_____. "Porn of the Dead: Necrophilia, Feminism, and Gendering the Undead." In *Zombies Are Us: Essays on the Humanity of the Walking Dead*, edited by Christopher M. Moreman and Cory James Rushton. Jefferson, NC: McFarland, 2011, 40–61. Print.

Kain, Eric. "How Technology Is Making 'The Walking Dead' Television's Most Popular Show." *Forbes*. 3 May 2013. Web. 18 July 2013. http://www.forbes.com/sites/erikkain/2013/05/03/how-technology-is-making-the-walking-dead-televisions-most-popular-show/.

Keetley, Dawn, ed. *"We're All Infected": Essays on AMC's* The Walking Dead *and the Fate the Human*. Jefferson: McFarland, 2014. Print.

Kenemore, Scott. "A Zombie Among Men." In *Triumph of the Walking Dead: Robert Kirkman's Zombie Epic of Page and Screen*, edited by James Lowder. Dallas: BenBella Books, 2011, 185–200. Print.

Kristeva, Julia. *Powers of Horror: An Essay on Abjection*. Trans. Leon S. Roudiez. New York: Columbia University Press, 1986. Print.

Land of the Dead. Dir. George A. Romero. 2005. Universal Studios, 2005. DVD.

Lauro, Sarah Juliet. *The Transatlantic Zombie: Slavery, Rebellion, and Living Dead*. New Brunswick: Rutgers University Press, 2015. Print.

_____. "Playing Dead: Zombies Invade Performance Art … and Your Neighborhood." *Better Off Dead: The Evolution of the Zombie as Post-Human*, edited by Deborah Christie and Sarah Juliet Lauro. New York: Fordham University Press, 2011, 205–230. Print.

Lewis, Tyson E. "Ztopia: Lessons in Post-Vital Politics in George Romero's Zombie Films." *Generation Zombie: Essays on the Living Dead in Modern Culture*, edited by Stephanie Boluk and Wylie Lenz. Jefferson: McFarland, 2011, 90–100. Print.

Lowder, James, ed. *Triumph of the Walking Dead: Robert Kirkman's Zombie Epic of Page and Screen*. Dallas: BenBella Books, 2011. Print.

Mayberry, Jonathan. "Take Me to Your Leader." In *Triumph of the Walking Dead: Robert Kirkman's Zombie Epic of Page and Screen*, edited by James Lowder. Dallas: BenBella Books, 2011, 15–

McGlotten, Shaka, and Steve Jones, eds. *Zombies and Sexuality: Essays on Desire and the Living Dead*. Jefferson, NC: McFarland, 2014. Print.

McIntosh, Shawn. "The Evolution of the Zombie: The Monster That Keeps Coming Back." In *Zombie Culture: Autopsies of the Living Dead*, edited by Shawn McIntosh and Marc Leverette. Lanham, MD: Scarecrow, 2008, 1–18. Print.

McIntosh, Shawn, and Marc Leverette, eds. *Zombie Culture: Autopsies of the Living Dead*. Lanham, MD: Scarecrow, 2008. Print.

McSweeney, Terence. "The *Land of the Dead* and the Home of the Brave." *Reframing 9/11: Film, Popular Culture and the War on Terror*. New York: Continuum International Publishing, 2010. 107–120. *Google Books*. Web. 5 June 2015.

Mellen, Joan. *Big Bad Wolves: Masculinity in the American Film*. New York: Pantheon, 1977. Print.

Melzer, Patricia. *Alien Constructions: Science Fiction and Feminist Thought*. Austin: University of Texas Press, 2006. Print.

Mogk, Matt. *Everything You Ever Wanted to Know About Zombies*. New York: Gallery Books, 2011. Print.

Moreman, Christopher M., and Cory James Rushton, eds. *Zombies Are Us: Essays on the Humanity of the Walking Dead*. Jefferson, NC: McFarland, 2011. Print.

Mulvey, Laura. "Visual Pleasure and Narrative Cinema." *Screen* 16, no. 4 (1975): 6–18. Print.

"New and Upcoming Zombie Movies (Coming Out in 2017 and Beyond)." By Demaris, writer at Creators.co. *Movie Pilot*. MoviePilot.com, June 3, 2017. 9 July 2017. Online.

Night of the Living Dead. Dir. George A. Romero. 1968. Timeless Media Group, 2009. DVD.

Night of the Living Dead (remake). Dir. George Romero. 1990. Columbia Pictures, 2006. DVD.

Nurse, Angus. "Asserting Law and Order Over the Mindless." In *"We're All Infected": Essays on AMC's The Walking Dead and the Fate the Human*, edited by Dawn Keetley. Jefferson: McFarland, 2014, 68–9. Print.

Ochoa, George. *Deformed and Destructive Beings: The Purpose of Horror Films*. Jefferson, NC: McFarland, 2011. Print.

Paffenroth, Kim. *Gospel of the Living Dead: George Romero's Visions of Hell on Earth*. Waco, TX: Baylor University Press, 2006. Print.

Patterson, Natasha. "Cannibalizing Gender and Genre: A Feminist Re-Vision of George Romero's Zombie Films." In *Zombie Culture: Autopsies of the Living Dead*, edited by Shawn McIntosh and Marc Leverette. Lanham, MD: Scarecrow, 2008, 103–118. Print.

Randell, Karen. "Lost Bodies/Lost Souls: *Night of the Living Dead* and *Deathdream* as Vietnam Narrative." *Generation Zombie: Essays on the Living Dead in Modern Culture*, edited by Stephanie Boluk and Wylie Lenz. Jefferson: McFarland, 2011, 67–76. Print.

Raw. Wr. And Dir. Julia Ducournau. 2016. Focus World. Amazon Prime Video.

Return of the Living Dead. Dir. Dan O'Bannon. 1984. Cinema '84, 1985. DVD.

Rieser, Klaus. "Masculinity and Monstrosity: Characterization and Identification in the Slasher Film. *Men and Masculinities* (3: 2001), 370–392. SAGE. Web. 10 June 2015.

Rife, Katie. "Jason Manoa and Keanu Reeves Rule the Wasteland at Fantastic Fest." *A.V. Club*. Avclub.com, September 26, 2016. 11 July 2017. Online.

Romero, George A. "Foreword." *Book of the Dead*. Eds. John Skipp and Craig Spector. New York: Bantam Books, 1989. Print.

Russ, Joanna. "What Can a Heroine Do? Or Why Women Can't Write" (1972). *To Write Like a Woman: Essays in Feminism and Science Fiction*. Bloomington: Indiana University Press, 1995. Print.

Ryan, Michael, and Douglas Kellner. *Camera Politica: The Politics and Ideology of Contemporary Hollywood Cinema*. Bloomington: Indiana University Press, 1988. *Google Books*. Web. 12 February 2013.

Santa Clarita Diet. Cr. Victor Fresco. 2017–

present. Netflix Original, February 3, 2017.

Shaun of the Dead. Dir. Edgar Wright and Wr. Simon Pegg. 2004. Universal Studios, 2007. DVD.

Simpson, Philip L. "The Zombie Apocalypse Is Upon Us!" In *"We're All Infected": Essays on AMC's The Walking Dead and the Fate the Human*, edited by Dawn Keetley. Jefferson: McFarland, 2014, 28–40. Print.

Smith, Cherry. "What Is This Thing Called Queer?" *Material Queer: A Lesbigay Cultural Studies Reader*. Ed. Donald Morton. New York: Westview Press. Print.

Steiger, Kay. "No Clean Slate." In *Triumph of the Walking Dead: Robert Kirkman's Zombie Epic of Page and Screen*, edited by James Lowder. Dallas: BenBella Books, 2011, 99–114. Print.

Towlson, Jon. "Rehabilitating Daddy, or How Disaster Movies Say It's OK to Trust Authority." *Paracinema*. 16 June 2012. Web. 28 October 2013.

28 Days Later.... Dir. Danny Boyle. 2002. Twentieth Century–Fox, 2003. DVD.

Vossen, Emma. "Laid to Rest: Romance, End of the World Sexuality and Apocalyptic Anticipation in Robert Kirkman's the *Walking Dead*." In *Zombies and Sexuality: Essays on Desire and the Living Dead*, edited by Shaka McGlotten and Steve Jones. Jefferson, NC: McFarland, 2014, 88–105. Print.

Waller, Gregory A. *The Living and the Undead*. Chicago: University of Illinois Press, 1986. Print.

Walking Dead, The. Adapt. Frank Darabont. By Robert Kirkman. AMC. 2010–Present. Television.

Warm Bodies. Dir. Jonathan Levine. Lionsgate, 2013. DVD.

Williams, Linda. "When the Woman Looks." *Re-Vision: Essays in Feminist Film Criticism*. Eds. Maryanne Doane, et al. Los Angeles: University Publications of America, 1984. 67–82. Print.

Williams, Tony. "Dawn of the Dead." *The Cinema of George A. Romero: Knight of the Living Dead*. London: Wallflower Press, 2003. 84–98. *Google Books*. Web. 12 April 2013.

_____. "Introduction: Family Assault in the American Horror Film." *Hearths of Darkness. The Family in the American*

Horror Film. Cranbury: Associated University Press, 1996. 13–30. *Google Books*. Web. 12 April 2013.

Wood, Robin. *Hollywood from Vietnam to Reagan ... and Beyond*. New York: Columbia University Press, 2003. Print.

World War Z. Dir. Marc Forster. 2013. Paramount Pictures, 2013. DVD.

Yakir, Dan. "Knight After Knight with George Romero." *American Film*. May 1981. 43. Web. 20 December 2013.

Young, P. Ivan. "Walking Tall or Walking Dead?" In *"We're All Infected": Essays on AMC's* The Walking Dead *and the Fate the Human*, edited by Dawn Keetley. Jefferson: McFarland, 2014, 56–67. Print.

Index